FOND DU LAC PUBLIC LIBRARY

Oct. 24, 1961 G. K. CHRISTIANSEN 3,005,282

TOY BUILDING BRICK

Filed July 28, 1958 2 Sheets—Sheet 1

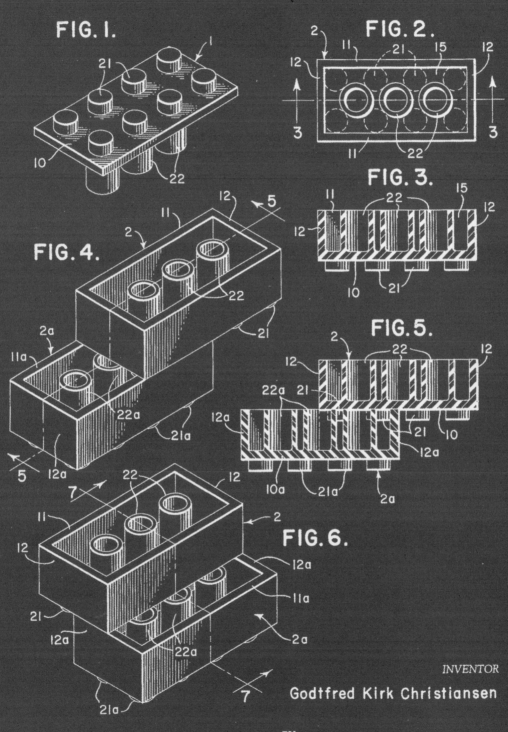

FIG. I.

FIG. 2.

FIG. 3.

FIG. 4.

FIG. 5.

FIG. 6.

INVENTOR

Godtfred Kirk Christiansen

BY
Stevens, Davis, Miller & Mosher
ATTORNEYS

WITHDRAWN

The Cult of LEGO®

John Baichtal
Joe Meno

The Cult of LEGO®

304 interlocking pages

The Cult of LEGO. Copyright © 2011 by John Baichtal and Joe Meno.

All rights reserved. No part of this work may be reproduced or transmitted in any form or by any means, electronic or mechanical, including photocopying, recording, or by any information storage or retrieval system, without the prior written permission of the copyright owner and the publisher.

Printed in China

15 14 13 12 11 2 3 4 5 6 7 8 9

ISBN-10: 1-59327-391-6
ISBN-13: 978-1-59327-391-0

Publisher: William Pollock
Production Editor: Serena Yang
Cover and Interior Design and Composition: Octopod Studios
Developmental Editor: William Pollock
Copyeditors: Kim Wimpsett and Riley Hoffman
Proofreader: Ward Webber
Indexer: Serena Yang

For information on book distributors or translations, please contact No Starch Press, Inc. directly:
No Starch Press, Inc.
38 Ringold Street, San Francisco, CA 94103
phone: 415.863.9900; fax: 415.863.9950;
info@nostarch.com; http://www.nostarch.com/

Library of Congress Cataloging-in-Publication Data
A catalog record of this book is available from the Library of Congress.

No Starch Press and the No Starch Press logo are registered trademarks of No Starch Press, Inc. All trademarks and copyrights are the property of their respective holders. Rather than use a trademark symbol with every occurrence of a trademarked name, we are using the names only in an editorial fashion and to the benefit of the trademark owner, with no intention of infringement of the trademark.

LEGO, the LEGO logo, DUPLO, BIONICLE, MINDSTORMS, the BELVILLE, KNIGHTS' KINGDOM and EXO-FORCE logos, the Brick and Knob configurations and the Minifigure are trademarks of the LEGO Group.

The information in this book is distributed on an "As Is" basis, without warranty. While every precaution has been taken in the preparation of this work, neither the author nor No Starch Press, Inc. shall have any liability to any person or entity with respect to any loss or damage caused or alleged to be caused directly or indirectly by the information contained in it.

I dedicate this book to my parents for inspiring me to write; to my littlest LEGO fans, Eileen, Rosie, and Jack; but most of all to my lovely wife Elise for her encouragement and inspiration.
—*John*

Dedicated to the many people that have been a part of the LEGO community, and personally dedicated to my family and friends.
—*Joe*

Thank you to all the LEGO fans whose work has inspired us.

Table of Contents

It's LEGO's World.
You Just Live in It.

Anyone who has played with LEGO bricks long enough eventually asks the question: Why isn't *every-thing* made from LEGO? Imagine a candy-colored world, infinitely configurable and limited only by your imagination. Bored with your furniture? Snap together a new living room set! Planning a fancy dinner party? Break apart the everyday plates and build new place settings! Tired of your two-year-old car? Rearrange the bricks so it sports tail fins that would make Harley Earl blush!

As you'll see in this fascinating book by John Baichtal and Joe Meno, the above scenario is not as far fetched as you might think. Many LEGO enthusiasts say that working with LEGO since childhood has caused them to see the world with different eyes. With LEGO on the brain, the physical world becomes a hackable platform, and LEGO is the ideal prototyping material for designing on the fly. You can find people who use LEGO to construct cameras, musical instruments, scientific instrumentation, and robots that make Mickey Mouse pancakes (shhh—don't tell Disney or they'll raid the poor guy's home the next time he makes breakfast for his kids).

Why are LEGO bricks so useful, both as a toy and a serious physical development platform? There are many reasons, but four stand out:

Standardized parts. Any LEGO brick will happily snap to almost any other LEGO brick in existence, from a vintage 1958 brick to the newest ones available at the LEGOLAND theme park in Carlsbad, California.

Variety of parts. Thanks to the proliferation of kits and TECHNIC parts, enthusiasts have hundreds of different kinds of LEGO parts to work with, from gears and wheels to pneumatics and microcontrollers.

Ease-of-use. The first thing a two-year-old child wants to do with LEGO bricks is put them in his or her mouth. The second thing he or she wants to do with them is snap them together and pull them apart. No manual is required to use LEGO bricks.

Indestructibility. I have a friend who scours garage sales and buys grungy, used LEGO pieces for pennies a tub. When he gets home he tosses them in a mesh bag and runs them through the dishwasher. They come out sparkling and as good as new. LEGO bricks can take almost any punishment you give them.

As John and Joe will show you in the pages that follow, these powerful features of such deceptively simple bricks have resulted in an explosion of creative diversity that boggles the mind.

Play well!

Mark Frauenfelder
Editor in chief of *MAKE* magazine

Introduction

The Cult of LEGO tells the story of an incredible toy and the adults who have made it a part of their lives. LEGO is merely a toy, you say? Think again.

Put simply, *The Cult of LEGO* is an ode to the brilliance of adult fans of LEGO as well as to the toy they love. These builders have built their craft into an art form (sometimes literally!) and in doing so, have grown in the public's consciousness. Tens of thousands of families visit LEGO conventions. Builders are profiled in newspapers and appear on late-night comedy shows. Their work grows in ambition and technique every year.

Central to the success of LEGO is the story behind the company that created the toy. How did LEGO transform from little plastic bricks to one of the most recognizable and respected brands on the market? Chapter 1 covers the **History of LEGO**, tracing the origins of the LEGO Group and its evolution from a small carpentry shop in Billund, Denmark, into a multinational company that has achieved great success by never giving up on the values its founder set down.

In Chapter 2, **Building Again**, we ask the central question of the book: Why is the toy such a huge hit with grown-ups? We explore the concept of the Dark Age, the time in a LEGO fan's life when he or she loses interest in LEGO, and even meet a sampling of these fans, learning a little about their interests and inspirations.

We get to experience **Minifig Mania** in Chapter 3. Somehow, expert LEGO builders are able to infuse their creations with the spark of humanity. Making it easier is the presence of minifigs—those adorable, customizable figures that serve as the people in LEGO sets. In this chapter we learn about minifig scale, a default set of proportions based on the assumption that minifigs are the size of actual people. Fans use official and third-party accessories to customize minifigs, often making them resemble famous people and characters from movies.

Chapter 4 covers the dedication that goes into **(Re)creating Icons**. We see the beginnings of this in a child's model of a house or car, but adult builders take this to the next step, creating models on a vastly more sophisticated level. These fans create mosaics of movie characters and re-create epic scenes from their favorite films. They build odes to office towers and replicate famous naval vessels.

Chapter 5, by contrast, describes models inspired by fantasy and science fiction that depict scenes that could never exist in the real world. In this chapter we explore the realm of **Building from Imagination**, covering such topics as steampunk—lovable neo-Victorian fantasy—and apocaLEGO, post-apocalyptic LEGO models.

In Chapter 6 we take a look at **LEGO Art** (with a capital *A*). We explore the work of recognized artists who have chosen to use LEGO as their medium of choice. The resulting creations end up hanging in museums or galleries and going on tour throughout the world. These works of art are respected for their brilliance and could find a place in any collection; the fact that they are made of (or depict) LEGO neither lends them undeserved praise nor prevents them from being taken seriously. To LEGO artists, LEGO is simply the tool they use to make art.

Every builder loves **Telling Stories** with LEGO. In Chapter 7 we explore all the ways adult fans weave a narrative with and about LEGO, including models, LEGO comics, and even stop-motion movies. We also learn about diorama building, where a builder—or a group of them—builds a gigantic model that contains dozens of smaller stories. By contrast, the vignette tells a story on a very small footprint, challenging the builder's creativity and discipline.

The topic of scale is discussed in Chapter 8, **Micro/Macro**. When creating a model, some seek to build as big as possible. It lends a certain "wow" factor: How could one not be impressed by a model that contains 100,000 elements? Others, however, build as small as possible. These microbuilders seek the challenge of creating their visions with as few bricks as they can, creating tiny but impossibly detailed models at the smallest scale LEGO parts allow.

Is LEGO really LEGO when it doesn't involve plastic bricks? In Chapter 9, **Digital Brickage**, we study one of the remarkable aspects of the LEGO Group: its willingness to redefine its product lineup. Since the '90s, this has included entertaining fans with games and building programs. There's even an entire online world, a massively multiplayer online role-playing game called *LEGO Universe*, that lets players take on the role of an adventuring minifig. Fans, too, have joined in on the fun, creating 3D models built with official and unofficial LEGO parts and printing them on 3D printers.

The focus on technology continues with Chapter 10, **LEGO Robotics: Building Smart Models**. This is another area in which the LEGO Group has managed to transition out of its traditional model, building a series of robotics sets over the years. One of these lines, MINDSTORMS, has actually become the company's number-one-selling product, with associated organizations and events of its own. Underscoring this trend toward robotics are the fabulous inventions profiled in the chapter, which include everything from a LEGO autopilot to a Rubik's Cube–solving robot to a contraption that floats in a swimming pool and kills pesky insects.

In Chapter 11, **Gatherings**, we chronicle the history of LEGO fan conventions. As long as there have been adult fans of LEGO, these builders have sought to meet others with the same interest. Conventions allow these fans to share techniques, commiserate over some product line the LEGO Group has discontinued, and, most importantly, share their creations. This tradition has become a way of spreading the word about their hobby. Now, almost every LEGO convention has "public days," where models are shown off to the public.

Throughout the book we are struck by the sense that LEGO is more than just a hobby—even one that commands intense loyalty from its fans. No chapter underscores this phenomenon more than Chapter 12, **Serious LEGO**. The projects featured in this chapter have nothing to do with whimsy or fun. We learn about how autistic kids develop social skills through cooperative building, how marketing departments publicize their products with LEGO representations, and how schoolchildren create science experiments with LEGO to study atmospheric phenomena. In many ways these projects demonstrate the toy's profound influence. It has transcended its use during playtime and contributed to science and art by helping to make people's lives better.

In *The Cult of LEGO*, you'll learn to embrace the brilliance of a toy—perhaps the greatest ever invented—that has been transformed into an art form by the passion of adults.

Read on.

The History
of LEGO

(OPPOSITE) **The diversity of LEGO bricks can be experienced simply by grabbing a handful**

Who can doubt the huge impact of LEGO? The toys are found in more than 75 percent of Western homes. According to the LEGO Group's website, an average of 62 LEGO bricks exist for every person on Earth, with 2,400 different elements in 53 colors. With all these parts floating around, one would think that there would be some neat things to see … and there are.

As of this writing, more than 200,000 LEGO videos appear on YouTube, and over a million pictures tagged with *LEGO* appear on Flickr. LEGO parts have been used to create 3D printers, autopilots, and buckyballs. Architects have used LEGO bricks to conceptualize structural models, and artists have used them to create inspired museum-quality works of art. Tens of thousands of LEGO fans attend worldwide LEGO conventions.

How could a humble toy brick manufactured by a family-owned company so profoundly impact the entire world? Let's find out.

Billund: Home of Peat Bogs and LEGO

The **LEGO Group's** corporate head-quarters is still located in **Billund, Denmark.**

The LEGO Group was founded in the Danish village of Billund, and in proper LEGO fashion it has remained there ever since. Billund may loom large in the realm of LEGO, but it's not exactly a metropolis. Before the predominance of LEGO, the region's primary fame came from the bog bodies pulled from the peat. These are human cadavers preserved by the unique properties of the bog, allowing for detailed scientific analysis of mummies of up to 5,000 years old.

After a 2007 merger with a nearby municipality, the town's combined area measures 207 square miles, with a population of just over 26,000 — with 6,000 people living in the village of Billund itself. To give this some perspective, the least populous of New York City's five boroughs, Staten Island, boasts a population of 477,000 and covers three times as much area.

It would not be an exaggeration to say that no major toy company has such a profound local presence. LEGO-LAND Billund is a huge draw that's mentioned on every Danish travel website. The corporate headquarters and the theme park have made the Billund Airport the second busiest in the country. However, visitors can't expect to have the same access to the LEGO Group's bustling factories. If you really want to visit the company's facilities, be prepared to shell out for the opportunity. Tours, which are conducted on a limited basis, cost 9,000 Danish kroners (DKK) — about US$1,700.

The country of Denmark as a whole has a remarkably LEGO-like feel. "There are LEGO products in nearly every family's home in Denmark," former LEGO Group employees Ulrik Pilegaard and Mike Dooley wrote in *Forbidden LEGO* (No Starch Press, 2007).

"In fact, the idea of LEGO itself is intertwined with Danish culture and psyche. Walk the streets of the small towns of Denmark and you sometimes feel like you're in a mini LEGO world — everything looks LEGO, down to the types of windows and the trademark colors that cover the walls, roofs, and doors. It's sometimes hard to tell whether the buildings are modeled after LEGO sets or LEGO sets are modeled after the buildings. Turn the corner and you might see a gas station with a garage; you'll wonder if it was inspired by LEGO designs or the reverse."

If Billund is a LEGO Group town, Denmark is a LEGO Group nation. "There's a certain pride of the LEGO company," Pilegaard said in an interview. "Most people would like to see LEGO do well on the international market. Most people growing up in Denmark will have been exposed to LEGO at some point and feel kind of attached to the brand. It fits well with the Danish way of living, where quality in many cases wins over cost." This mind-set can be seen in the company's products, which typically cost more than the competition's but last for decades.

The LEGO Group's creative toys also mirror Danish culture. Denmark is a creative country that gave birth to such cultural icons as children's author Hans Christian Andersen, author Karen Blixen (who wrote as Isak Dinesen), humorist and musician Victor Borge, and philosopher Soren Kierkegaard. Danish industrial design is famous the world over and hugely dominant within the country. The per capita gross domestic product of Denmark is higher than that of the United States and most other European countries, and this fact, combined with the country's penchant for good design, has instilled the Danish with a love of quality.

Only the Best Is Good Enough

(LEFT) A wooden plaque at the LEGO Group's headquarters in Billund, Denmark, displays the company's slogan in Danish: "Only the best is good enough."

There's an old story that says the LEGO Group founder Ole Kirk Christiansen once noticed that his son Godtfred was skimping on the varnish used to coat the company's original wooden pull toys. Although the toys normally carried three layers of varnish, Godtfred was applying only two in order to save money. The elder Christiansen made Godtfred revarnish all the toys because, as the LEGO Group slogan says, "Only the best is good enough."

How many times have we heard that from a company? Every business promises to focus on the consumer experience, but few back up that promise. No matter how earnest that commitment is at first, sooner or later reality overcomes the fading promises. Perhaps a thriftier manufacturing solution comes along or there's an opportunity to cut a couple of seemingly innocuous corners. What customer doesn't want cheaper products, and what CEO doesn't want to make more money?

The difference with the LEGO Group is that it actually seems to mean what it says. By all appearances, the company has indeed put product quality over greater profits, despite all the pressures and temptations it faces. But why? Perhaps it's because the LEGO Group is privately held. One of the problems with publicly traded corporations is that investors typically expect the greatest possible return on their investments in the shortest time possible. When management doesn't explore those cheap overseas factory deals or streamline production methods, shareholders raise a ruckus. For these businesses, creating a durable and attractive product is secondary to the bottom line.

Far from employing sweatshop labor, the LEGO Group keeps core manufacturing processes in-house to maintain a remarkable quality level — claimed to be a mere 18 duds per 1 million bricks; in addition, the LEGO Group maintains the human expertise necessary to bring other operations in-house again, if necessary. Not only are the bricks designed to meet toy safety standards, but they also meet food safety standards. Their quality is so high you can eat off of them!

Some toy manufacturers that emphasize quality find their products relegated to the category of "premium playthings." Think of toys that cost hundreds of dollars — the kind you drooled over as a kid and then scrawled on your birthday wish list, knowing you had no chance of actually getting them.

The quality issue is a conundrum for businesses: Put too much quality into a product, and no one can afford to buy it. On the other hand, streamline manufacturing to keep retail prices down, and the toys manufactured risk becoming cheap junk. For organizations that choose the latter path, quality becomes a bugaboo, from lead paint and manufacturing defects to the moral controversy of employing dollar-a-day laborers to stuff people's homes with consumer products.

Despite these pressures over the years, the LEGO Group kept its manufacturing in Billund for decades, until competition forced it to grudgingly open facilities in Mexico and Eastern Europe. However, the company still uses expensive formulations of plastic, even though lesser and cheaper varieties are available.

Then why aren't LEGO products priced sky-high? The answer lies in the toys' modular format. By constructing models out of numerous tiny (and individually inexpensive) parts, the company can ramp up product costs to appeal to a wide array of income levels. A 1,000-brick model set is pricey, for instance, but a 20-brick set is affordable to most parents. Once purchased, a LEGO set becomes an heirloom: A tub of bricks can be passed down from child to child and even from generation to generation.

The LEGO Group Reality: Change Happens

Although a tradition-bound family company, the LEGO Group seems to embrace change. At first, change was a matter of survival. The company's founder, Ole Kirk Christiansen, was a carpenter who specialized in building and remodeling homes. In the depths of the Great Depression, housing construction dropped precipitously, and most homeowners couldn't afford to remodel. In response, Christiansen changed his focus: He began building toys instead of homes. He called his company *LEGO*, a contraction of the Danish *leg godt*, or "play well."

At first, Christiansen's new company created a wide range of consumer products, including such sundries as ironing boards, clothes hangers, and stepladders, but his specialties were pull toys and blocks. The company's first hit was a duck pull toy introduced in 1935 that proved so popular that the duck has endured as a symbol of the company's genesis ever since. During the LEGO Group's 75th anniversary celebrations, the duck was incorporated into the event's logo, and every employee got a duck-related gift.

Throughout the rest of the 1930s, the LEGO Group experienced modest growth, doubling in size to 10 employees. During the early 1940s, Denmark was occupied by the Nazis, but work continued at Christiansen's shop unabated. In fact, payroll increased to 40 employees by 1943.

In 1947, a radical change occurred at the LEGO Group. With plastic toy-making materials becoming increasingly more common, the company bought an injection molding machine for the princely sum of 30,000 DKK (about US$5,700). Within two years, the LEGO Group's top three products were made of plastic: a fish, a sailor, and a stackable block Christiansen called the *automatic binding brick*.

By 1953, the LEGO Group's plastic bricks had become so important to the company's bottom line that they became the company's signature product and were renamed *LEGO bricks*.

(TOP LEFT) **An assortment of wooden toys at LEGO Group's Idea House shows visitors the products that predated the LEGO brick.**

(TOP RIGHT) **Grandson of company founder Ole Kirk Christiansen and current owner of the LEGO Group, Kjeld Kirk Kristiansen, still represents the company's original vision to legions of fans.**

(BELOW) **The duck that started it all, the wooden pull toy that was Ole's first product**

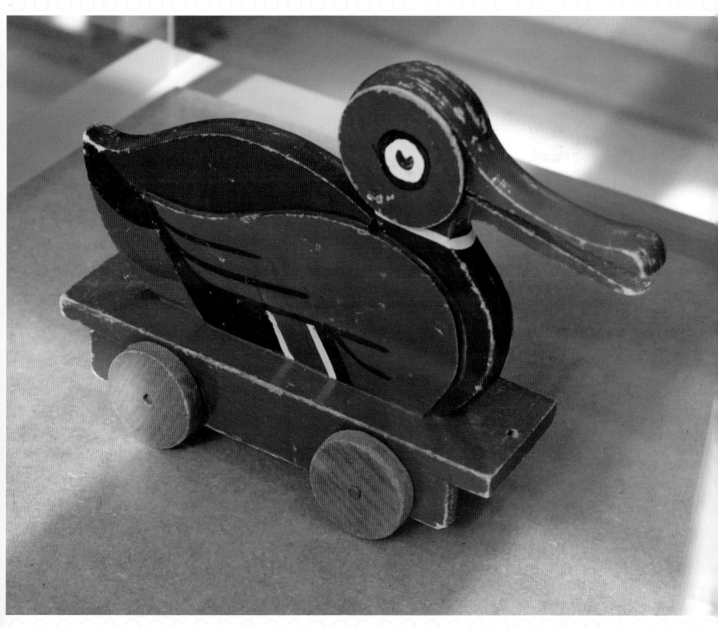

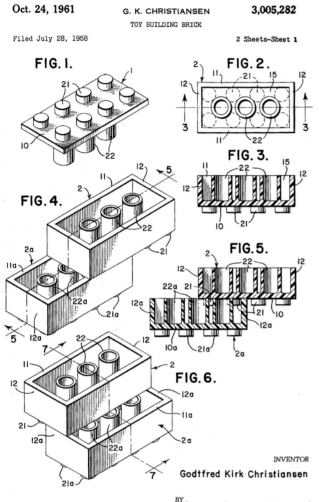

Oct. 24, 1961 G. K. CHRISTIANSEN 3,005,282
 TOY BUILDING BRICK

Filed July 28, 1958 2 Sheets-Sheet 1

FIG. 1.

FIG. 2.

FIG. 3.

FIG. 4.

FIG. 5.

FIG. 6.

INVENTOR
Godtfred Kirk Christiansen

BY
Stevens, Davis, Miller & Mosher
ATTORNEYS

(ABOVE) **The US patent for the LEGO brick, dated 1961**

The LEGO Group continued to play with the basic form of the bricks, searching for a way to connect the bricks that would keep models together but that wouldn't be so strong that children couldn't separate them. In 1958, the brick finally reached the form that we know today, with an improved connection system consisting of plastic tubes on the underside of one brick that squeezed the studs on another brick with enough force to keep the constructions together. Sadly, this year also marked the death of founder Christiansen.

Following Christiansen's death, the changes at the LEGO Group continued. In 1960, Ole's son Godtfred bought out his three brothers, took over the company, and ended the production of wooden toys. As the decade progressed, the LEGO Group continued to innovate, releasing its first electric train in 1966 and opening LEGOLAND Billund two years later. The year 1969 saw a new version of the electric train and the release of DUPLO bricks for smaller children.

By the 1970s, LEGO Group management realized a need for a more robust line of LEGO bricks that would appeal to older children. In 1977, this idea took form with the release of the LEGO Expert Series, a major evolution in the company's core product line. The Expert Series was a move away from the stud-and-tube setup of the classic brick, toward a stronger and more challenging hole-and-pin connection that allows for more durable creations. You're probably already familiar with the Expert Series: Today it's known as TECHNIC.

As the turn of the 21st century neared, the LEGO Group became aware of other, more radical changes in the way children played with toys. Specifically, a growing movement toward electrical and electronic playthings emerged, including computer games. True to its roots, the company focused on adapting to this new environment.

In the late 1990s, LEGO registered LEGO.com and licensed its first movie-related theme—the dazzling and successful *Star Wars* sets. In 1998, the company created MINDSTORMS, a robotics set for kids. With the turn of the 21st century, the LEGO Group developed BIONICLE, a new approach coupling TECHNIC pieces with custom elements to evoke a biomechanical theme, along with a pre-packaged story line told with commercials, web shorts, and comics. BIONICLE also appealed to collectors by offering an assortment of items (masks, disks, and so forth) in each set, although in order to get a set of masks, collectors had to buy or trade with other BIONICLE collectors.

(TOP) A production line creates LEGO bricks in a LEGO factory.

(BOTTOM) The factory's vast storage bins hold countless elements for eventual sorting and packaging.

(OPPOSITE) **A LEGO mold cranks out bricks.**

In 2005, the LEGO Group posted its first-ever deficit, the effect of rising production costs and increased competition. "LEGO had lost its way," CEO Jørgen Vig Knudstorp told the LEGO-focused magazine *BrickJournal*. But, he amended, "We are no longer in an identity crisis."

Was this corporate double-talk or a genuine turn-around? No matter how you look at it, the LEGO Group experienced its most challenging times in 2005, most likely as a result of a variety of pressures on the company. For one, interactive and video game play was increased at the expense of physical toys. The LEGO Group has countered by developing increasingly more robust interactive products and continuing to evolve LEGO robotics from a niche product to a worldwide phenomenon. At the same time, it has had to be careful not to overdiversify to the point where its core product — the LEGO brick — becomes overshadowed by LEGO robots and video games.

Another challenge facing the company has been its expensive production processes. To its credit, the LEGO Group has refused to compromise on quality, sticking with color-safe and durable acrylonitrile butadiene styrene (ABS) plastic. "Some might say it's overkill for a toy line to have those quality levels," former LEGO Group employee Ulrik Pilegaard said, "but I think that's one of the many reasons LEGO has done so well over the years. The fact that 15- to 20-year-old parts are still compatible with current sets from the store is pretty amazing — and the old pieces just need a ride in the washing machine!"

Still, it's difficult for any company to keep its numbers up when the competition has lower standards and prices.

In response to the challenges of the 21st century, the LEGO Group developed a seven-year plan for renewed profitability. One controversial change involved reducing its production costs by relocating manufacturing to Eastern Europe and Mexico. Since the company had always kept its plants in Denmark, this was a big step. Cutbacks and layoffs added to the company's trauma, with approximately 1,000 employees losing their jobs between 2003 and 2004.

Despite the company's difficulties (or perhaps because of them), the LEGO Group continues to experiment with new ideas. It developed a massively multiplayer online role-playing game (MMPORG) called *LEGO Universe*, as well as LEGO Factory, a custom visualization and parts-ordering system. With LEGO Factory, LEGO complemented its traditional sales model with a unique online store. Builders use the online computer-aided design (CAD) software to build their own models, rather than buying prepackaged sets. Once their virtual creations are complete, builders simply click a link to order the elements to create their model "for real."

Meanwhile, the LEGO Group's robotics endeavors have never been stronger. MINDSTORMS has become a certified hit, spawning the worldwide robotics design competition FIRST LEGO League, which entertains and challenges millions of teens. Similarly, MINDSTORMS's simplified cousin WeDo promises to bring computer-controlled LEGO to elementary-school children everywhere.

Change, it seems, remains part of the LEGO Group's business process.

Just Another Brick?

The little LEGO brick has become the perfect tool for expressing our imaginations. "Playing with LEGO growing up let me build anything I wanted to build," professional LEGO builder Nathan Sawaya said in an interview. "It let my imagination control the playtime. If I wanted to be a rock star that day, I could build myself a guitar. If I wanted to be an astronaut, I could build myself a rocket."

The LEGO Group stands apart from the competition by any objective standard. It has lasted longer and has produced more varieties of its core product. It has remained true to its founding values, while successfully reimagining its products to keep them current. Yes, Erector Set and K'NEX sell millions of dollars worth of kits, but the LEGO Group sells billions, leaving dozens of competitors in the dust. Much of its continuing success is because of Godtfred Christiansen, who, in 1963, presented these 10 characteristics for LEGO products:

- Unlimited play potential
- For girls and for boys
- Fun for every age
- Year-round play
- Healthy, quiet play
- Long hours of play
- Development, imagination, creativity
- The more LEGO, the greater the value
- Extra sets available
- Quality in every detail

Godtfred's vision reads like a parent's dream: intelligent, quiet play that's good for both boys and girls, with the value increasing as more elements are purchased. The LEGO Group followed this vision for decades, with perhaps one exception: Although LEGO isn't intrinsically male-centric, many of the sets sold in stores are blatantly so. Just try to find anything in the BIONICLE line, for instance, that would appeal to a mainstream female audience.

Despite their faithfulness to Godtfred's vision, however, his successors haven't been shy about altering LEGO products to keep up with the times, even going so far as to expand their product line beyond the stud—arguably the company's most recognizable symbol. (The word *LEGO* is even printed on every single stud.) And yet, since the invention of TECHNIC in 1977, the LEGO Group has increasingly produced

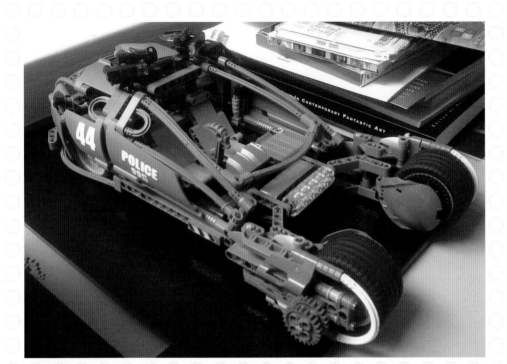

(ABOVE) **The *Blade Runner* "Spinner" police car model is a unique creation presented to the movie's conceptual artist, Syd Mead.**

elements that do not rely on studs. TECHNIC pieces use pins and holes, sacrificing child-friendliness for greater strength and movability. The result has been a new generation of highly customizable bricks that allow advanced builders to connect elements in ways Godtfred couldn't have imagined.

Despite all the innovation and evolution, the classic brick remains timeless and vital. "LEGO is infinitely reusable. It has the ability to allow someone to create a form from nothing," LEGO fan Bryce McGlone enthused.

Pilegaard describes it simply: With LEGO, "everything is possible."

A LEGO DUPLO brick (left) sits next to a knockoff MEGA Blok. Compare the bright and sturdy LEGO product to the MEGA Blok's scratched and faded plastic.

Fake LEGO

In addition to the LEGO Group's other problems, the company has become increasingly concerned with competitors selling poorly made knockoff bricks that nevertheless interlock with real LEGO bricks. Oddly enough, LEGO has been around so long that its patents have expired. Although the LEGO Group has filed suits claiming the bricks are protected by copyright, the courts have maintained that the expired patents no longer protect the LEGO Group's intellectual property.

One of the most egregious offenders is MEGA Brands, a Canadian company that manufactures knockoff LEGO bricks, though the company would contend that its products are merely plastic building toys that happen to be completely compatible with LEGO. The fact is, MEGA Bloks are inferior to LEGO bricks in terms of color, design, and durability. They're also cheaper: A 500-piece MEGA Bloks set costs about US$20, compared with about US$50 for a LEGO set of similar size. To many customers, price wins over quality.

Building Again

It happens with nearly every adult LEGO builder. First, there's the initial exposure to LEGO as a child—a few models for Christmas, perhaps, and maybe a tub of bricks from an older relative. Then, as the child enters adolescence, priorities change, and they aspire to adult trappings such as clothes, dating, and a driver's license. Unfortunately, these priorities seldom involve little plastic bricks.

Thus begins the Dark Age.

The *Dark Age* is a time when kids decide that they're too cool for LEGO and set it aside, dooming the bricks to languish in a basement or be sold for a pittance at Mom's garage sale. Of course, for most people, being LEGO-free simply represents growing up. When we reach adulthood, we set aside our toys, don't we?

However, some adults (more than you may think) in their Dark Ages return to their LEGO hobby. Perhaps a dad picks up a set on a lark, or he helps his son or daughter build a model. Or maybe a college student happens upon a box of bricks at a thrift store. Once those adults are reexposed to LEGO bricks, something magical happens: They begin to build again, but this time they seek out new challenges, such as building scale models or reproducing classic scenes from cinema. They spend eyebrow-raising amounts of money on bricks, sometimes straining bank accounts and marriages. For those who rediscover LEGO, the Dark Age is only an unfortunate hiatus in a lifelong hobby.

Every adult fan of LEGO (AFOL) who has experienced a Dark Age can tell a story of how they rediscovered this lost love. "I did have a long Dark Age, lasting from early high school until the end of grad school," admitted adult builder Windell Oskay, a lifelong tinkerer with a passion for electronics and building sets. Interestingly, it was a technical need that brought him back into the LEGO fold. "I first got back into it as a way to build some simple mechanical machines that seemed like they could be built in LEGO." Very quickly he discovered that secondhand LEGO bricks could be bought by the bucketful at online auction sites, and soon he was building again like a kid.

But why does this happen? You don't hear about businesswomen buying Barbie dolls for their daughters and taking up playing with them themselves. No worldwide phenomenon involves

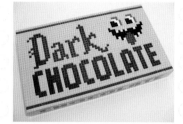

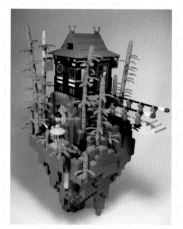

(TOP) **This ode to a Whitman's Sampler could have come only from an adult's imagination.**

(BOTTOM) **This sort of model, an exotic temple built on a floating rock, is the sort of project that brings adults out of their Dark Age.**

(OPPOSITE) **LEGO event volunteers work on a Yoda model.**

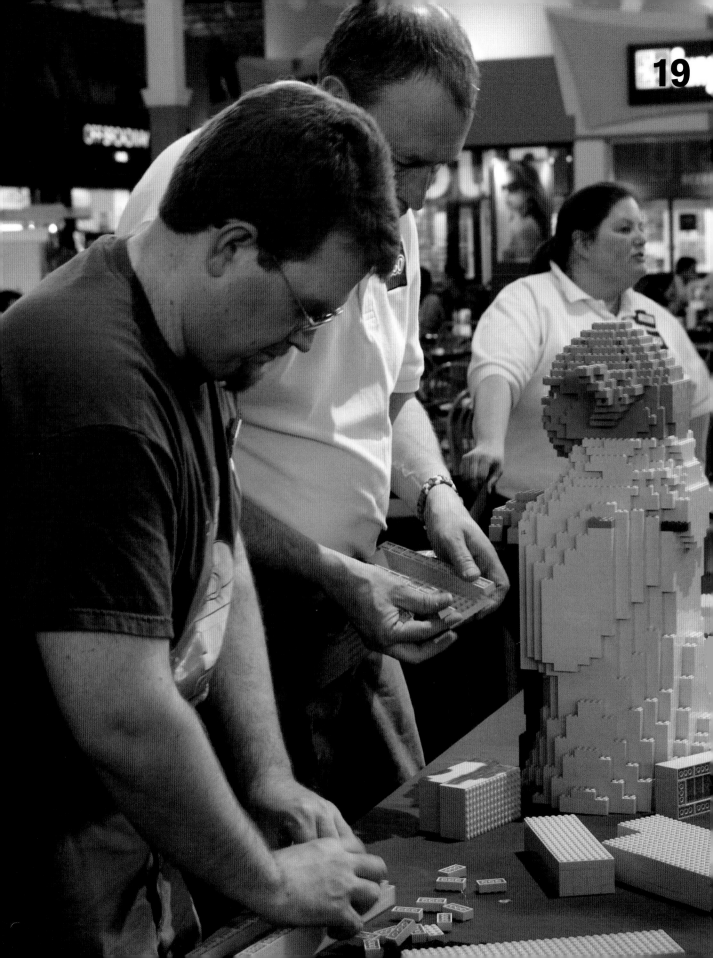

recidivist tiddlywinks-playing adults. Part of the difference is that, unlike a lot of games, LEGO still challenges grown-ups. "LEGO as a toy encapsulates many childhood memories but still possesses an adult level of challenge," explains builder Bryce McGlone. "Adults tend not to 'play,' so toys like action figures fall away. LEGO allows adults to create while still providing that childlike outlet."

The secret of these deceptively simple bricks is that they allow builders to ramp up to any level of difficulty. Some builders attempt to create scale models involving hundreds of thousands of bricks. Others attempt to build fantastic robots with MINDSTORMS, or they re-create Picasso masterpieces using only LEGO bricks. Still others build models that are very small, making city blocks that can fit in the palm of their hand. The builders have the ability to control the complexity of their builds, which makes this a different mode of building than, say, that of a model kit.

For some adults, the allure is as simple as being able to afford toys they were denied as a child. Perhaps they were envious of a friend's 1,000-brick LEGO collection. Now, as an adult, they can buy the LEGO Ultimate Collector Series Millennium Falcon, weighing in at nearly 5,200 elements and costing an allowance-busting $500. As a child, this set would have been relegated to wish lists. As adults, though, this is attainable, if the desire is there.

AFOLs

Who are these grown-up LEGO fanatics? They call themselves *adult fans of LEGO* to differentiate themselves from the usual toy-related fan groups. LEGO fans come from all walks of life: They are homemakers, students, computer scientists, and retirees, among others. Most are men, but many women have taken up the hobby as well. Like any group, you'll encounter misfits and weirdos, but ultimately this group reflects the complexity and diversity of society as a whole.

Here are some builders you might meet at a typical LEGO convention.

Mik, 34

Occupation: Elementary school teacher.

Location: Knoxville, Tennessee.

I'm Building: A fantasy dungeon/cavern and some microscale spaceships.

Favorite Set: Recently, #7036 Dwarves' Mine; of all time, 1981's #6927 All-Terrain Vehicle (which I still have!).

Brick Color: Classic grey.

Music: Either Rush or Death in June (apocalyptic folk).

Scott, 35

Occupation: Stay-at-home dad.

Location: Kirkland, Washington.

Brick Color: Flat matte gold.

Genre: City.

Music: Bluegrass.

"Remember Brick 3:16 — Thou shalt only use LEGO and cast thou MEGA Bloks into the fiery depths of the return aisle."

Nathan, 31

Occupation: Author/illustrator.

Location: Provo, Utah.

Favorite Set: #6951 Robot Command Center. It was my first big set, Christmas of '85. Amazing part selection — you could build anything with those pieces. And it came with the black spaceman.

Brick Color: I'm a real sucker for orange.

Music: No music; I like to have a movie on. I have a very nice memory of building #6195, the Aquazone Neptune Discovery Lab, while watching Miyazaki's *Kiki's Delivery Service*.

Brendan, 25

Location: San Francisco, California.

Favorite Set: #6270 Forbidden Island, my first-ever largish set. I get a big warm rush of nostalgia just thinking about it.

Brick Color: Tough, but I think I'll go with trans-orange. I loved Ice Planet when it came out.

Best Building Time: I prefer the natural light provided by early afternoon, though it means having to be careful to keep my white bricks out of direct sunlight.

Junkstyle Gio, 46

Occupation: Retired logistic manager.

Location: Breda, Netherlands.

I'm Building: Most of the time I'm building big things!

Favorite Set: #8880 Supercar. My all-time favorite. It had it all, without the use of too many special TECHNIC stuff!

Genre: LEGO TECHNIC, LEGO TECHNIC, and LEGO TECHNIC!

Music: Dance and downbeat.

Joz, 28

Occupation: Senior information officer.

Location: Sydney, Australia.

I'm Building: I'm currently building a temple monument of my own design to act as a meeting place for my "Peace Keepers."

Favorite Set: #10185, Green Grocer. Great price, details, and design for playability and modification.

Brick Color: Lime.

Genre: Exo-Castle-Space-Town-Alpha-Agents-Pirate-Force" minifigs. I like a mix of minifigs. They add a nice little dimension to models and creations.

Music: Billy Joel, Me First and The Gimme Gimmes, Grandmaster Flash, Run-DMC, The Flood, Weezer, Stereophonics, Creedence Clearwater Revival.

Lino, 36

Occupation: Until recently I was a financial aid advisor at Cornish College of the Arts, but as I've been getting a lot of artistic commissions as of late, I'm trying that whole commercial artist thing full time. So far, so good.

Location: Seattle, Washington.

Favorite Set: Probably the old Red Baron legendary plane set, or any set that I consider to have a lot of what I call "hot rod" pieces.

Brick Color: That one rusty-looking color. What's it called? I don't know. Ask one of the other LEGO geeks.

Music: Tom Waits mostly.

Erica, 25

Occupation: Information designer.

Location: Cincinnati, Ohio.

I'm Building: Right now I'm working on creating a few new characters out of my hordes of body parts.

Brick Color: Black.

Genre: City.

Music: Actually, my brother and I put on movies we've seen too many times (*UHF*, *Con Air*) and leave that running in the background.

Spencer, 19

Occupation: Computer technician.

Location: San Luis Obispo, California.

Working On: A personalized LEGO mead hall, based on Heorot from the movie *Beowulf*.

Favorite Set: #7672 Rogue Shadow.

Brick Color: Dark grey.

Music: I tend to listen to a mix of electronic music, mainly centered around hard-style electronic.

How Many Lego Bricks Do You Own?: Around 30 gallons; I have no idea of the number of individual pieces.

Ean, 23

Occupation: Student/waiter.

Location: Washington.

Working On: A frog scientist's lab, a drinks machine, a couple mecha, a BSG Viper.

Favorite Set: #1382, #8560, and #6437, to name a few.

Brick Color: Dark orange and regular orange rock my socks in many different ways. Interpret that how you will. I also like black. And old dark grey. None of this "bley" nonsense.

Music: I prefer silence, but sometimes I'll crank up my *Iron Man* or *Transformers* soundtracks when I'm building things appropriate to that sort of music.

J.W., 25

Location: Kearns, Utah.

Favorite Set: #6563 Gator Landing, because it had a little bit of everything: animals, plants, a car, a boat, an airplane, a small building, three unique figures, and some gear for each of them. I took it on a vacation once precisely because I had not much space, I needed something to fill some of the time, and it had a nice variation of stuff.

Brick Color: I like the standard green; it bugged me for years that they didn't have general bricks in that color.

Ochre Jelly, "41 going on 14"

Occupation: Software engineer.

Location: Seattle, Washington.

Brick Color: Magenta (although which of the nine shades of magenta I could not say).

Music: Random instrumental electronic music streamed continuously off the Internet.

Best Building Time: When my kids are building, too. There's nothing like pouring your entire LEGO inventory over the living room floor and spending the entire weekend LEGO-ing it out. The family that builds together stays together! Just remember to check the empty pizza boxes for bricks before you chuck them out.

Nathan, 32

Occupation: Full-time stay-at-home dad and part-time building superintendent at my church.

Location: Abbotsford, British Columbia, Canada.

Working On: Lately I have been building a lot of cars. I dabble in a bit of everything, though, from Space to Castle, Trains and Town, to sculpture and mosaic.

Favorite Set: The 50th anniversary Town Plan set.

Best Building Time: Getting build time while I am taking care of my toddler can be a challenge. I end up building for a few minutes here and a few there without many long build sessions.

Women Builders

Looking at the list of builders, you might assume that women simply aren't an important part of the fan community. Women are underrepresented numerically but overrepresented creatively. Do grown women play with LEGO? You bet.

From the beginning, the LEGO Group intended for its bricks to appeal to both boys and girls. It could have simply been good business sense — an effort to double the company's market — or maybe it was some expression of Scandinavian egalitarianism. Nevertheless, the company's founding family could not have realized their bricks' full appeal to adult women.

To be sure, women represent a minority of adult builders — at least those whose passions lead them to attend fan conventions or participate in online forums. For example, the MINDSTORMS Community Partners (MCP) group, which serves as a liaison between the LEGO Group and NXT fans, consists of 29 men and only 1 woman.

One of the most mysterious differences between male and female fans could be their respective motivations for building. A person looking at the phenomenon from the outside might anticipate stereotypical behavior with men competing for bragging rights with bigger and more massive models,

(ABOVE) **Breann Sledge defies stereotypes by specializing in awe-inspiring BIONICLE creations.**

(OPPOSITE TOP) **Jennifer Clark's New Holland LS160 Skid Steer Loader was designed to be as authentic as possible, taking into consideration such details as gearbox mechanics, center of gravity, and scale.**

(OPPOSITE BOTTOM FOUR) **What could be more classically girly than a dollhouse? With her hospital project, Yvonne Doyle took the LEGO Group's Belville line — the company's take on the dollhouse — and made it sophisticated and utterly feminine.**

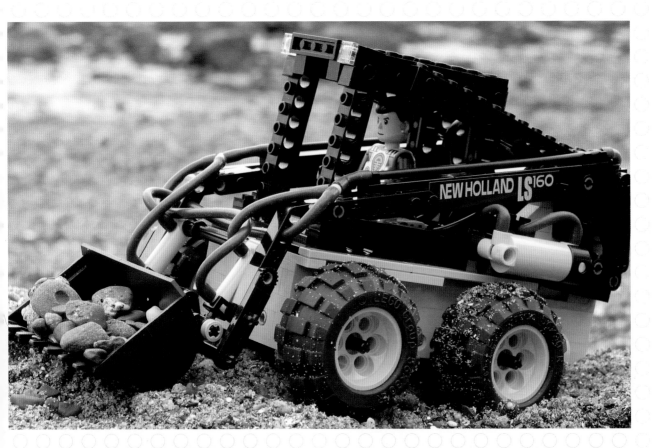

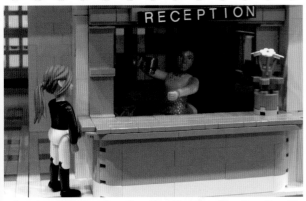

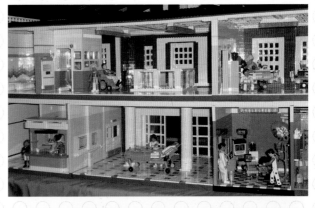

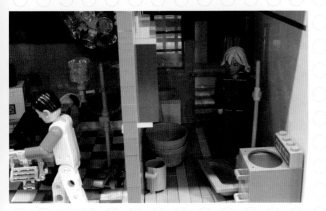

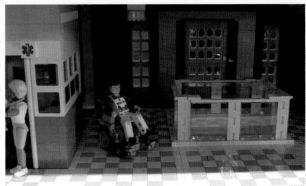

while ignoring women's less grandiose creations. The truth, however, seems far more complex and a lot more fascinating.

Jennifer Clark started playing with LEGO to fulfill a technical need. "I was working in robotics at the time, and the MINDSTORMS programmable brick came to the attention of my colleagues and myself. We thought it might be useful for prototyping simple mechanisms, so I decided to investigate the possibilities. While doing so, I came across the #8448 Supercar and thought it would make an ideal Christmas present, and it was that set that rekindled my interest."

Clark demonstrates a unique flair: She builds incredibly detailed and authentic construction equipment. Her loaders, cranes, and excavators have received a lot of exposure on the convention circuit. Clark, who has a computer science degree, taught herself basic mechanical and electrical engineering principles to help her create more authentic models. "The model should 'behave' like the real thing, even if mechanically it does not work the same way," she said. "Visually, I like the models to be instantly recognizable as the machines they represent, right down to the make and model number."

Although authenticity was a major goal, it wasn't enough for her. "My interest is in things that do something, that work; TECHNIC allows this."

Rather than avoid the LEGO Group's girly products, some women builders see them as a challenge. Yvonne Doyle created an incredibly detailed hospital using Belville bricks and figures, evoking a sophisticated, feminine style that the LEGO Group seems unable to master. Decorated with pastels and featuring an understated elegance, this model serves as a potent counterargument to the "bigger, badder, and more complex" male-centric building obsession.

LEGO Builder Interview: Fay Rhodes

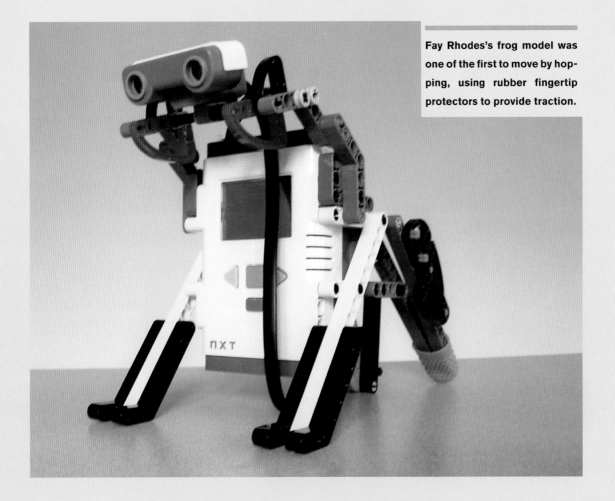

Fay Rhodes's frog model was one of the first to move by hopping, using rubber fingertip protectors to provide traction.

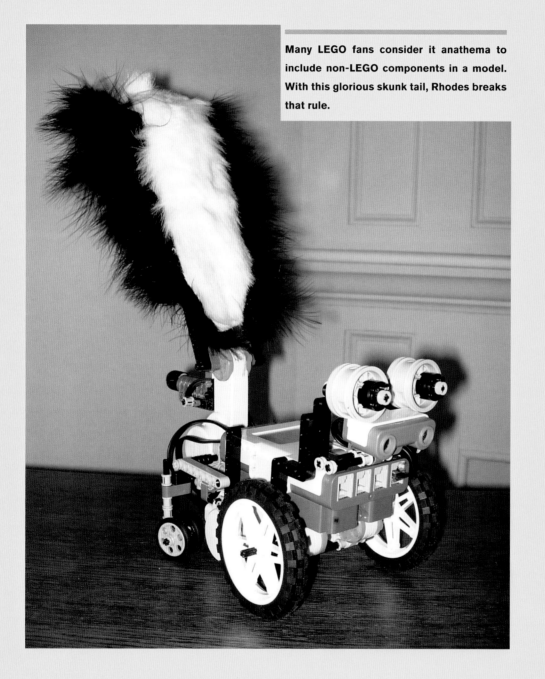

Many LEGO fans consider it anathema to include non-LEGO components in a model. With this glorious skunk tail, Rhodes breaks that rule.

Every fan has different interests. When it comes to LEGO, author and educator Fay Rhodes has two passions: building animals and teaching robotics to kids. She also serves on the MINDSTORMS Community Partners committee as the only female liaison between robotics fans and the company.

Do you think the female perspective leads you to approach LEGO projects differently than male builders?

I'm generally more concerned with using the NXT to encourage interest in engineering while children — particularly girls — are young. The reason I created animal models was that girls were not generally interested in "death dozers" and competition. Animals are universally interesting — even boys enjoy building a dinosaur or a walking robot of any kind. But I have to say that nothing makes me happier than reading reviews by fathers who have daughters suddenly become interested in robotics when they see my models.

I also come at the NXT from more of an artistic viewpoint. When LEGO sends blocks to members of the MCP for whatever purpose, the men thrill over the amazing new inventions they can design. I look at the box and say, "New colors! Cool!"

Have you encountered preconceived attitudes or prejudice from men about you as a woman builder?

I've never felt disrespected as a woman. But I do find there is a *lot* of ego and boasting. If anything, I have sometimes felt talked down to by some because of my lack of scientific credentials. If I were a less confident person, that would be a problem, but I'm not intimidated in the least.

What women builders have inspired you?

Believe it or not, I don't even know any women builders. It's probably one of the things that made me most anxious to introduce robotics to girls at a young age — to engage them before their interest in science can be socialized out of them.

Do you think the LEGO Group aims its products more at boys than girls? How about NXT?

Have you seen the LEGO Shop at Home catalog? Fifty-two pages of almost entirely "guy" stuff. I guess that would reflect who they consider their market to be.

What about adult women?

Men and women seem to have different motivations for getting involved with the NXT. I don't think I'd be interested if the NXT wasn't such a great educational tool. Men seem more interested in the robotics. There are women involved, but they stay behind the scenes, encouraging their children (and students) to become more engaged and inspired to learn more about mathematics and technology.

Now that I think of it, I don't know any women who are obsessed with the NXT. On the other hand, I know many men who seem consumed by it. There are women who are dedicated First LEGO League (FLL) leaders and teachers, but there is definitely more of a balance.

Springing for a $250 toy is a pretty big step. How did you convince yourself it was a good idea?

My husband got into the NXT (to use with his son) before it was even released and ended up being invited to join The NXT STEP blog. When the blog group decided to create some models for an NXT book, Rick turned to me. He is not mechanically oriented and had never done any programming.

I tend to be the one who fixes things that aren't working, and I enjoy problem solving—real problems, not brainteasers. I have a natural curiosity to learn how to do a lot of things. As a result, I create websites and newsletters for nonprofits. I suppose you could say that I'm a "jack-of-all-trades."

Okay, change of subject. What makes builders recreate scenes from famous movies in LEGO or redo the Mona Lisa in bricks? Have you ever done anything like that?

LEGO blocks are just another medium available for artists. I'm pretty much known for building animal robots, which I consider more to be works of art than anything else. Also, I'm primarily interested in the creative process. I like to create robots and program them. I rarely build someone else's design—admire them, yes, learn from them, yes.

The NXT offers an opportunity for teachers (and schools) to integrate the arts with science and mathematics. The arts have been squeezed out of the schools with the No Child Left Behind legislation. I say, get creative and have it all.

What is your day job?

Six years ago, I married a Presbyterian minister. At the time, I'd been working at a liberal arts college in a variety of jobs. I was diagnosed with Parkinson's disease a little over 10 years ago, so when we moved to be nearer to Rick's church, we decided that I should develop some freelance skills (website design, writing, and desktop publishing) and use those skills to assist nonprofits. Since moving to Oklahoma in February, my focus has been on getting robotics into the local schools, as there is little or no technical education in these rural public schools—at least not in this area.

What sorts of skills does NXT teach kids that would be of value to them later on in life?

One father wrote to me about how much his son enjoyed building my models. In his letter, he said that his son was learning to "see problems and setbacks as challenges, and not failures." It's my observation that way too many people are unprepared to face failure—to see setbacks as something to overcome with persistence and creativity.

What's the next step? What do you hope to build as your skills progress?

My next step is to come up with classroom materials that teachers can use for teaching programming for NXT-G and also some practical activities for use with the robots in the NXT Zoo.

Rhodes is the author of *The LEGO MINDSTORMS NXT Zoo!* (No Starch Press, 2008).

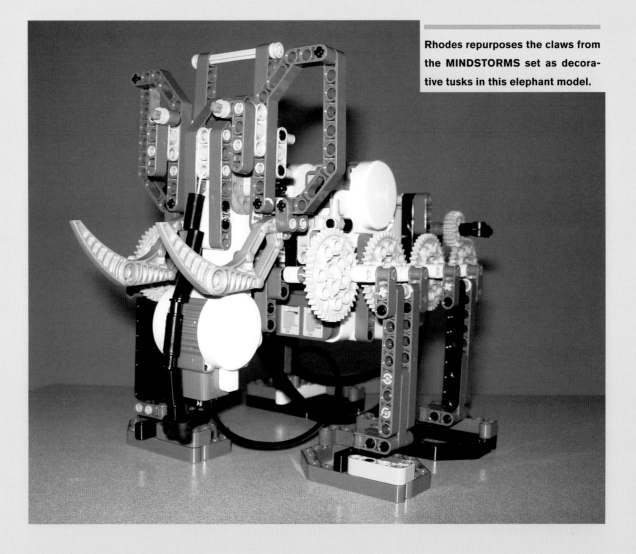

Rhodes repurposes the claws from the **MINDSTORMS** set as decorative tusks in this elephant model.

Organizing the Trove

If you have a ton of bricks (sometimes literally!), you'll need a way to organize them. Some adults splurge on $2,000 televisions, but that screen is a lot easier to store than $2,000 worth of LEGO elements. Devoted "brickheads" accumulate LEGO elements rapidly, and storing them can be a real challenge. Most kids can fit their collection into a couple of large plastic storage bins, but adults' buying power makes this method ridiculously inadequate. It's one thing to dig through one container to find that beige 2×2 plate, but imagine looking through 10 of them—sooner or later, avid builders look for better ways to organize their bricks.

Consider the phenomenon of the "LEGO room." Outwardly, it's not a radical idea. Empty nesters have converted guest bedrooms and dens into workspaces and shrines to collectables, so why not do the same with LEGO? Matt Armstrong has been building for more than 20 years, and a gloriously anarchic collection of bricks fills up a room of his house, overflowing from multiple 32-gallon trash cans, plastic tubs, shelves, and even a child's wading pool. "I don't live at my mommy's house," his Flickr page defiantly tells visitors.

Some professional LEGO fanatics take the LEGO room to the next level, with an actual building studio. Nathan Sawaya described his organizational style: "All of my bricks are separated by shape and color in large transparent bins that line the shelves of my art studio. The rows and rows of color make walking into my studio a lot like walking into a rainbow."

Every builder has their own method for sorting bricks. LEGO fan Nannan Zhang shared his technique: "I use clear, shallow, and wide drawers to separate parts by color first and then by shape. When I build, I reach into a drawer of one color of parts in similar shapes and see which ones fit well onto the creation."

Windell Oskay uses a different approach, using LEGO's stud-and-tube system to link together similar bricks for easy access. "All of my 2×3 bricks are stuck together in one single structure, designed to come apart easily as needed and to make it easy to find any particular color—or estimate the quantity—at a glance."

(ABOVE LEFT) **Your first inclination might be to dump your LEGO bricks into a bin, and then multiple bins. Here, builder David McNeely sorts by color…mostly.**

(BELOW) **The bricks stack, so stack them!**

(ABOVE RIGHT) **The classic organizational method: bins with separators. But is it the best way?**

(RIGHT) **When all else fails, devote a room to storing elements. Matt Armstrong's LEGO room even includes a kiddy pool full of bricks.**

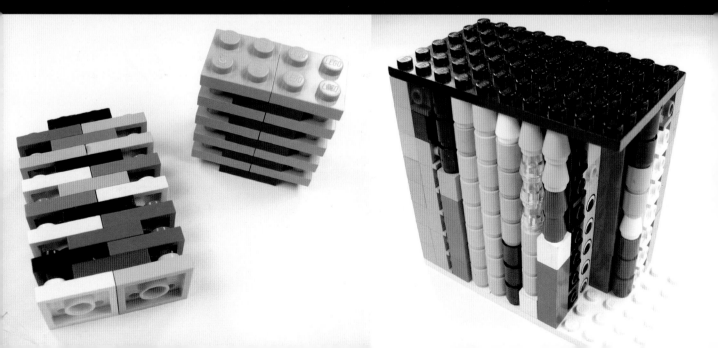

Ingenious LEGO

Having all those LEGO bricks around may be inconvenient at times, but it also presents a distinct benefit: a handy supply of building materials for your next challenge, even if that challenge has nothing to do with a hobby.

Have you ever cursed your iPod dock or computer case for not having the features you want? Most people merely shrug and accept that they have little control over the consumer products in their life. However, many LEGO fans have realized that they have the wherewithal to create their own products using the materials at hand (LEGO bricks, of course).

The following projects illustrate the truism that necessity, and LEGO bricks, is the mother of invention.

Hard Drive Enclosure

Creators: Sergei Brin and Larry Page

The legend goes that in 1996 the founders of Google were penniless graduate students at Stanford University. In need of a chassis to hold the hard drives of their first server, they turned to LEGO for a building material. Ironically, the keen eye reveals that the bricks are actually MEGA Bloks, the LEGO Group's gimcrack rival. Allegedly, the nascent billionaires were too poor to afford *real* LEGO bricks, so they bought a tub of MEGA Bloks!

(The original chassis is on display at the Stanford University Museum.)

Guitar Hero Controller

Creator: David McNeely
Website: *http://www.mocpages.com/home.php/5230/*

Builder David McNeely used the circuitry from a *Guitar Hero* controller to create his own axe with the style he wanted. "I gutted the real controller," he wrote on his Flickr page, "taking out the electronic boards and special working components, and placed them inside a LEGO chassis of my design. It's modeled after a B. C. Rich Warlock guitar (a personal favorite of mine second only to the Explorer). The LEGO guitar controller works just as well as the real controller, and all components work correctly (except for the whammy bar, whose wires need to be resoldered), from the strum bar to the buttons on the guitar."

(BELOW) **Hard drive enclosure**

(RIGHT) *Guitar Hero* controller

The Original Goog

In 1996 Larry Page and Serg
students in Stanford CSL
Digital Library Project, m
amount of diskspace to t
Pagerank™ algorithm on
wide-web data. At that ti
hard disks were the large
they assembled 10 of the
low-cost cabinet.
In Nov 1999, Google Inc, by t
one of the primary search
web, provided replacemer
capacity to the Digital Libr
that we could move this or
assembly into our history
As of September 2000, Google
in Mountain View, operates
searching and web crawlin
LINUX operating system,

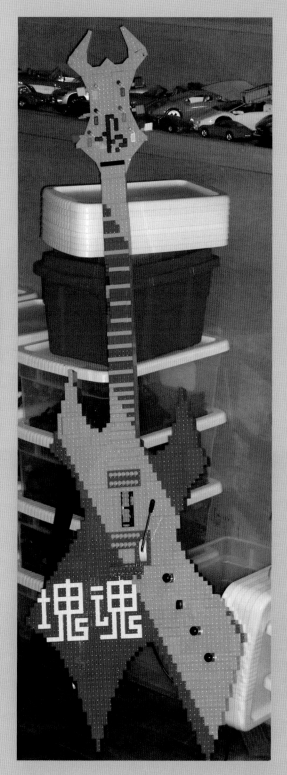

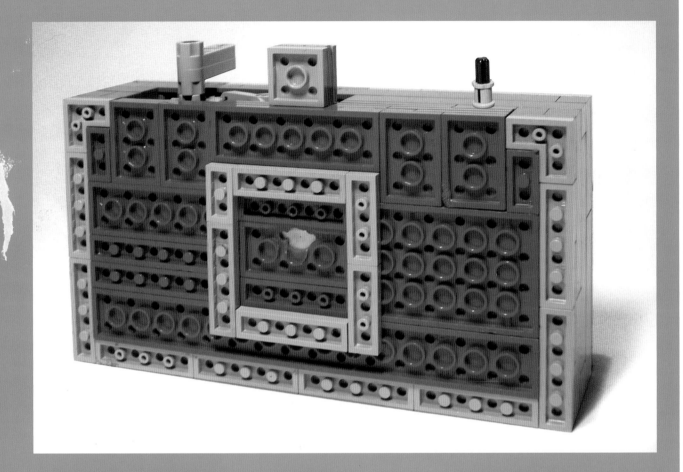

Pinhole Camera

Creator: Adrian Hanft
Website: *http://www.foundphotography.com/*

Adrian Hanft's LEGO pinhole camera was born out of the love of a challenge. Ordinary pinhole cameras, such as those made out of cardboard boxes or oatmeal canisters, lack the mechanical features of modern cameras. Using TECHNIC gears, he was able to add that capability. "I had several goals for the LEGO camera: First, I wanted to make sure that the film advance knob only turned one direction. Secondly, I wanted to have a film counter in addition to the red window. And last but not least, it would be nice to have some sort of viewfinder."

Computer Chassis

Creator: Winston Chow

Winston Chow wanted a unique case for his home-built PC. He took advantage of specialized LEGO elements such as hinges and ladders to complement the system bricks that formed the chassis. The project resulted in a fully functional computer with a 933 MHz processor, video and audio ports, an 8X DVD drive, a slot for RAM, and a CPU fan. "The project took longer than I thought and the computer was heavier than I thought it would have been," he wrote in his blog. "I hope that this case will inspire other modders to create even better LEGO PCs or Macs. I wouldn't mind taking the board out of a first-generation iMac and put it into a LEGO case with an LCD screen, but who has money for that?" His main regret? He didn't have enough bricks to make the case all black.

Bookend

Creator: Mark Palmer

A useful creation need not be complicated; sometimes the needs it fulfills are simple ones: "I needed a bookend," Palmer said. "This was a quick proof of concept. I'm sure there are better patterns, etc. Will need something anti-slip underneath."

Circuit Board Separators

Creator: Windell H. Oskay
Website: *http://www.evilmadscientist.com/*

Sometimes LEGO's usefulness is serendipitous. Tinkerer Oskay needed spacers for an electronics project. The LEGO elements he used were handy, unobtrusive, and nonconductive—a perfect fit!

(OPPOSITE TOP) **Pinhole camera**

(OPPOSITE BOTTOM LEFT) **Computer chassis**

(OPPOSITE BOTTOM MIDDLE) **Bookend**

(OPPOSITE BOTTOM RIGHT) **Circuit board separators**

Air Fern Planter

Creator: Bob Kueppers
Website: *http://www.thebobblog.com/*

"Today I was browsing around Smith & Hawken on my lunch break and found the little air fern that was included in the $150 wallet rape. The fern only cost $5, so I decided to just build my own planter out of the best building materials known to man, LEGO."

iPod Dock

Creator: Samantha
Website: *http://www.flickr.com/photos/xlacrymosax/*

Samantha had a dock for her iPod touch, but she wanted something prettier. "Actually I was just bored, with access to LEGO," she admitted. The dock also has room for her Apple and Nikon D40 remotes.

XO Viewfinder

Creator: Mike Lee
Website: *http://curiouslee.typepad.com/weblog/*

Amateur photographer Mike Lee was playing around with one of the One Laptop Per Child program's XO computers when he tried to use it as a camera. "The OLPC XO-1 camera only faces in the same direction as the screen. When the camera and screen are turned to face the camera subject, you can press the 'O' game button to take a picture. Because it's hard to frame up the shot without a viewfinder, I made one out of seven standard LEGO bricks that slips into the USB port." (One Laptop Per Child is an organization that strives to create educational opportunities for poor children worldwide by providing laptops and software to encourage and enhance learning.)

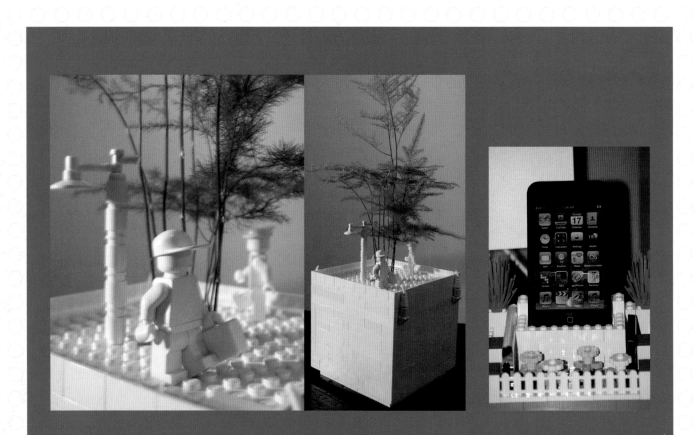

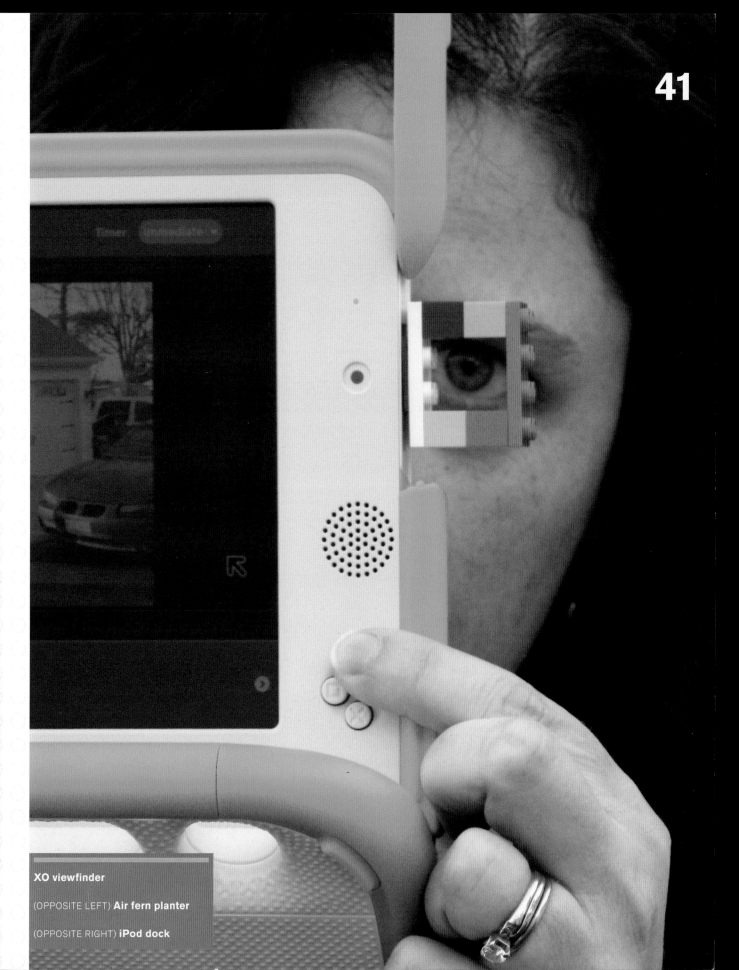

XO viewfinder

(OPPOSITE LEFT) **Air fern planter**

(OPPOSITE RIGHT) **iPod dock**

Remixed Bricks

Another aspect of the adult Lego fan is that, no matter how many bricks a person buys, ultimately that fan has to accept that the company cannot or will not make *everything*. As a business, the LEGO Group can't be all things to all fans, and it falls to third-party companies to fill in the gaps.

One such creator, Jeff Byrd, bought the *Star Wars* TIE Fighter model and noticed that the stormtrooper minifig had a rather inauthentic gun. "So one day, when I was cobbling some plastic bits together for something completely different, the basic design for the trooper gun just hit me," he told *BrickJournal*. "I started creating other blasters from scratch, to go along with the trooper." Within a few years, his business, Little Armory Toys (*http://www.minifigcustomizationnetwork .com/manufacturer/little_armory/*), was building all sorts of minifig weaponry and accepting orders from around the world.

Other companies skip the plastic molding and focus on creating decals to help builders customize bricks and minifigs. In their most basic form, minifigs are utterly without personality if they lack facial and clothing details. With limited designs available from the LEGO Group, some builders have figured out how to create their own decals and stickers. Typically, these appliqués consist of laser-printed designs on a transparent, adhesive substrate.

Although most third-party activity seems focused on LEGO's human element, the minifig, some businesses specialize in the bricks themselves, creating custom elements unavailable from official sets. One such business, LifeLites (*http://www.lifelites.com/*) creates light-up bricks, as well as 9-volt battery packs that power the lights. The business was started by Rob Hendrix, who specializes in fitting light-emitting diodes (LEDs) into LEGO creations, and Stuart Guarnieri, an expert in programming microchips. Their eLite Advanced product comes with preprogrammed lighting sequences for street lights, railroad layouts, vehicles, and so on. The set comes with eight LED cables and two switches and is compatible with the standard LEGO battery pack or with LifeLites' custom power supplies.

Other companies take the LEGO kit approach, buying bricks in bulk and creating their own models, complete with step-by-step building instructions and packaging. For example, the aim of ME Models (*http://www.me-models .com/*), formed in 2003, is "to add a little realism to your hobby by providing high-quality LEGO models in the same style as 1980s LEGO." The company's models consist of nostalgia-laden re-creations of Volkswagen buses, vintage diners, and old-fashioned gas stations.

The LEGO Group, it seems, can't fulfill every specialized need, but the company is content to let small manufacturers do their thing without interference.

LEGO fans who can't find official products that suit their needs turn to third-party manufacturers. **LifeLites** (BOTTOM LEFT) **sells light-up LEGO bricks. BrickArms** (TOP) **specializes in realistic modern weaponry, an area that the LEGO Group deliberately neglects. Big Ben Bricks** (BOTTOM RIGHT) **gives train fans options for accessorizing their models.**

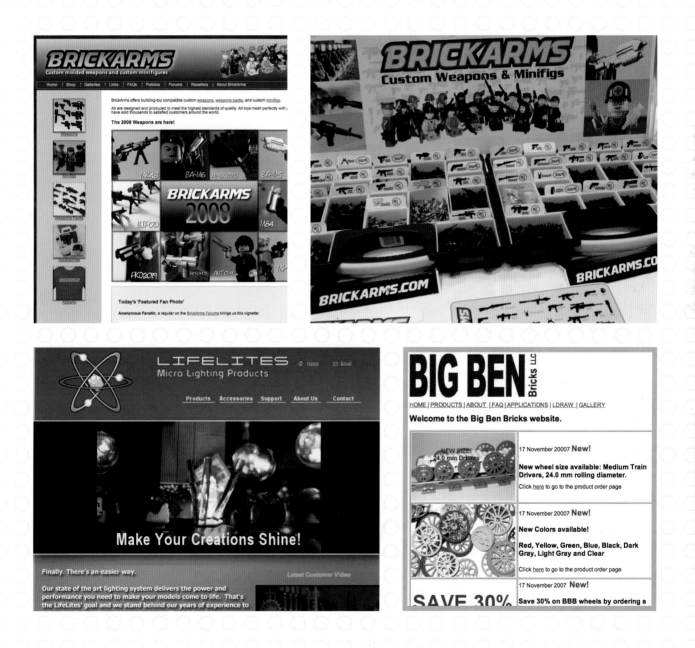

LEGO in Print

One sign that the phenomenon of the adult LEGO fan has crossed over from a disorganized group of hobbyists to a full-blown subculture is that fans have started producing their own literature. Like with any other fan group, adult builders have unique in-jokes and arguments that may not appeal to outsiders—or even be comprehensible to them. Cartoons crack jokes about the LEGO Group's incomprehensible-seeming changes to the colors of their bricks. Magazines interview notable builders and share building techniques. Here are a couple of examples.

BrickJournal

In 2005, the idea of crafting a publication about the adult LEGO community was pushed forward with the creation of *BrickJournal*. Originally planned as a newsletter, it quickly changed to a magazine format when the articles submitted were of a much more global scale than expected. The first issue of the journal was released in summer 2005 as an online magazine, with 64 pages of articles on events, building, and, of course, the people of the community.

From that first issue, *BrickJournal* has established a following of both fans and the general public with its readership. Although the magazine was an online and free publication, thousands of downloads were made of each issue, and the launch of *BrickJournal* got the attention of Slashdot and Boing Boing, two websites that immediately contributed to the demand of the magazine. The articles also expanded to cover building and international events. *BrickJournal* also began working with the LEGO Group to interview staff and set designers, with an annual interview with the LEGO Group CEO. *BrickJournal* is now read by members of the LEGO Group and offers issues in the LEGO Idea House (the company's internal archive and museum).

In 2007, *BrickJournal* began print publication, and it is now available in newsstands, LEGO stores, and LEGOLAND parks. *BrickJournal* has expanded its scope to include LEGO-based activities, such as LEGO Play for Business and FIRST LEGO League. In each step of its growth, though, the magazine has never swayed from its primary missions: to present the best of the LEGO adult community, inspire the public to build, and invite everyone to join the community.

The Magazine for LEGO® Enthusiasts!

$8.95
in the US

Issue 2, Volume 2 • Summer 2008 **45**

Brick Journal

people · building · community

INDIANA JONES®!

**LEGO Sets and
Other Models!**

**Building
a LEGO
Indy Statue**

**LEGO Factory
Goes to Space**

**Events:
Frechen

FIRST LEGO
League, Hawaii

Instructions
AND MORE!**

(TOP ROW) **The grey/bley controversy gets full coverage with this series of strips.**

(BOTTOM ROW) **Cartoonist Greg Hyland explores the unholy rage that true-blue LEGO fans visit on MEGA Bloks, LEGO's rival.**

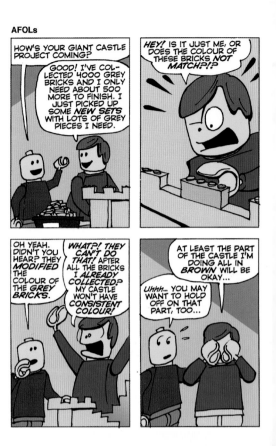

AFOLs

How do you tell a LEGO fan's unique story? Canadian cartoonist Greg Hyland rose to the challenge with *AFOLs*, a comic strip that illustrates the stories of a small group of adult LEGO builders, depicted appropriately as human-sized minifigs. Hyland revels in such in-crowd minutiae as speed-building competitions, getting to meet LEGO Group owner Kjeld Kirk Kristiansen, and fretting over newbie blunders such as using the term *LEGOs* to refer to multiple LEGO elements.

Hyland's work has appeared in *BrickJournal* since the first issue and has even attracted the attention of the LEGO Group with his humanity-filled depictions of minifigs. At the BrickFest 2004 fan gathering, the company gave away a 17-page comic book with illustrations by Hyland. Also called *AFOLs*, the book followed the strip's lead by describing adult LEGO builders and all their foibles, including adults embarrassed by their toy-related hobby, LUGs, fan conventions, LEGO-imitating rip-off bricks, and so on. Hyland's illustrations have appeared on numerous model packages including a SpongeBob SquarePants set and several Batman boxes.

Of course, *BrickJournal* and *AFOLs* aren't the only resources builders have for information and in-jokes. With offerings such as *RailBricks* and *HISPABRICK* (for Hispanic LEGO fans) providing coverage of even more aspects of the fan community, the LEGO phenomenon, it seems, is bigger than any one periodical could adequately cover.

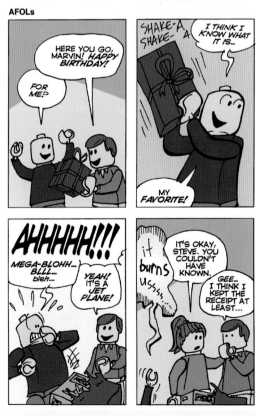

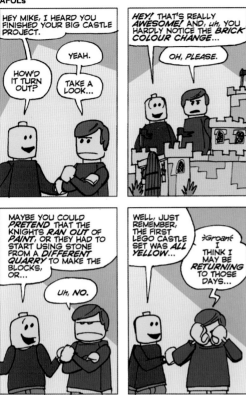

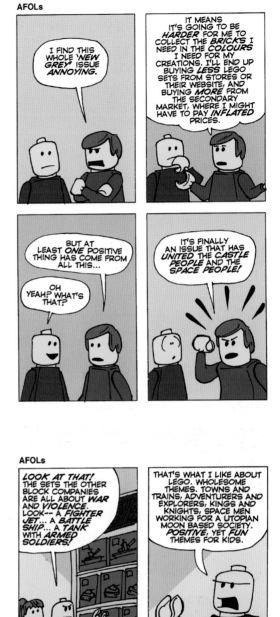

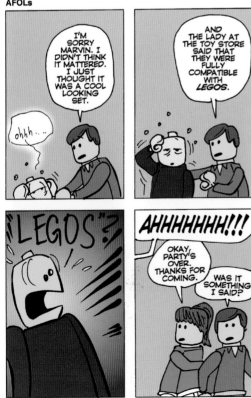

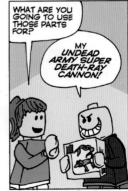

LEGO on the Web

These days, it seems as if the Internet impacts nearly everyone's life in some way. But for LEGO fans, it serves as a lifeline to widely scattered peers. You might not personally know any adult fans of LEGO, but online they're easy to find.

One of the most popular LEGO fan sites is Brickshelf, an image-hosting service that allows builders to share photos of their models with other fans, inspiring casual builders to create more challenging models. The site features almost 3 million photos but lacks any mechanism for sharing text—none of the photos carry captions or comments. Ironically, this seeming limitation has made Brickshelf a cornerstone of the international fan community because pictures of beautiful models have no language barrier.

Despite the success of Brickshelf, there is a clear need for text-based interaction in the form of discussion boards and online forums. Lugnet.com relies primarily on text, allowing for more interaction, with the stated goal of connecting all LEGO Users Groups (LUGs). Similarly, MOCpages.com combines Brickshelf's image-hosting services with the ability for visitors to comment on and discuss models.

Countless other LEGO-related websites support specialized interests. Whether it's brick flick aficionados who record stop-motion movies using LEGO elements for sets and actors, microbuilders focusing on tiny models, or LEGO train fans, every subgroup has its online haven.

LEGO Fan Glossary

Most subcultures come up with a unique mix of acronyms and slang to describe things important to their members. LEGO fans are no different. While writing *The Cult of LEGO*, we deliberately went easy on the lingo. You may not find dyed-in-the-wool fans so accommodating. Here is a list of terms you may encounter:

ABS: Acrylonitrile butadiene styrene; the high-quality plastic used in LEGO elements.

AFFOL: Adult female fan of LEGO; a regular section in *BrickJournal* is bringing visibility to this under-served demographic.

AFOL: Adult fan of LEGO.

Beams: TECHNIC girders.

Bley: A disparaging term for a recently implemented bluish-grey color.

Brick: A LEGO piece.

BURP: Big ugly rock piece; a preformed LEGO rock.

CC: Classic Castle.

CRAPP: Crummy ramp and pit plate; a little-liked element.

CS: Classic Space; the space-oriented sets released by the LEGO Group.

Dark Age: The time in an AFOL's life when they (gasp!) stopped playing with LEGO.

Diorama: A large model, typically minifig scale; often shows a scene complete with buildings, vehicles, and people.

DUPLO brick: Double-size LEGO bricks, using the same plastics and colors, that are able to interlock with their smaller cousins; preschoolers are the target market for the line.

Element: Any LEGO part, whether a brick or some other shape.

GKC: Godtfred Kirk Christiansen, the second CEO of the LEGO Group and the visionary who made it an international success.

Greebles: Decorative "technical" elements added to a science-fiction model to make it seem more realistic.

KFOL: Kid fan of LEGO.

KKK: LEGO Group owner and former CEO, Kjeld Kirk Kristiansen.

LIC: LEGO Imagination Center; free standing LEGO stores run by LEGO Brand Retail, including stores in Orlando, Anaheim, and the Mall of America.

LUG: LEGO Users Group.

MF: Minifigures, those charming LEGO representations of human form; or Millennium Falcon, a LEGO *Star Wars* set that was released in the Ultimate Collector's theme in 2007.

Microscale: A smaller scale than minifigure, in which the figure of a person is either a 1×1 round brick or a 1×1 round brick with a 1×1 round plate on top.

Minifig scale: Usually described as being 1:30, this scale is centered around LEGO minifigures. Minifig-scale models have a tendency to become impractically huge when they are attempting to depict larger objects such as skyscrapers.

MOC: My own creation, as opposed to a creation from a set purchased from a store.

Mosaic: Two-dimensional "paintings" created with LEGO elements, such as pixels in computer art.

Nanoscale: Smallest scale in building, in which a building story is represented by a plate height, and a person is a 1×1 round plate.

NLF: Non-LEGO friend.

NLS: Non-LEGO spouse.

NLSO: Non-LEGO significant other.

OKC: LEGO Group founder Ole Kirk Christiansen.

PaB: Pick-a-Brick; the section of LEGO retail stores where builders can buy individual bricks.

PCS: Pre–Classic Space; a fan-created theme created by Chris Giddens and Mark Sandlin, made as a preface to the Classic Space LEGO theme.

Pins: Small pins of varying sizes used to connect TECHNIC elements.

Plates: LEGO elements that are thinner counterparts to bricks. Three plates equal the height of one brick.

S@H: Shop at Home, the LEGO Group's online store.

SHIP: Seriously huge investment of parts; a model that is unusually large. The definition comes from the amount of parts needed to be purchased to make such a model.

Sig-fig: The online representation of an AFOL as a mini-figure; basically an avatar.

SNOT: Studs not on top; a building technique that upends the Classic System building paradigm in which the bricks' studs are on top.

Studs: Knobs on the top of bricks and plates.

System: Used to describe classic LEGO bricks, plates, and related parts, as opposed to BIONICLE, TECHNIC, DUPLO, or other innovations.

TFOL: Teen fan of LEGO.

TLG: The LEGO Group; formerly TLC, The LEGO Company.

UCS: Ultimate Collector Series; adult- and collector-oriented sets, with a high part count and complex construction.

Vig, vignette: A tiny diorama about the size of a 6×6 or 8×8 base plate.

Minifig
Mania

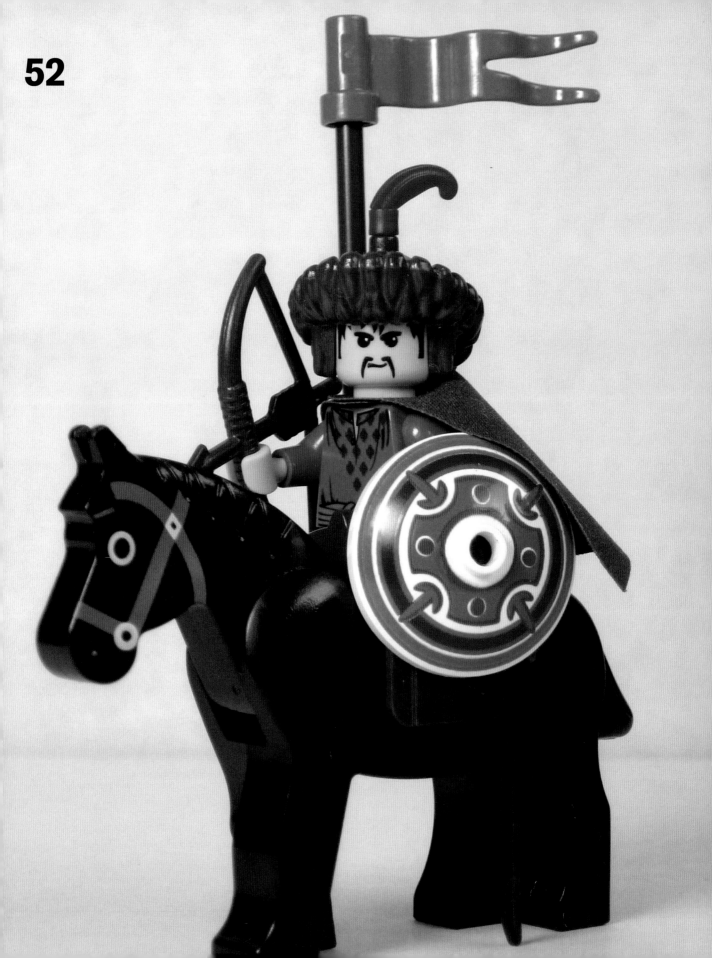

(OPPOSITE) **Andrew Becraft uses a variety of parts to make a plausible Genghis Khan.**

There's something special about the LEGO minifig. At first glance, it seems to be a simple, commonsense solution to a problem: how to add the human element to a basically industrial, inorganic toy.

According to legend, a LEGO master builder was dissatisfied with his models. They were beautiful but lacked a critical *something*—they lacked *humanity*. So, he got a bunch of bricks and began tinkering until he came up with the very first LEGO person, a prototype that years later would be refined into the minifigure.

Minifigs are unusual looking, and they embody an atypical coolness. Unlike Barbie or Bratz figures, which try to evoke a stylish look, minifigs are rather goofy looking. "When standing, they can look quite austere," said minifig fan Thom Beckett. "But when you sit them down, their feet stick up like a *Peanuts* character. It must be quite galling for them."

Regardless of what you think of minifigs, as one of the most recognizable LEGO elements, their popularity transcends their modest appearance. Fans collect thousands of them. Some build armies of minifigs to show off at conventions. Others painstakingly modify the minifigs' appearances, creating new faces and clothing designs and purchasing LEGO-compatible accessories from small specialty vendors.

For those who love LEGO, there is no more perfect way to depict the human form than the minifig.

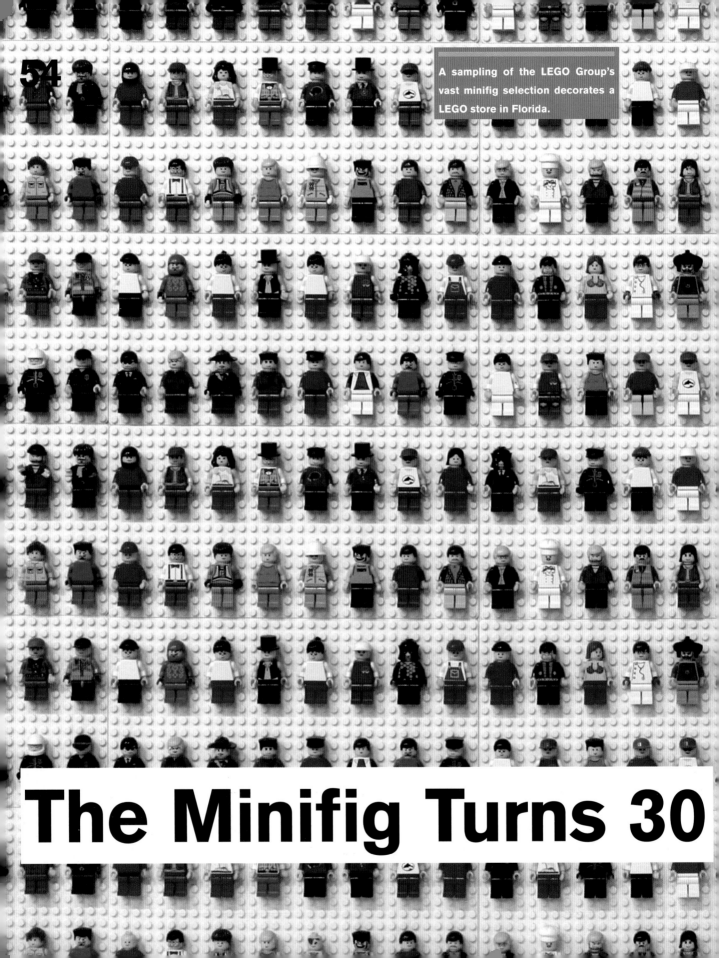

54

A sampling of the LEGO Group's vast minifig selection decorates a LEGO store in Florida.

The Minifig Turns 30

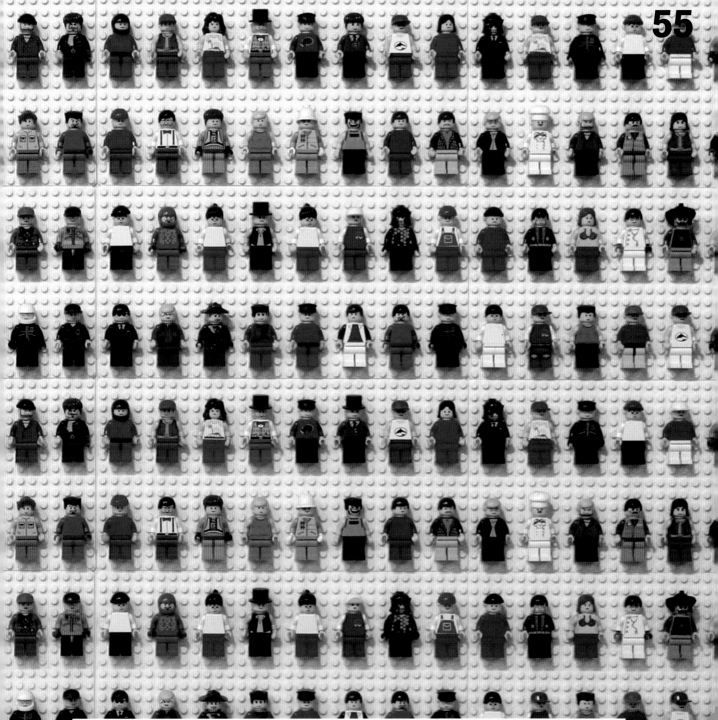

In 2008, the LEGO Group celebrated the minifig's 30th anniversary. Though the minifig's year of origin is debatable since a version with fixed limbs came out a few years before the movable minifig we know today, this anniversary marked a special milestone that transcended a mere marketing event. "The minifig is as iconic as the basic brick and as much a critical component of the LEGO System of Play as its studded cousin," said Andrew Becraft, co-editor of the fan blog The Brothers Brick (*http://www.brothers-brick.com/*). The minifig has been used to add humanity to LEGO models, to lend scale, and even as an art form in itself. LEGO wouldn't be the same without it.

Minifig Facts

With such an impressive history, it's only natural that the LEGO Group would come up with a myriad of facts and statistics that tell the story of this remarkable little creature:[1]

More than 4 billion minifigs have been manufactured, with nearly 4 figures sold every second, for an average of 122 million per year.

The first minifig was a police officer. To date, 41 different cop minifigs have been enclosed in 104 sets.

More than 4,000 different minifigs have been released since 1978, including those with subtle differences in color, with 450 head designs alone. Mathematicians tell us that this means more than 8 quadrillion different combinations are possible.

The first minifigs with noses drawn on their heads were Native American figures in LEGO Wild West.

The first female minifig was a nurse. The ratio of male-to-female minifigs is 18:1.

The minifigs' trademark vacuous smile did not change until 1989, when the Pirates line introduced other facial expressions as well as such lovable deformities as eye patches and hook hands.

The year 2003 marked the first year the minifig's yellow coloration changed to a more realistic flesh coloration.

The only way to make a completely nude minifig is to use the torso and legs from a classic LEGO Space astronaut.

1 **Source:** http://parents.lego.com/en-gb/news/minifigure%2030th%20birthday.aspx/

58

This minifig, originally from the LEGO Sports line, was used to re-create the character Pelé dos Santos from the 2004 movie *The Life Aquatic with Steve Zissou*. Although the minifigs released by the LEGO Group have a variety of expressions, this one's Sambo-like grin raised a few hackles.

Minifig Controversy

The popular minifigs are not without controversy. Originally, the LEGO Group sought to leave racial and gender differences to the imagination of builders by using a stylized, generic face with outfits to differentiate roles. Remember that the first minifig was a cop, and the first female minifig was a nurse.

The most noticeable feature of the majority of minifigs is their ostensibly "race-neutral" yellow coloration. This paradigm lasted until 2003, when LEGO Sports' Basketball theme was released, featuring minifigs based on real-life NBA players. The LEGO Group decided that expecting kids to appreciate figures that didn't really resemble the stars they represented was a losing proposition. There was also a general perception that the yellow color of the minifigs actually signified a Caucasian. "I've always disagreed with those who say that yellow equals neutral," Becraft said. "No, yellow equals light-skinned. I was glad when LEGO released the Ninjas and Wild West themes, because both those series had specifically ethnic minifigs."

Beckett agrees. "I think that LEGO didn't want to admit that the yellow minifig head was more white than black," he said. "The flesh-tone minifigs were a bit of a fudge really. The fact is, minifigs aren't a diverse bunch. Even amongst the film tie-ins, black people are extraordinarily rare, as are women."

Part of the problem is that the LEGO Group decided to use only flesh-colored minifigs for licensed products. Is it the LEGO Group's fault that no black women appear in *Star Wars*, *Batman*, or *Harry Potter*? The two themes praised by Becraft—Wild West and Ninjas—both featured yellow minifigs with stereotypical identifiers. For instance, the Native Americans in Wild West all have war paint, and the Ninjas figs have slanted eyes, seemingly reinforcing the perception that the neutral faces are in fact meant to represent Caucasians.

As for gender, male and female minifigs do not exhibit secondary sexual characteristics, so men and women have the same body. Instead, the LEGO Group relies on hair, facial details, and printed body contours to differentiate the sexes. A female police officer looks just like a male cop, except for the lipstick and big eyelashes. In later minifigs, women had figures, but they were printed on the torso. For the most part, though, the default is asexual or male, depending on your point of view.

Some say the minifig is a product of its culture. LEGO came from Denmark, an extremely homogenous nation. In creating these figures, the original designers may have considered themselves exceedingly progressive for using yellow rather than specific flesh tones. In recent years, the LEGO Group has recruited more international talent, possibly leading to more genuine inclusiveness.

In any case, catering to political correctness is a no-win battle that could be never ending. Where's the obese or amputee minifig? Ultimately, the LEGO Group remains consistent, making licensed figures resemble their real-life counterparts, while keeping classic core minifigs the original yellow. Still, as long as generic yellow equates to Caucasian and male to some, the debate is unlikely to subside anytime soon.

The Minifig in Pop Culture

Although LEGO fanatics have appreciated the minifig for ages, the public at large has kept the lovable plastic figure on its radar, associating it with the core LEGO product more so than any other LEGO element, except perhaps the classic System brick. Nobody should be surprised when the minifig continues to crop up in mainstream culture.

Simpsons Intro

The concept of the LEGO-animated films has been around for some time—think stop-motion flicks with minifigs instead of actors. Urmas Salu, a 14-year-old filmmaker from Estonia, filmed this ode to *The Simpsons* opening sequence using minifigs and System bricks, winning $40 in a movie-making contest. Before he realized it, the video had "gone viral" and was featured on countless blogs and websites. See the original film on YouTube: *http://tinyurl.com/bz5e3f/*.

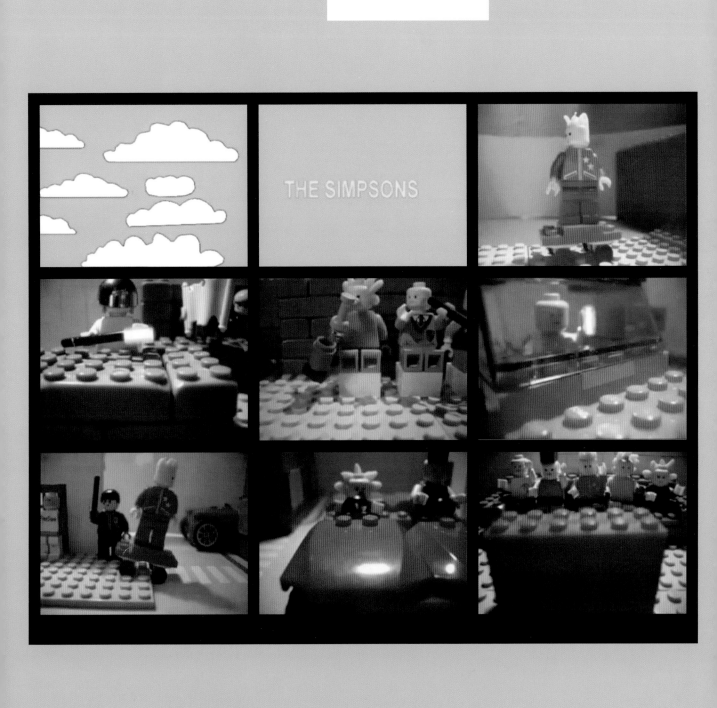

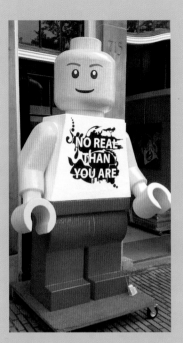

Graffiti

The iconic minifig even appears as graffiti painted on walls around the world. It's human yet inhuman. When part of social commentary, it's an icon that people can relate to, no matter what country they come from.

Egg Timer

The LEGO Group got in on the minifig craze with a product that has absolutely nothing to do with bricks. This egg timer resembles a minifig head and comes in a variety of models that evoke classic minifig visages.

Ginormous Fig

Bathers at a Netherlands beach noticed something floating ashore: an 8-foot minifig with "No Real Than You Are" written on its chest. The figure was placed in front of a nearby concession stand, and the international press responded with a flurry of articles on the event.

As it turned out, the figure was a promotion for a Dutch artist who called himself Ego Leonard and whose paintings feature LEGO minifigs. The artist, whose name suggests both *LEGO* and the Latin word for *I* (*ego*), gives interviews as if he were actually the minifig. This photo shows the figure guarding the entrance to an Amsterdam studio where Leonard's work is featured. (Read more about Ego Leonard in Chapter 6.)

Minifig Cakes

A LEGO-themed birthday is a rather common occurrence. But a LEGO-themed wedding? When two LEGO fans get married, what better way to depict the bride and groom than with a couple of minifigs?

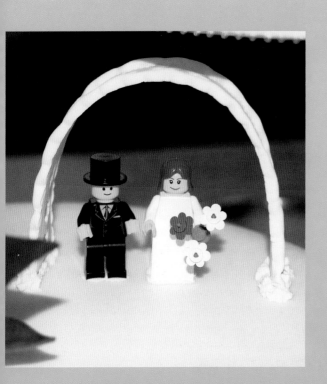

Halloween Costumes

Minifig costumes always pop up around Halloween. Usually the costume focuses on the big round head and ignores the boxy arms and legs. Although sometimes the costumes are rather slapdash, many exhibit a clear love of minifigs, with a great deal of work put into the project. The most ingenious creators come up with imaginative solutions such as yellow socks for the featureless, grasping hands.

Red-Headed Step-Figs

If the minifig is so great, why tinker with it? Like always, the LEGO Group hasn't rested on its laurels. LEGO has never stopped exploring new avenues for depicting the human shape, experimenting several times over the years with different types of figures. However, none of these efforts has succeeded in dethroning the minifig as the ultimate way to depict a human.

Six also-ran competitors to the minifigure exist: TECHNIC *maxifigs* (bigger than minifigs), Galidor and Jack Stone maxifigs, Homemaker and Belville figs, and built creations called *miniland figures*.

TECHNIC Figures

TECHNIC models usually end up much larger than System LEGO constructions, possibly because of their large gears: If you want to use the gearboxes and MINDSTORMS electronics, you have to build to a scale that accommodates these elements. The LEGO Group developed larger figures to go with these models, but the figures never took off the way minifigs have. (One surprising omission in the TECHNIC figure line is that there are no female figures.)

Galidor, Jack Stone, and Knights' Kingdom

As orphans of failed lines, these figures have joined the list of also-rans, remembered mainly as unexceptional maxifigs often compared to the action figures sold by other toy companies. Although some builders remember them fondly and a few use them in the occasional model, for the most part these figures are remembered as failures.

Homemaker and Belville Figures

The Homemaker and Belville figure lines evoke the classic dollhouse feel: sets depicting families, homes, and neighborhood businesses. As with many less-successful lines, Belville offers some fun elements, though it mainly consists of domestic items such as sausages, turkeys, and bowls. Some people appreciated Belville's unique style so much that they wish the LEGO Group had decided to go the minifig route with the line's figures. Speculation is that the decision to take Belville to maxifig scale was made after the failure of Paradisa, pink LEGO at minifig scale.

Pink LEGO, the disparaging term for the LEGO Group's half-hearted attempts at girly themes, tends to baffle fans who love the company's effortless boy-centric lines. Similarly, the company's persistence in exploring maxifigs provokes amused shrugs.

Miniland Figures

Miniland figures are in their own category because they populate LEGOLAND's Miniland. Built from individual elements rather than from specialized figure parts, they can be incredibly challenging to create. As such, casual builders avoid them, while experts consider a deftly constructed miniland figure to be a sign of utmost skill.

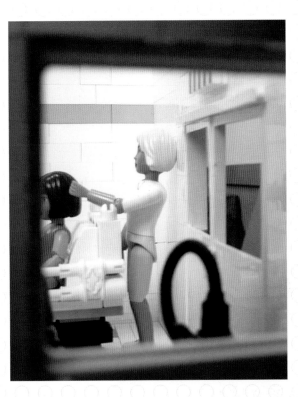

Yvonne Doyle deftly uses Belville and **TECHNIC** figures in her hospital model, though this work is the exception rather than the norm for these underappreciated figures.

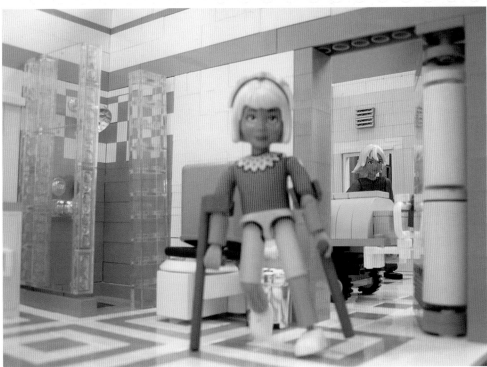

Angus McLane's loveable 'Dudes instantly spawned a trend.

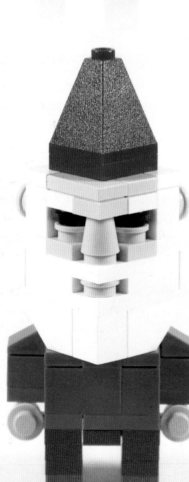

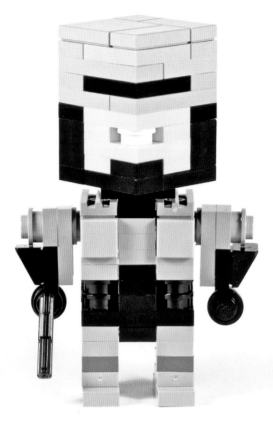

CubeDudes: Cartoony Geometric Figures

One day Angus McLane, an animator for Pixar, watched an episode of the G.I. Joe TV show and decided that he wanted to build a miniland figure of one of the characters, Snake Eyes. He wanted to build small (due to a lack of space) and ended up building at a size only slightly larger than a minifig. As he played around with the bricks, he came up with the more "deformed" appearance that is the CubeDude's signature look: a cubical head presented in such a way that one angle serves as the face. He built about a half-dozen characters before he began sharing them online, and they were an immediate hit. Since the debut of McLane's models, dozens of LEGO fans have tried their hands at creating CubeDudes, but McLane is still considered the grandmaster. To date he has built over 100 CubeDudes, most of them recognizable figures from TV and cinema.

Sig-Figs: LEGO You

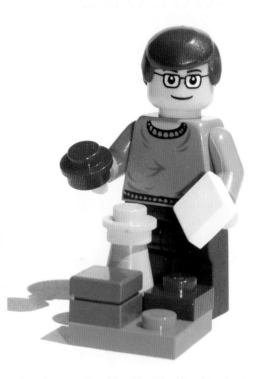

If you love LEGO and need an avatar for your online presence, it's only natural to use the LEGO Group's ubiquitous minifigs, suitably customized, to show off your personality. Not only do you get yourself an avatar, but you also tell other fans that you're one of them.

Some builders even add a fantasy element, showing themselves in costume or wielding light sabers. Others go the surreal route, with featureless unicolor models that look like statues. Of course, the standard LEGO elements are finite in number, so a lot of builders include custom, third-party, and unusual elements to make their *sig-figs* more memorable.

Whimsically, senior LEGO Group employees use minifigs as business cards, with the staff member's name on the front of the minifig's shirt and email address and phone number on the back. The minifigs also resemble their human counterparts as much as can be expected with matching hairstyles and beards, as appropriate.

Some builders take their sig-figs beyond the avatar role and actually tell stories with them. Heather Braaten brought her sig-fig to a fan convention and photographed it as it went on adventures over other builders' models, even tangling it in the bushy beard of fellow builder Lino Martins. "Lino is one of the most awesome artists and LEGO builders out there," Braaten wrote on her Flickr page. "He's also super cool for putting up with my strange requests."

(TOP) **Andrew Becraft's sig-fig shows him doing what he loves doing best: building with LEGO.**

(BOTTOM) **The standard LEGO Group executive business card**

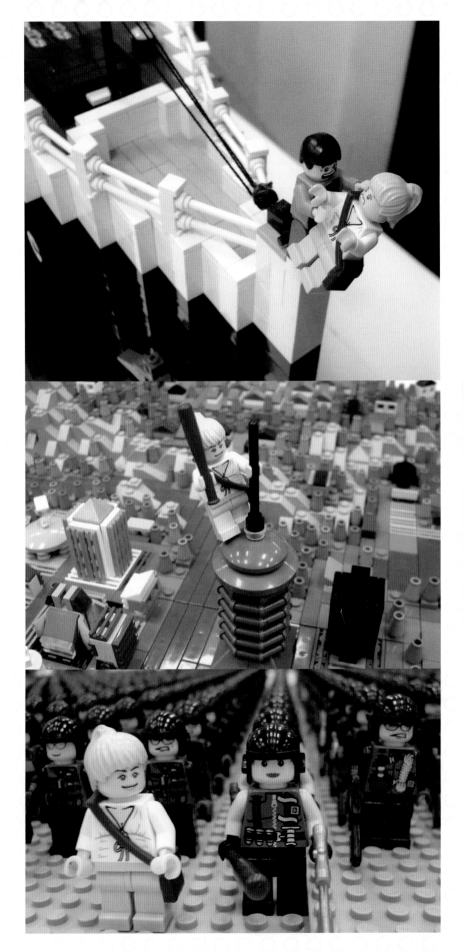

(TOP) **On the bow of a minifig-scale *Titanic*, Heather is the queen of the world, whether or not she wants to be.**

(MIDDLE) **Heather subjugates the miniature world of Shannononia— with a baseball bat.**

(BOTTOM) **Heather finds a kindred spirit. But did she sign up for something?**

Pimp Your Fig

Minifig fans face an inevitable conundrum. At first they are content to play with standard-issue minifig accessories, but sooner or later they realize that what they want simply isn't available. Whether it's the designs printed on the fig's clothing or customized hair and equipment, builders are always looking for ways to put a unique twist on their minifig projects. And if they lack the skills to create their own gear, a plethora of third-party companies are ready to step up.

BrickForge (*http://www.brickforge.com/*) represents the elite of the minifig customizer community. The company got its start in 2002 manufacturing minifig weaponry and selling its weapons online. If you don't like the LEGO Group's standard minifig add-ons, plenty of third-party alternatives are available. In particular, BrickForge and cohorts have filled deliberate gaps in the LEGO line. For instance, there will never be a Marines in Baghdad set, but with modern weaponry from BrickArms, you can make your own.

BrickArms (*http://www.brickarms.com/*) was founded in 2006 when founder Will Chapman's son asked him for World War II weapons to equip his minifigs. Such items aren't available from the LEGO Group, so Chapman made his own. In just a few years his business has expanded to a line of 45 different weapons, weapons packs, and custom minifigs, including medieval, science-fiction, and modern weaponry.

For those lacking the means to create their own plastic castings, a simpler approach is available: making decals to apply to blank minifigs for instant customization. Of course, most people can't print actual decals, but they can print on clear plastic labeling material using a color printer. The result, although not as slick as store-bought LEGO elements, definitely suffices for many builders.

Amanda Baldwin has a how-to on her Flickr site, describing how she used the free Windows art program Paint.NET to create dozens of castle designs. She produced knights' shield emblems, princesses' dress designs, and simple medieval garb to give her court a unique flair.

But not everybody is on board for customizing figs. Many builders, accustomed to the LEGO Group's high-quality standards, harbor unrealistic expectations of amateur products. How can a person working in a garage create decals as sophisticated as the designs found in LEGO sets? Although sticklers may turn up their noses at these amateur efforts, many others willingly sacrifice quality for the ability to design their own minifig graphics.

A recent development has been to print onto the minifig itself, much like the minifigs printed for LEGO Group employees. The quality of these printed parts, which also include tiles and bricks, matches the LEGO Group's own printed bricks and are starting to show up in fan models.

(TOP) **An assortment of plastic weaponry created by BrickForge, a two-man company that sells mini-fig accessories**

(BOTTOM) **Amanda Baldwin's princess minifig shows off a unique figure design that she created herself.**

Famous People, Minisized

As the number of official and unofficial minifig elements grows, so does the temptation to use those elements to make figures look like recognizable public figures. For Beckett, the appeal involves a juxtaposition of a child's toy with the adult world. "I think it was one of the few ways I could find to connect a lot of my hobbies together," he said. "I've done political and musical minifigs, some of films, some of sci-fi characters."

Figs of Fiction

Creating an ode to a fictional character presents a special challenge. Can you give the minifig the spirit of the original without descending to mere stereotypes? How would you create a Robinson Crusoe beyond the leather umbrella?

(1) **Robinson Crusoe,** (2) **Long John Silver,** (3) **Rick Deckard from** *Blade Runner,* (4) **Pinocchio,** (5) **Jack the Ripper,** (6) **Ebenezer Scrooge,** (7) **Jack Bauer from TV's** *24,* (8) **Captain Ahab,** (9) **Heidi,** (10) **Vincent Vega and Jules Winnfield from** *Pulp Fiction*

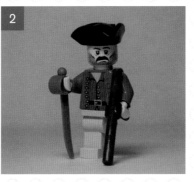

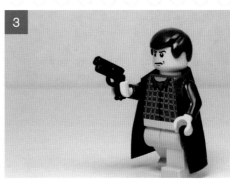

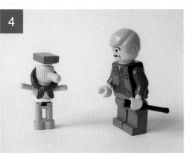

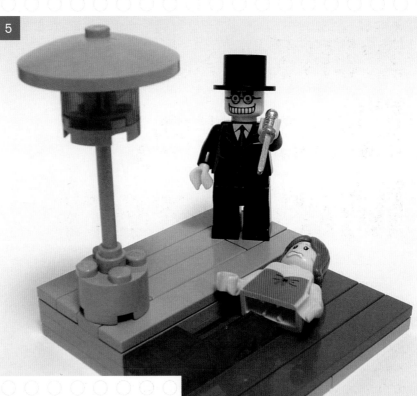

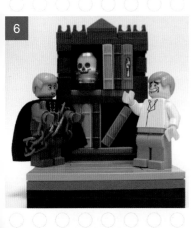

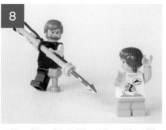

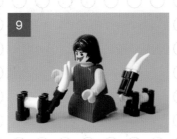

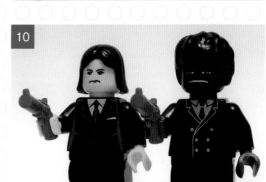

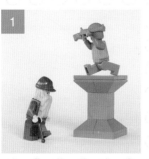

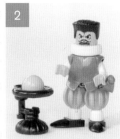

Leaders

Creating minifigs of politicians seems easy, but there is a hidden challenge: How do you tell an interesting story? Thom Beckett's Dick Cheney vignette lampoons the former Vice President's infamous hunting accident.

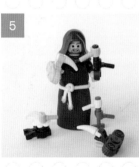

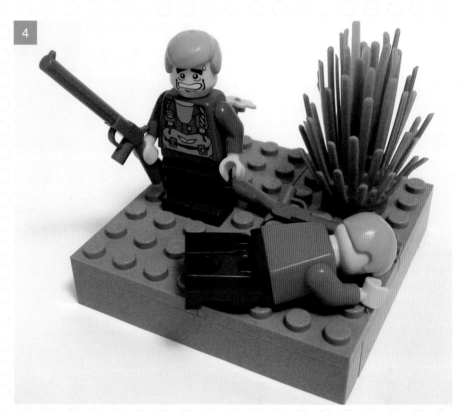

(1) **Fidel Castro and Ernesto "Che" Guevara,** (2) **Sir Francis Drake,** (3) **Mao Zedong,** (4) **Former US Vice President Dick Cheney,** (5) **Saint Francis of Assisi,** (6) **Tenzin Gyatso, the Dalai Lama,** (7) **Dr. Martin Luther King, Jr.,** (8) **Rosa Parks,** (9) **Chief Seattle,** (10) **Mohandas Gandhi,** (11) **Native American activist Winona LaDuke,** (12) **George Washington,** (13) **Journalist and social activist Dorothy Day,** (14) **Norwegian explorer Erik the Red**

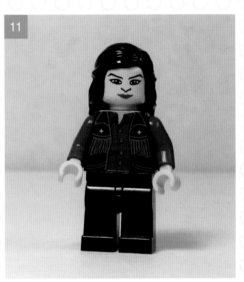

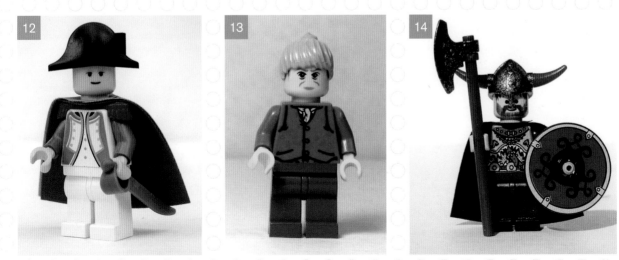

Creators

Re-creating a writer or another creative figure in minifig form presents certain difficulties that are unlike the challenges faced when re-creating a politician or actor whose face is familiar to the public at large. What does E. E. Cummings look like, really? One solution to the problem involves creating a tiny scene called a *vignette*. In Beckett's *Socrates*, the great philosopher clutches his cup of hemlock just as he does in the famous Jacques-Louis David painting *The Death of Socrates*.

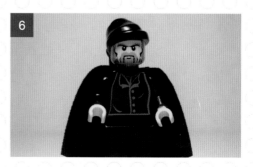

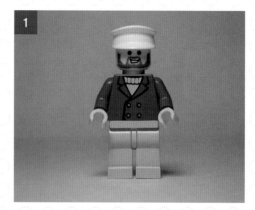

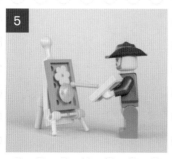

(1) **Ernest Hemingway,** (2) **Socrates,** (3) **Virginia Woolf,** (4) **Ansel Adams,** (5) **Vincent van Gogh,** (6) **Geoffrey Chaucer**

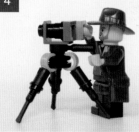

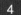

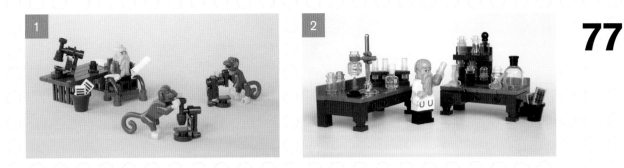

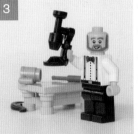

Nerds

Are nerds the great thinkers of our time? It comes as no surprise that LEGO nerds like building minifig nerds.

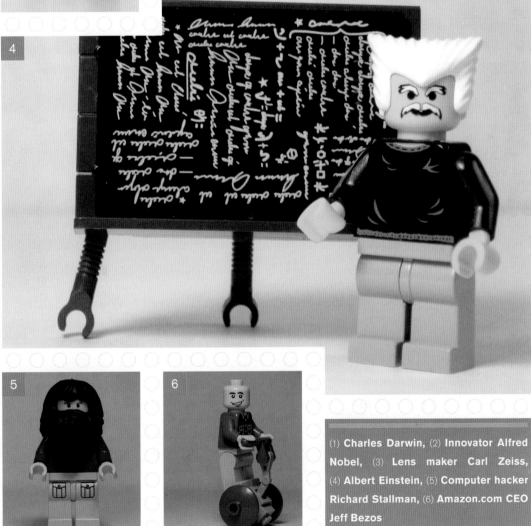

(1) **Charles Darwin,** (2) **Innovator Alfred Nobel,** (3) **Lens maker Carl Zeiss,** (4) **Albert Einstein,** (5) **Computer hacker Richard Stallman,** (6) **Amazon.com CEO Jeff Bezos**

Performers

Actors and musicians are some of the most recognizable individuals in our society. Because of this, they often find themselves re-created by minifig fans.

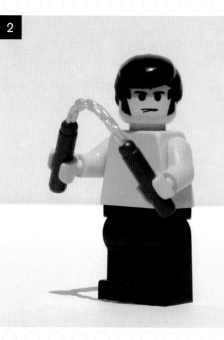

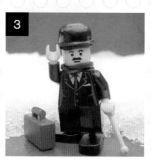

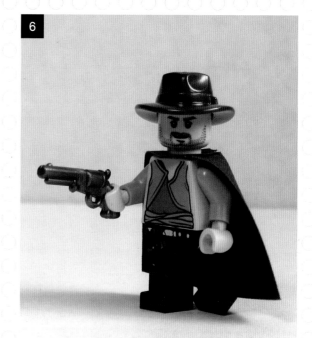

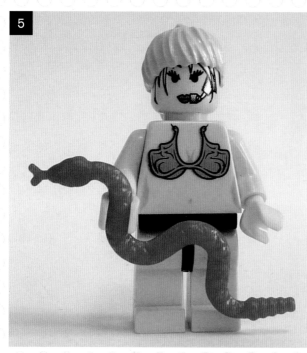

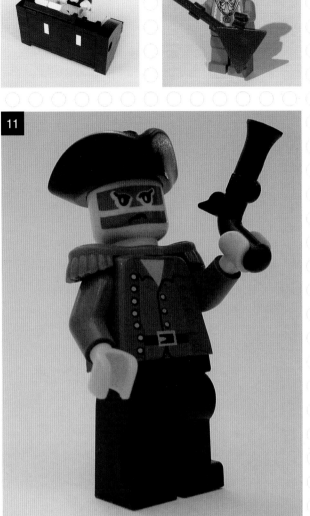

(1) **The White Stripes,** (2) **Bruce Lee,** (3) **Charlie Chaplin,** (4) **Michael Jackson,** (5) **Britney Spears,** (6) **Clint Eastwood,** (7) **Scott Joplin,** (8) **Wolfgang Amadeus Mozart,** (9) **Jimi Hendrix,** (10) **Fatboy Slim,** (11) **Adam Ant,** (12) **The Village People**

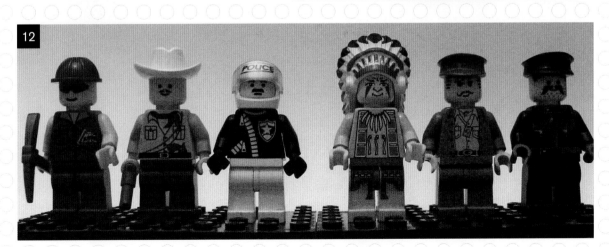

Minifig Scale

The monstrous scale of the HMS *Hood* is apparent even without minifigs swarming the deck.

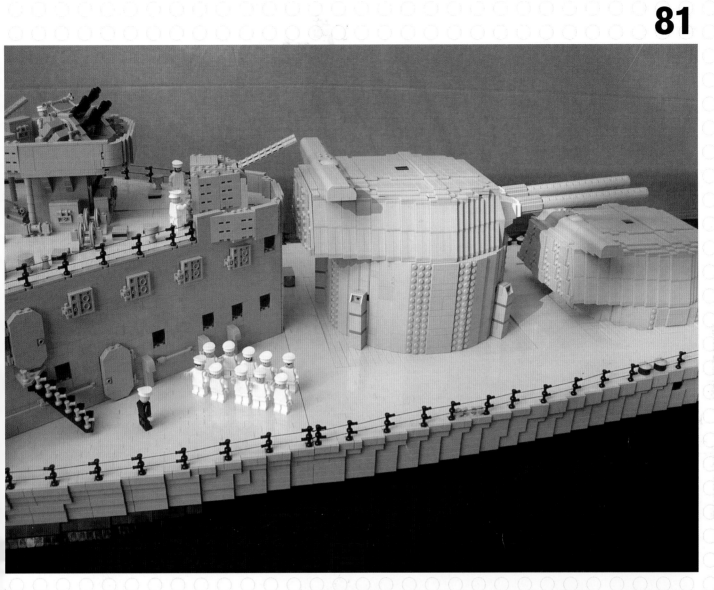

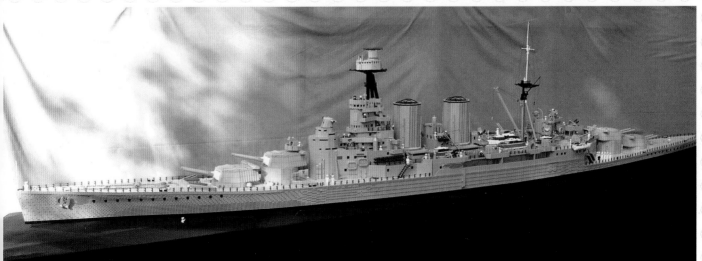

You've seen how important LEGO minifigs are to fans. It should come as no surprise, therefore, that many models are built to the minifig's scale, where the dimensions of the project are determined as if the minifig were a real person. In fact, nearly all official LEGO models are built to conform to the minifig's dimensions. The LEGO Group's classic lines, such as Space and City, are all this scale.

Minifig scale is a default that makes for fun and easy model building, but it also makes for some massive, nigh untenable, models that take over entire living rooms. Even a four-story building can become an expensive and time-consuming project when it's built to minifig scale. Just imagine the colossal breadth of a minifig-scale *Starship Enterprise* or Sears Tower. In fact, you'll have to imagine it, because as yet no one has built such giant creations in full minifig scale. Many attempts have been made to build scale re-creations of famous structures, but they usually end up truncated or abbreviated in some way. The final model evokes the *feel* of the original, but the dimensions are off.

What exactly *is* minifig scale? If you realize that the average minifig represents a human being about 5 feet 9 inches (1.8 meters) tall, then a minifig of 1.6 inches (3.8 cm) tall represents a 1:44 scale. In general, anything between 1:30 and 1:48 is considered classic minifig scale.

As with anything in LEGO, however, there is always some wiggle room. Some builders hold 1:30 to be the classic scale, while builders who assemble massive creations sometimes distort the ratio a bit. Consider, for instance, Malle Hawking's model of modern aircraft carrier *Harry S. Truman*, the world-record–holding LEGO boat model built to 1:68 scale, with minifigs that fit in the airplanes.

Some minifig-scale creations are so massive they are models of patience and planning. For example, Ed Diment's HMS *Hood*, which uses just under 100,000 bricks, cost about $15,000 and took seven months to build. It's 20 feet (6 meters) long and breaks into sections for storage in his LEGO room. "All four turrets are motorized with Power Functions motors for rotation and elevation," Diment told The Brothers Brick. "I'll be keeping it together for at least a couple of years."

A World War II battleship is certainly a huge construction, but it's hardly the largest man-made object in history or fiction. This begs the question, how big would a 1:44 Great Wall of China or Death Star be? No one can be sure until someone tries to build it, but we can speculate.

The following are some whimsical ideas of minifig-scale colossi that will probably never be built.

Empire State Building

Dimensions:	1,470 feet (448 meters) tall, including the antenna spire
Minifig scale:	33 feet (10.2 meters)

Starship Enterprise "NCC-1701-D"

Dimensions:	203 feet (642 meters) long by 1,532 feet (467 meters) wide, with a dish of about 2,000 feet (610 meters) across
Minifig scale:	48 feet (14.6 meters) by 35 feet (10.7 meters)

Babylon 5 Space Station

Dimensions:	27,887 feet (8500 meters) long— or 5.25 miles
Minifig scale:	633 feet (193 meters)

Larry Niven's Ringworld

Dimensions:	997,000 miles wide at the *narrowest*
Minifig scale:	Get serious!

How many bricks would it take to build one of these creations? If Diment's *Hood* packs 100,000 bricks for a mere battleship, how many would one of these absurdly large models use?

Regardless, good building isn't just about using a lot of LEGO bricks. The most well-known of the massive LEGO creations sport magnificent detail as well as a huge number of elements.

In the end, LEGO fans' obsessions with minifigs and minifig scale are secondary to their ultimate goal—building the best model they can.

(Re)creating
Icons

When LEGO fan Henry Lim decided to build a LEGO harpsichord, he didn't want a mere model — he wanted his creation to function as a musical instrument and be as authentic as possible in every respect.

The first step was designing the basic structure of the harpsichord. Lim, who works in UCLA's Music Library, consulted a number of books to make the measurements and proportions as accurate as he could make them. But that was the easy part; Lim wanted the instrument to sound like a harpsichord too. "I consulted my friend Robert Portillo, who is an expert musical instrument conservationist," Lim said in an interview. "He calculated the lengths of the strings for each note before I built the soundboard."

The resulting instrument weighs about 150 pounds and uses an estimated 100,000 LEGO elements. For the sake of the instrument's appearance, as well as to improve acoustics, Lim covered nearly every exposed LEGO stud with smooth plates.

The harpsichord project serves as an example of the phenomenon in which builders seek to re-create famous, iconic objects — whether buildings, artwork, or other recognizable cultural artifacts — in LEGO bricks. For these fans, authenticity and accuracy are paramount, despite their use of a profoundly inauthentic medium.

Some builders replicate artists' creations using LEGO bricks, crafting homages to masterpieces by Picasso, as well as music album covers re-created in bricks and minifigures. Others transform famous historical events into minifig-populated vignettes or build intricate maps out of the tiniest LEGO elements.

Other fans, in a nod to LEGO's movie licenses, love depicting scenes and characters from movies, ranging from blockbusters like *Star Wars* to cult movies familiar only to the cognoscenti.

It could be argued that what most distinguishes these builders isn't so much what they build and how. For them, the challenges of re-creating a well-known building or vehicle come second to playing around with the plastic bricks that they love.

Henry Lim built a working, full-size harpsichord out of LEGO.

Carl the LEGO Guy

"My favorite builds are creations that mirror real-ity," Carl Merriam declared. "There is something oddly satisfying to me when someone sees my work and doesn't immediately realize it's LEGO. I was setting up a display and one of the guys I was working with grabbed a LEGO pen out of my bin to write something down with. He came back a few seconds later, we chuckled at his mistake, and he promptly grabbed a LEGO marker and left again!"

While he loves LEGO, Merriam sees his medium as being secondary to being truthful to the original object. "I try to use symbols of real-life items that already exist in the mind. My goal is to always reference that symbol directly, so that a double—or hopefully triple—take is necessary."

Like many other builders who re-create real objects in LEGO, Merriam exhaustively researches his subject online—then comes the noodling. "I'll think about what I want to build and go into a stupor during dinner, when I'm driving, while I'm working," he said. "Really, anytime I'm not doing something important—i.e., playing with LEGO."

Merriam begins building with the most diffi-cult part of the model. "From there it's trial, error, pain, crying, and frustration," he said. "I'll usually go through about 3–5 builds of the same item until I'm either happy with it out or run out of time."

Carl Merriam spends hours online researching his builds, and frequently his creations pass the ultimate test: being confused for the real deal.

Architectural Re-creations

As builders themselves, many LEGO fans have a passion for architecture, which often leads them to try their hand at replicating a recognizable structure like the Sears Tower or Empire State Building.

Almost immediately those builders realize the difficulty of these projects. When creating a fictitious building, no one can say that the proportions are wrong or some detail isn't faithful to the original, because there is no original with which to compare the model. A builder who attempts to re-create a famous structure, on the other hand, inevitably faces critics who nitpick inconsistencies and disproportions. Even if builders carefully design the model, they must still find the right bricks to achieve that vision. Many lack the money to buy thousands of LEGO bricks whenever they want.

Sean Kenney's 1:150-scale Yankee Stadium took three years to build, uses 45,000 LEGO bricks, and features minuscule ballplayers and fans.

Dome of the Rock

Cleveland high-school math teacher Arthur Gugick likened his approach to a mathematical puzzle. "It's an amazing, complex, totally open-ended math problem that can only be solved through creativity and ingenuity," said Gugick. "You're given a finite set of three-dimensional shapes, and, with them, you need to duplicate what you see."

In his Dome of the Rock model, Gugick captured the spirit—if not every detail—of the original's intricate Islamic tile art. He simulated complex mosaics by stacking layers of LEGO with colors peeking through holes in the outermost elements. In a display of skill, he even eliminated all traces of LEGO studs on his creation by covering every surface with smooth-topped elements, using a building technique called SNOT (Studs Not on Top).

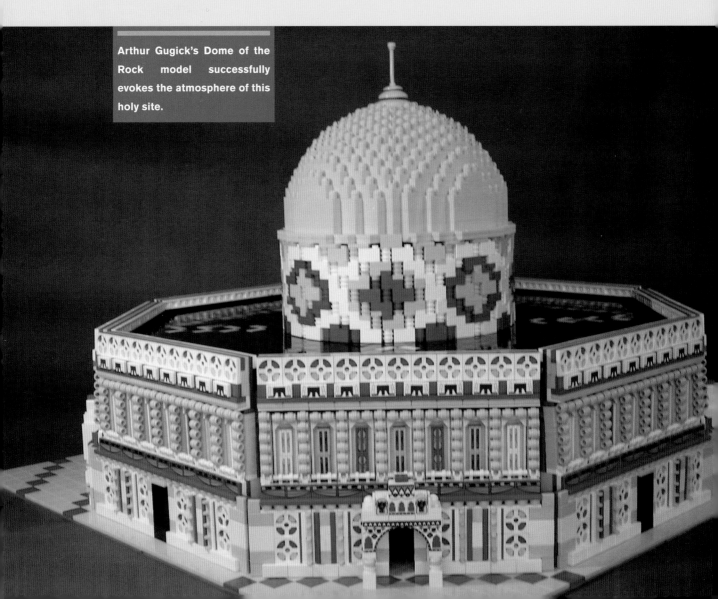

Arthur Gugick's Dome of the Rock model successfully evokes the atmosphere of this holy site.

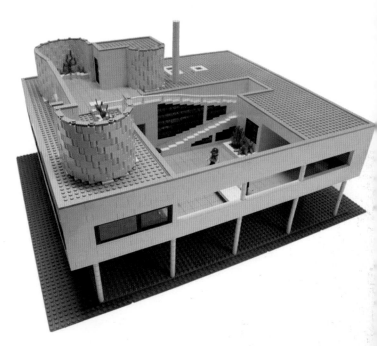

Villa Savoye

Some builders looking to re-create a famous building look to books for inspiration and research material. Croatian architecture student Matija Grguric wanted to build a model of Le Corbusier's Villa Savoye. He found a book on the architect's work, where he was able to find sufficient material to determine the dimensions and colors of the original and build a scale model of the famous structure.

When Grguric published pictures of his creation on the LEGO fan site Mocpages.com, he discovered one of the most appealing aspects of re-creating cultural icons: It garners a lot of attention. Grguric's pictures received more than 10,000 hits in the first few weeks. Many viewers who probably had no interest in LEGO become fascinated with this re-creation of a famous building.

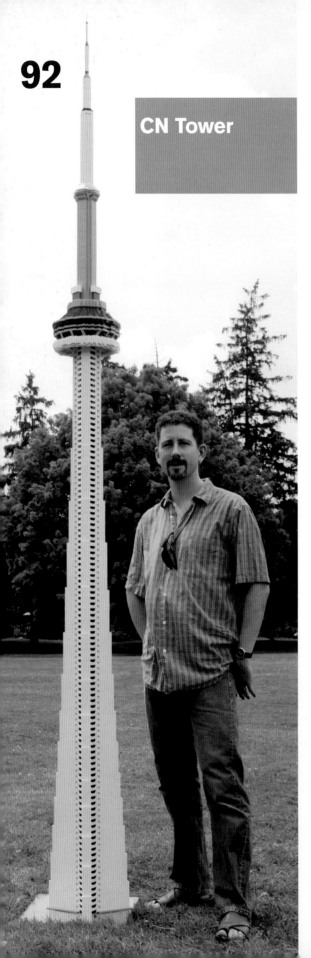

CN Tower

In the fall of 2003, Allan Bedford set out to re-create Toronto's CN Tower in LEGO bricks. His foremost goal was to make the model as faithful as possible to the original, so he researched the building's proportions on the Internet and built his duplicate to match. When he showed off the model in Toronto later that year, it was well received, but something was missing. Although true to the real tower, Bedford didn't like it, so he started over.

"When I rebuilt it, I made a conscious decision not to be as technically accurate with scale," Bedford said in an interview. Instead, he chose to focus on making a beautiful model rather than an authentic duplication. The current version is 10 feet tall and uses about 5,000 bricks. It has been featured at Toronto's Hobby Show and at Brickworld 2006.

Allan Bedford poses by the second version of his CN Tower model.

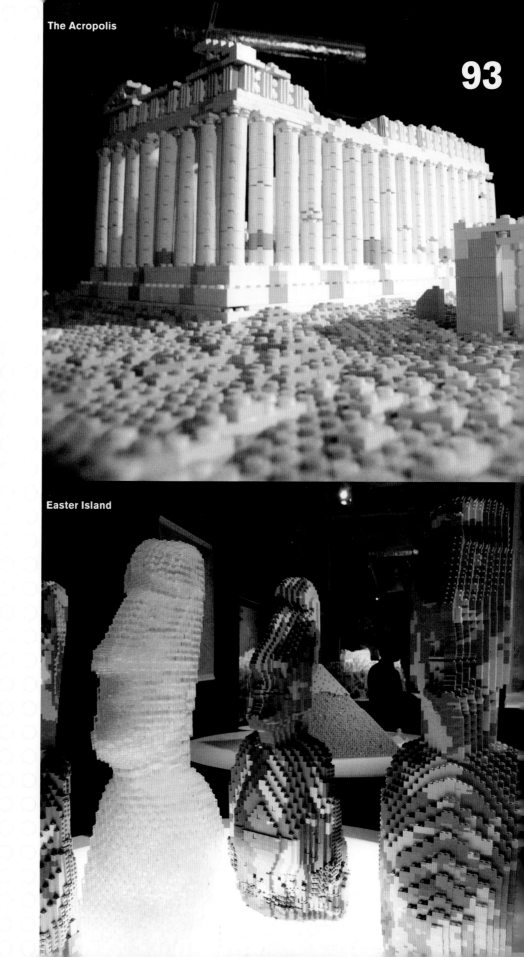

The Acropolis

Easter Island

Pieces of Peace: World Heritage Sites in LEGO

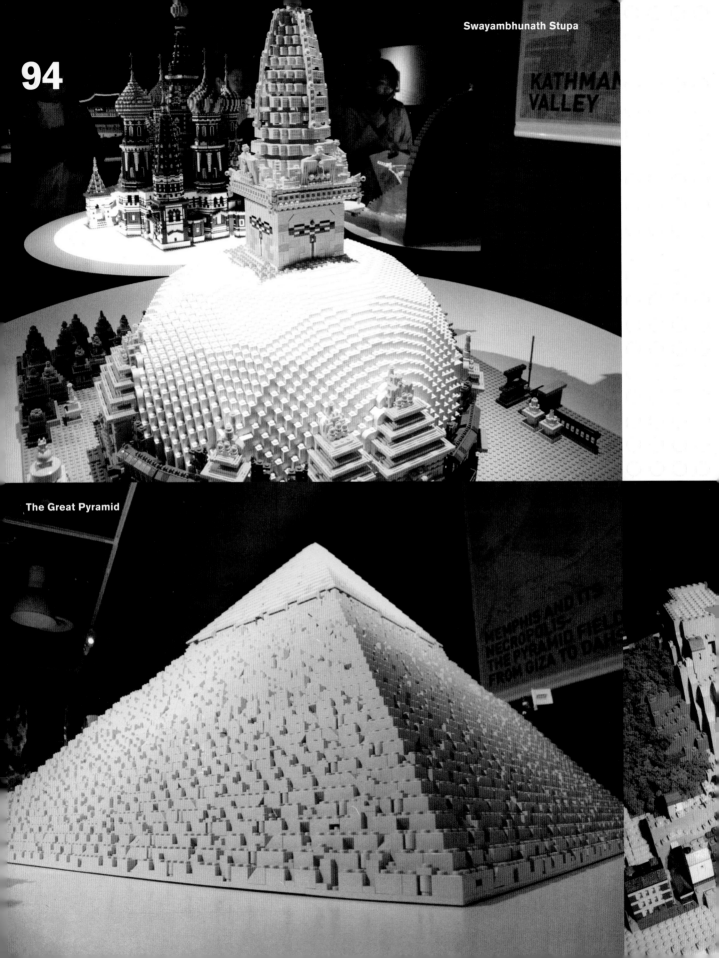

Swayambhunath Stupa

KATHMANDU VALLEY

The Great Pyramid

MEMPHIS AND ITS
NECROPOLIS—
THE PYRAMID FIELDS
FROM GIZA TO DAHSHUR

The creation of LEGO master builder Kazuyoshi Naoe, the multiple-masterpiece exhibition Pieces of Peace, consists of 26 World Heritage sites re-created in LEGO. It includes such iconic structures as Big Ben, the Leaning Tower of Pisa, the Coliseum, and the Statue of Liberty. Sponsored by Yahoo! Kids Japan, the LEGO Group, and the PARCO department store chain, the exhibition raised money for UNESCO, the division of the United Nations that specializes in sponsoring cultural understanding among nations.

The exhibit debuted in 2003 at the PARCO store in Shibuya, Japan, followed by a multiyear tour of various PARCO stores throughout the country. A second exhibition began in 2008, visiting 10 Japanese cities throughout that year. Pieces of Peace garnered such international interest that the exhibition's official blog has received more than 80 million hits since the opening of the exhibit.

> Pieces of Peace includes such epic structures as the Acropolis of Athens, the Easter Island statues, the Swayambhunath Stupa of Kathmandu Valley (with Saint Basil's Cathedral in the background), the Great Pyramid, Mont Saint-Michel, and Barcelona's Sagrada Familia.

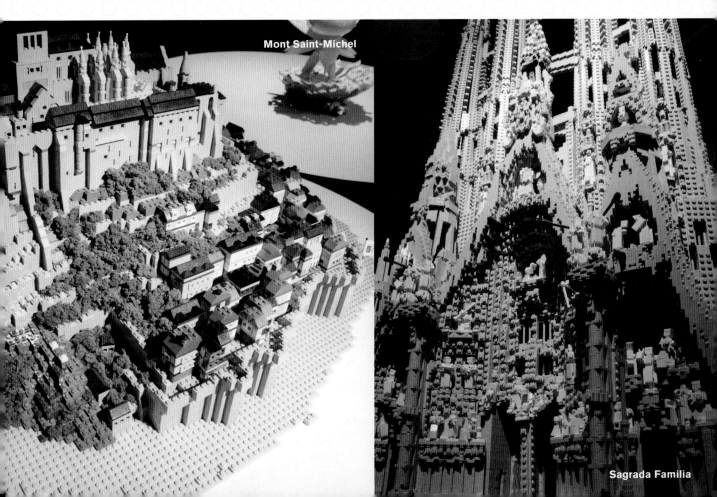

Mont Saint-Michel

Sagrada Familia

Trains

Look through a LEGO catalog or peruse the company website, and you might miss it: LEGO model trains, a product line tapping into the same demographic as traditional model railroads. Tucked away in the recesses of the company's gigantic City product line and frequently absent from catalogs, LEGO trains don't receive very much mainstream attention.

But despite the lack of marketing, LEGO trains have their fans. Train builders represent a distinct subset with their own interests and politics; perhaps most noticeable is their obsession with accuracy and detail. For the typical train builder, much like mainstream model train aficionados, authenticity is paramount. "It is one of the main concerns that I address when approaching a build project," said Jeramy Spurgeon, editor of the LEGO fan magazine *Railbricks*. "I often gather diagrams and schematics to get just the right scaled dimensions."

Train fans' obsession with accuracy puts them in an odd place. As LEGO aficionados, they are used to certain unrealistic yet inevitable sacrifices like having LEGO studs peppering their models. But if realism is paramount, why do train fans use LEGO when other, more authentic materials are available? They're in a quandary; they often have the prejudice that no proper LEGO creation uses non-LEGO elements. Still, as train purists, surely every inaccuracy rankles.

(OPPOSITE) **Jeramy Spurgeon's industrial train layout sports accuracy and incredible detail from the curve of the silos to the weeds growing between the train tracks.**

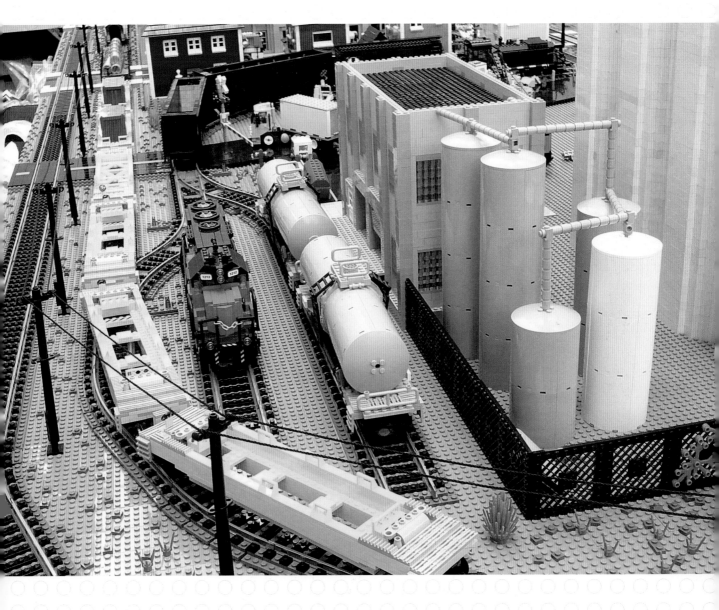

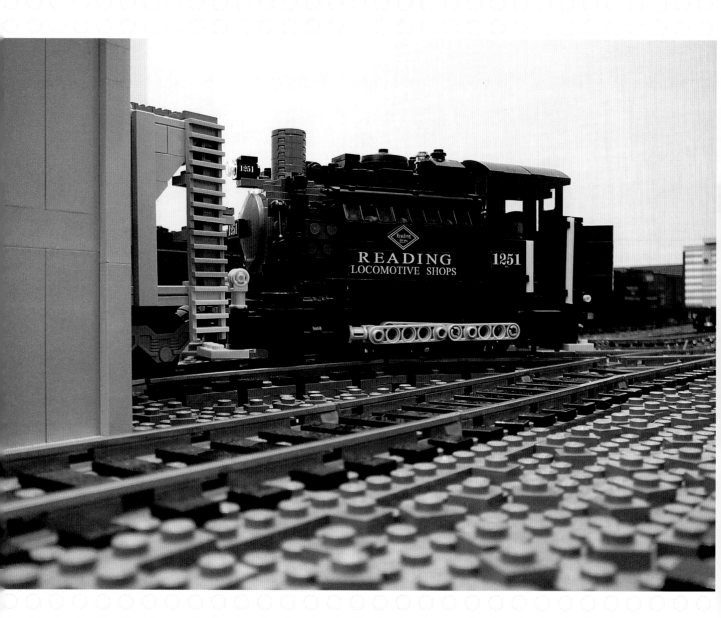

Part of the joy of building with LEGO, of course, is to overcome the limitations of the medium. Some builders employ specialized techniques like SNOT, using smooth-topped plates to give the trains a more realistic appearance. Their creations so closely mimic more traditional model trains that convention goers assume they're S- or 0-gauge model trains on LEGO landscapes.

LEGO also has the advantage of not being permanent. "I think this is the heart of it, really," Spurgeon said. "LEGO builders continually revisit their models as their skills increase, new techniques are discovered, or new pieces are added to the LEGO palette." In many cases, it seems, having landscapes and train cars that can easily be altered makes up for the medium's lack of realism.

Another challenge for train fans is when the LEGO Group redesigns its product lines. The LEGO Group's first train system came out in 1966. It was a 12-volt line, modeled after the German Deutch Bauhn, a realistic approach that helped attract cross-over fans from traditional model railroading. In 1980 the company overhauled the entire product line, enhancing its control system to allow for electrically powered rail switches, signals, and crossing gates. In 1991 the line received its most radical change yet, switching to a 9-volt power system, similar to those found in model railroading where the tracks have a metal rail that powers the trains and other electrical components.

(OOPOSITE) **This gorgeous Reading Railroad locomotive represents a level of detail bordering on obsession, and yet the engine serves as only one part of the train.**

Train fans are a traditional bunch whose hobbies stretch over years. Imagine the frustration that a builder must feel after having invested in a gigantic layout, only to find out that its format is being discontinued. Forced to use LEGO motors and controllers, the LEGO train builder has to keep to a standard—until it changes.

The most recent example of this was the adoption of a remote-controlled powering system. In 2006, the LEGO Group made the decision to forgo the electrified tracks in lieu of battery-powered trains that used a remote-control system. "Many adult train fans have poured much money into the 9V system," Spurgeon said. They would have to rely on garage sales and online auctions to add to their collections, and any future sets were incompatible with their layouts. Is this the way the company rewarded its faithful? The LEGO Group was facing an unwinnable war; either it ignores the business rationale behind its products' evolution or it offends a small but very vocal group of customers. "I think LEGO made the decision that the company had to make to stay competitive in the toy market," Spurgeon said. "Is it a decision that I liked? No, but it is a decision that I can support."

For its part, the company has resolved to do a better job of involving adult fans in the evolution of its products, consulting a core group of adult train fans about future releases and including them in the testing of these new products. "The next line of trains will be the direct result of this relationship," Spurgeon said. "I only see good things for the future."

(OPPOSITE) **What could be more complex than a bustling city? Spurgeon's urban layout depicts the people and objects you'd expect: fire trucks, kids on bicycles, cops directing traffic—and trains.**

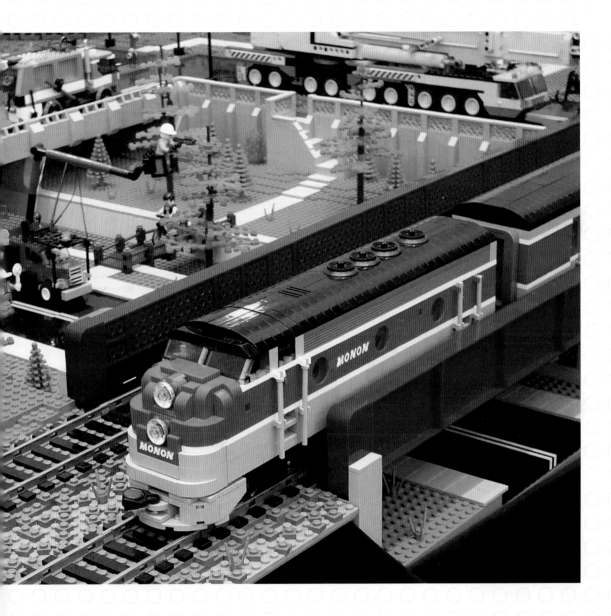

Arthur Gugick uses circular plates on top of squares in his ode to Salvador Dali's *Persistence of Memory.*

Brick Classics

While train fans faithfully re-create the industrial infrastructure of another era, other builders focus on odes to the classics. It's an understandable urge. If you love Picasso's *Guernica*, why not create your own version in LEGO? Although re-creating such works in plastic bricks may not match the genius that inspired the original artist, it does demand a certain degree of ambition.

The result, if executed skillfully, attracts a great deal of attention. Ordinary people may not like LEGO the way fans do, but they can appreciate the artistry of a re-creation because they already possess the cultural understanding of the original. However, some LEGO fans remain unimpressed, claiming that builders re-creating classics are merely riding the coattails of an established crowd-pleasing masterpiece rather than conceiving a new and unknown project. However, even skeptics must acknowledge the skill required to successfully evoke the feel of the original works.

The following are some examples of re-created masterpieces.

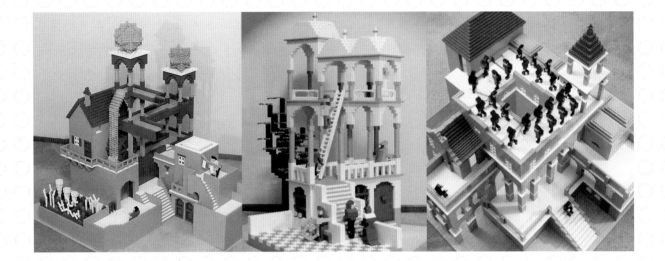

M. C. Escher's Optical Illusions

Escher, though not himself a mathematician, obsessed over geometric shapes and orderly patterns called *tesselations*. Many LEGO fans are fascinated with Escher's work; one in particular, Henry Lim, re-created several Escher masterpieces in bricks. Lim was commissioned by the Hong Kong Science Museum to create the models for an Escher exhibit.

Many LEGO models are built at minifig scale, where the toy's humanoid figures are assumed to be the same general size as a human being. However, Lim chose a larger scale, assembling his LEGO people out of bricks. In some respects, Lim's figures evoke Escher's featureless humanoids better than minifigs could. The sexless, faceless, tunic-wearing denizens of *Relativity* possess so little personality that even a minifig stands out.

The greatest challenge Lim encountered was creating a scene that simply could not exist. It's one thing to *draw* an optical illusion, as Escher did, but to create one in real life is another matter entirely. Take the artist's *Waterfall* illusion, for example. The water flows up a zigzagging aqueduct before arriving at the starting point via the titular waterfall. Lim's solution was to set up a "sweet spot" through which visitors viewed the model. From that angle, the illusion held up. However, museum goers were invited to walk around the sculpture, revealing the secret to the illusion.

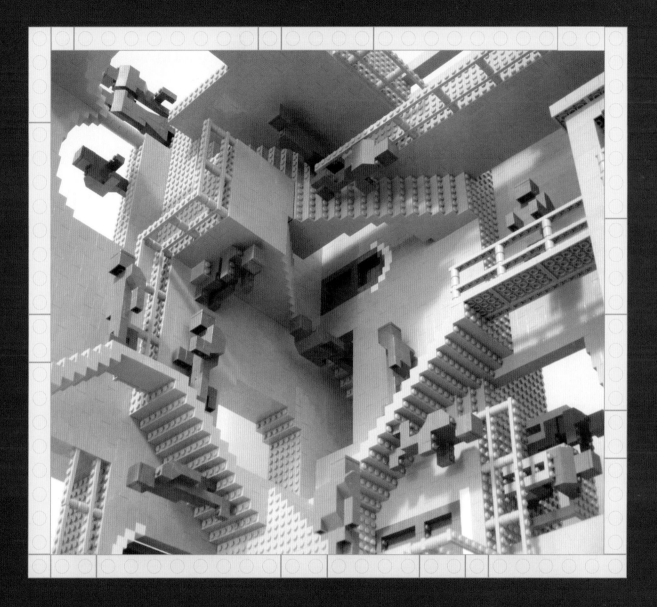

Henry Lim explores Dutch engraver M. C. Escher's most famous optical illusions. While Escher had the luxury of keeping his mind benders in the realm of illustration, Lim had to rely on viewing angles to make the impossible happen.

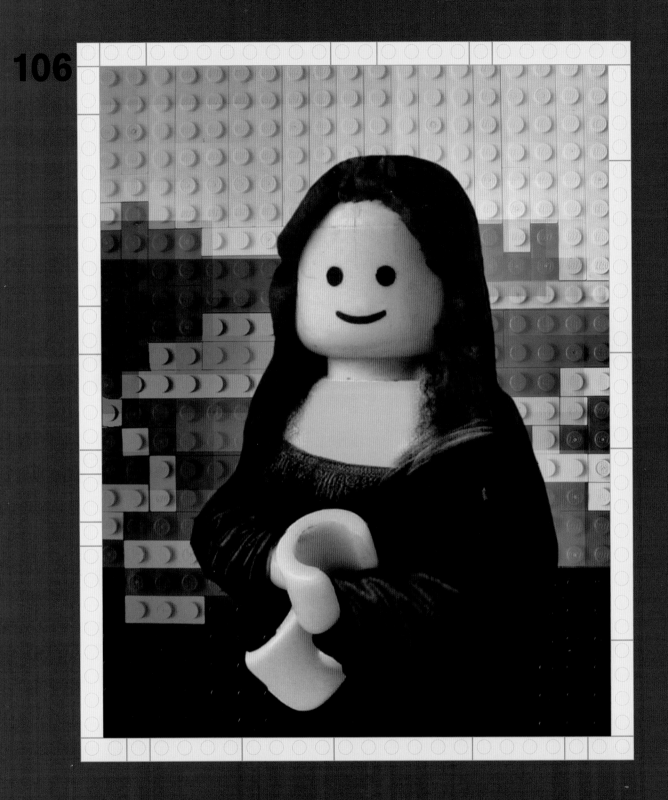

What would the Italian master have made out of LEGO? Probably nothing like his paintings, re-created here by Marco Pece.

The Masterpieces of Leonardo da Vinci

Leonardo da Vinci's two most iconic works, *The Last Supper* and *Mona Lisa*, have so thoroughly penetrated our culture that it was inevitable that *some* builder would want to re-create them. Marco Pece's odes are probably the best of these efforts, perfectly evoking the feel of Leonardo's paintings with only a little Photoshop work.

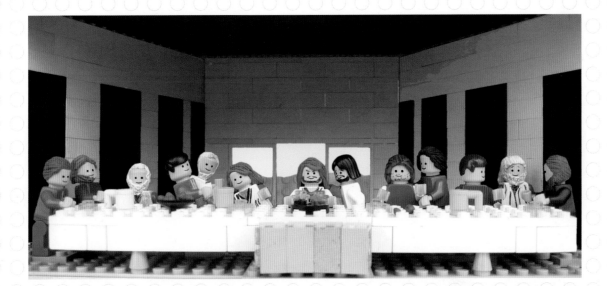

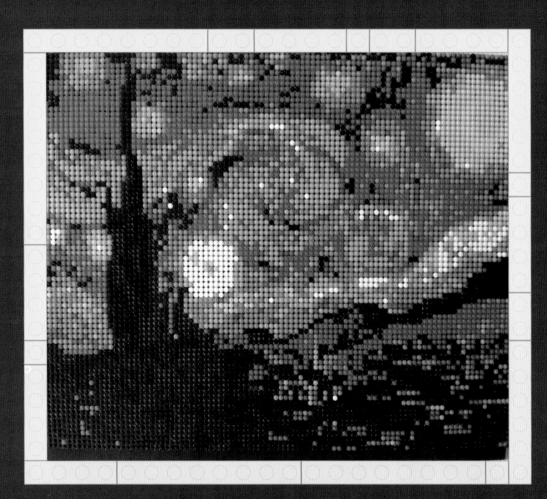

Arthur Gugick's *Starry Night* mosaic uses sophisticated color to add complexity to the creation.

Vincent van Gogh's Starry Night

Van Gogh made the history books with his matchless command of color. LEGO fan Arthur Gugick's re-creation of the Dutch painter's masterpiece uses round plates laid on top of square ones to allow different colors to peek through.

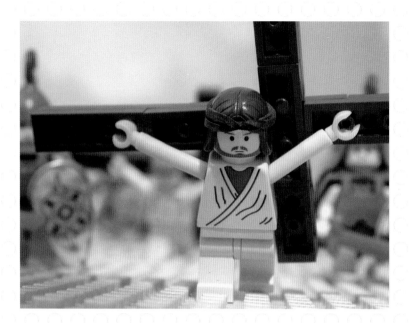

The Brick Testament

A lot of LEGO fans have built scenes from their favorite movies and books, though none with the tenacity of Brendan Powell Smith: His project, Brick Testament, claims to be "the world's largest, most comprehensive illustrated Bible." Smith, who calls himself the Reverend, has retold some 400 stories from the Bible, with the help of more than 3,600 photographs, using LEGO dioramas to illustrate the scenes.

Smith covers all the well-known stories like Cain and Abel and the birth of Moses, but he doesn't neglect the minor stories like the capture of Rabbah by Joab in 2 Samuel 12:26. He has illustrated many stories from the Old Testament but relatively few from the New Testament thus far, but Smith continues to work on the project. Each story is rated for nudity, sexual content, cursing, and violence, though all within a LEGO context — naked minifigs look like regular ones except being all yellow, and the violence features transparent red LEGO elements to simulate gore.

Smith, who describes himself as a "blaspheming heretic with a heart of gold," isn't actually a reverend, but that hasn't stopped him from getting more than 200 requests from Sunday schools and church groups to use his works to help teach the Bible. He grants these groups permission so long as they don't turn a profit; he directs other requests to his online store where he offers Brick Testament posters, books, and custom LEGO sets (*http://www.thebricktestament.com/*). *The Brick Bible*, published in Fall 2011 by Skyhorse Books, contains Smith's work on the Old Testament.

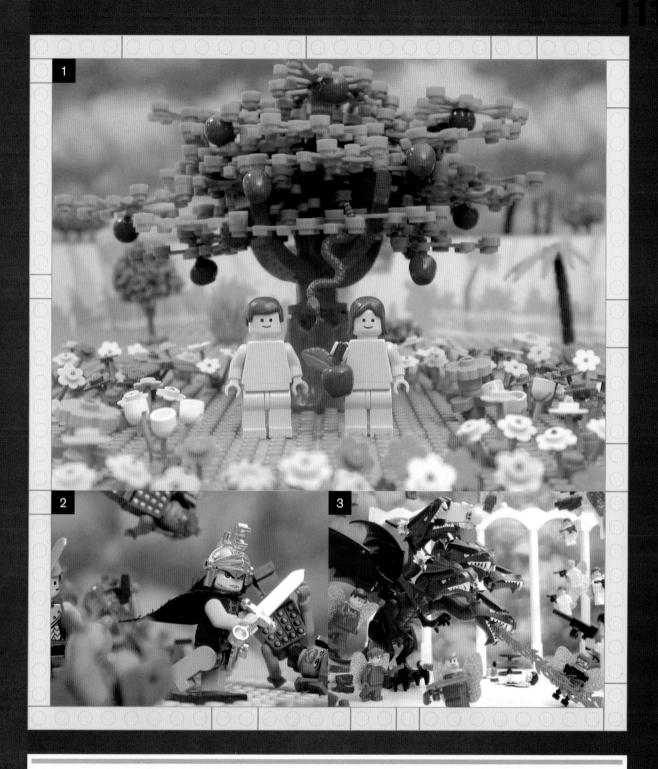

(OPPOSITE) **Smith's willingness to modify LEGO models is clearly seen in this depiction of Jesus carrying the cross to Golgotha, with non-standard arms and a rubber-band crown of thorns.** (1) **Minus fig leaves, Adam and Eve check out the apple tree; the snake watches in anticipation.** (2) **A biblical warrior mows down the opposition. Smith adds warnings to his images if they contain nudity, sex, violence or cursing.** (3) **In a very fanciful interpretation, Michael and his angelic gunmen battle Satan (in dragon form) and his glowering red-clad followers.**

Cinematic Inspirati

LEGO fans have always been eager to build the scenes and vehicles from the movies they loved. For its part, the LEGO Group has jumped on this bandwagon with its own movie-inspired models, licensed re-creations of epic scenes from recent and not-so-recent pictures.

Wall-E

Joe Meno, publisher of *BrickJournal* and coauthor of this book, designed his version of the Wall-E animated character over a period of three months. It took just over two months of research to produce an initial model and three weeks of redesigning to arrive at the current form. Meno's original goal was to have his model functional—motorized and remote controlled—as well as faithful to the movie robot. The first hurdle he had to overcome was that of scale: How big should he build Wall-E?

He started with the treads, finding the ones he liked best (TECHNIC treads from the Motorized Bulldozer set) and determining scale from there. He finished his model two weeks before the movie *Wall-E* premiered in theaters; pictures of the project went viral on Flickr, he won an award at the Brickworld LEGO convention for Best Mechanical Creation, and his creation has been displayed at the National Fantasy Convention at Disneyland and the Festival of Masters at Disney World.

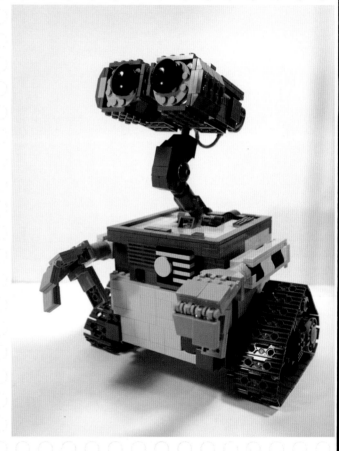

(ABOVE) **Joe Meno's Wall-E captures the holy grail of re-creating reality—not only the appearance of the original but also its spirit.**

ons

(TOP) **What better use of LEGO's BIONICLE line than to re-create the H. R. Giger–designed xenomorph of movie fame?**

(BOTTOM) **This re-creation of the robotic skeleton of the *Terminator* movies makes perfect use of BIONICLE's unique style.**

Alien Queen

Jeff Ranjo made ingenious use of BIONICLE elements to make this queen from the 1986 movie *Aliens*. More than 2 feet long, this beautiful model evokes the spirit of the movie monster without worrying too much about precise details. For instance, Ranjo used a circular TECHNICS gear for the teeth.

BIONICLE Terminator

Matt Armstrong's *Terminator* re-creation exemplifies a common scenario where a builder is playing with parts and suddenly starts building. "The Terminator arm started with a few LEGO pieces that vaguely resembled fingers," Armstrong said. "Then they grew into the wrist and hand and eventually into the arm itself. After that, I tackled a couple of other various robot appendages, tore those apart, and created the robot skull." Armstrong used the perfect medium for this project: the ornate, gothic bricks of LEGO's BIONICLE product line, which features cybernetic life forms that do battle with gigantic weapons.

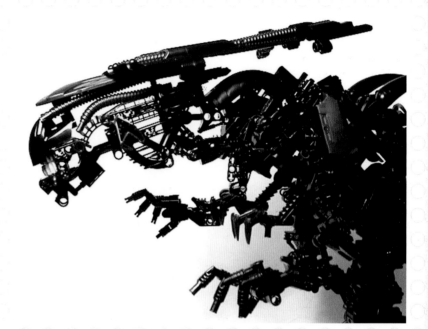

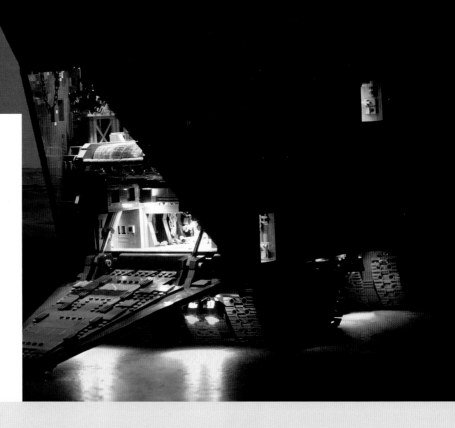

Jawa Sandcrawler

Hannes Tscharmer's 10,000-brick, remote-controlled LEGO Sandcrawler from the *Star Wars* universe packs in vast amounts of movie-authentic detail using Power Functions motors, battery packs, and LEDs. The interior consists of three minifig-scale levels, a powered crane and tank treads, and a ramp that moves up and down. The intricately detailed workshop has a moving conveyor belt and lights.

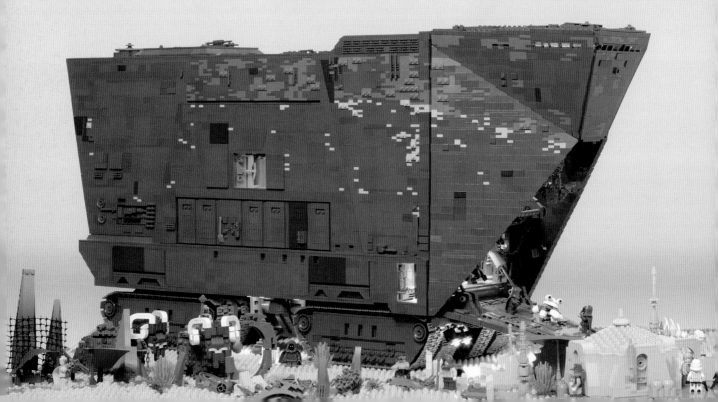

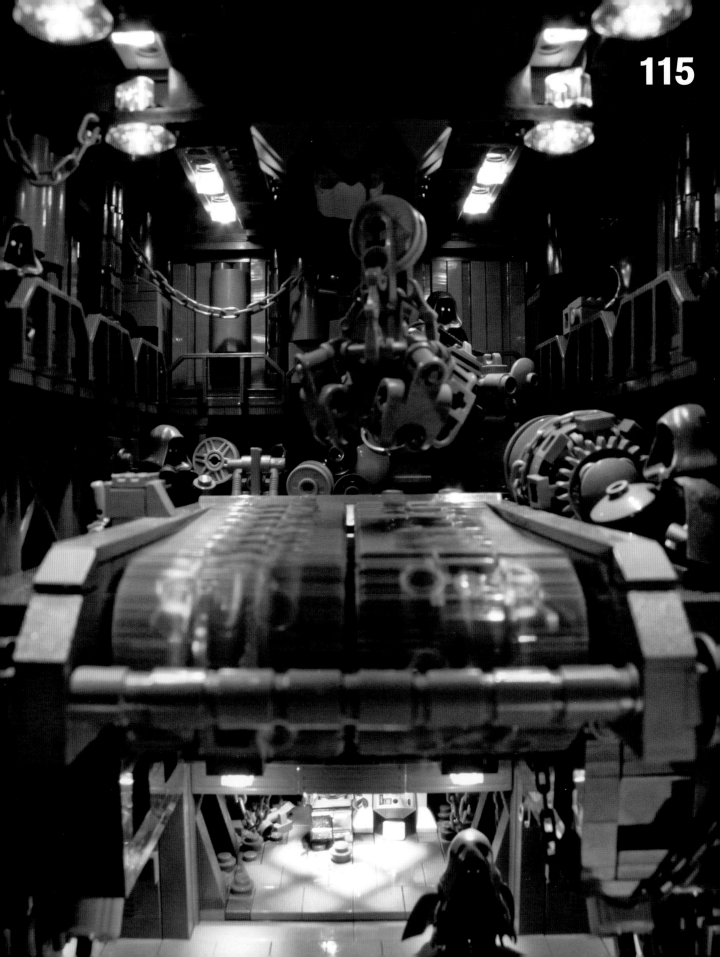

Boba Fett Costume

Simon McDonald's armor is made entirely of LEGO except for the cloth jumpsuit and the armor's Velcro fasteners. Designed as an ode to the popular *Star Wars* character, it features a forearm-mounted gun that fires TECHNICS darts and another arm guard that uses a red LED from an EXO-FORCE set to create a laser. McDonald has also created a similarly detailed Darth Vader costume.

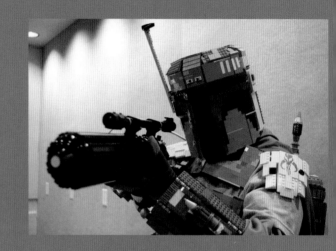

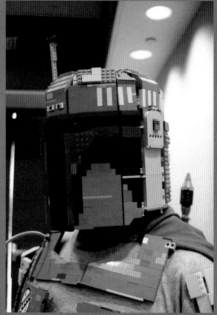

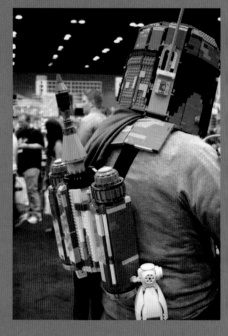

Simon McDonald's Mandalorian armor wowed convention goers with its faithfulness to the movie costume.

Darth Maul Mosaic

This mosaic, created by Arthur Gugick, evokes a unique look by using rare, preprinted bricks that come with some LEGO sets. The first person to build this kind of mosaic was Eric Harshbarger, whose "Girl" composition won an award at the 2004 BrickFest. It's a challenging medium. Only a couple of preprinted bricks come with every set, so very few builders have accumulated enough of these elements to create a work like Gugick's, even if they were inclined to attempt it.

In a sense, Gugick's work serves to demonstrate the challenge of those who re-create famous images using LEGO. Never mind creating a photographic reproduction of the original—that's impossible. But capturing the elusive *feel* using little plastic bricks is a testament to the builders' expertise and demonstrates the magic of LEGO.

Arthur Gugick's Darth Maul mosaic uses preprinted tiles to depict the villain featured in *Star Wars: The Phantom Menace* (1999).

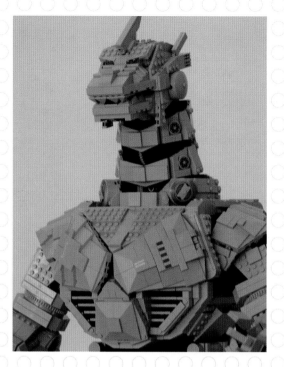

(RIGHT) **Brian Cooper's Mechagodzilla serves as an ode to the kaiju villain, as well as showing off Cooper's masterful building skill.**

(BELOW) **Henry Lim's ode to the DC comic-book heroine Catwoman renders a two-dimensional publicity photo in 1×1 plates.**

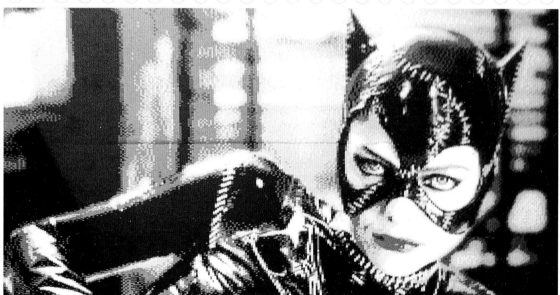

Mechagodzilla

Brian Cooper's re-creation of Godzilla's nemesis doesn't merely mimic the appearance of the robot. It also features most of Mechagodzilla's unusual attributes, including light-up eyes, a moving jaw, spinning talons, and a chest plate that opens up to reveal a cannon. But no laser-beam breath?

Catwoman Mosaic

Beyond the practical aspects of building flat — ease of transport and display, not to mention the need for fewer bricks — there are aesthetic benefits as well. Henry Lim created this mosaic of the *Batman Returns* character to show off her shiny suit using only black and grey bricks, with a variety of elements ranging from 1×1 plates to 2×8 bricks.

Building from
Imagination

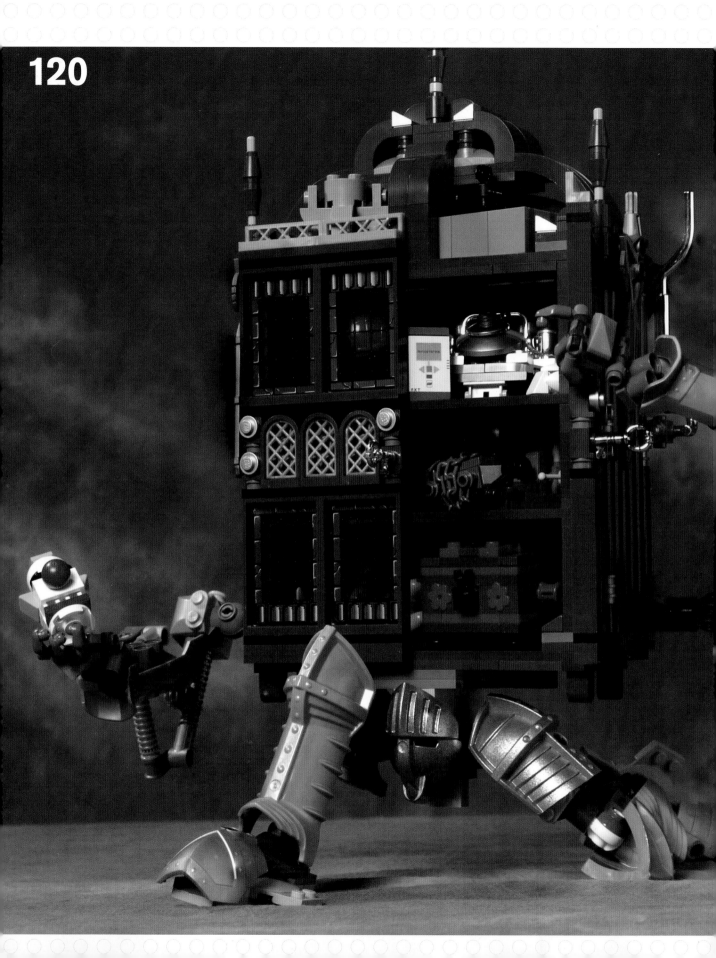

The LEGO builders featured in Chapter 4 take pride in accurately re-creating real-world phenomena. Ultimately, their accomplishments are measured in terms of their technical skill and faithfulness to the original item. But what about building beautiful models of things that exist only in one's imagination?

When building from the imagination, anything is possible. Builders don't need to limit a project to what can be found in the real world or limit it to depicting technology that could actually function. Some builders draw inspiration from movies, dreams, or simply conversations. Others crank up the music, grab a pile of bricks, and just create. Still others take a more methodical approach, sketching out entire fleets of vehicles before placing a single brick.

Guy Himber's "Cabinet of Curiosities" evokes the Renaissance tradition of collecting natural marvels and odd discoveries in a cabinet, except that this cabinet is also a robot!

It could be argued that the LEGO Group's City products serve as a tribute to reality, featuring wholesome models such as houses, fire trucks, and hospitals. However, the LEGO Group hasn't ignored more fantasy-based themes. The company's two most successful and long-lasting themes of this type are Castle and Space, which salute the two major subsets of fantastic storytelling—swords and sorcery, and science fiction, respectively. Castle typically involves concepts that arguably cannot exist and are derivative of legends and myths, including the requisite dragons, sorcery, and goblins. Conversely, Space focuses on scenarios that don't exist but that could. We may not be able to travel to other stars, visit aliens, or mine Martian ore, but we may be able to someday.

Besides their longevity, what is remarkable about Castle and Space is that as the product lines have fluctuated over the decades, builders continue to create models that fit into the basic archetypes laid down in LEGO sets.

The LEGO Group's Odes to Imagination

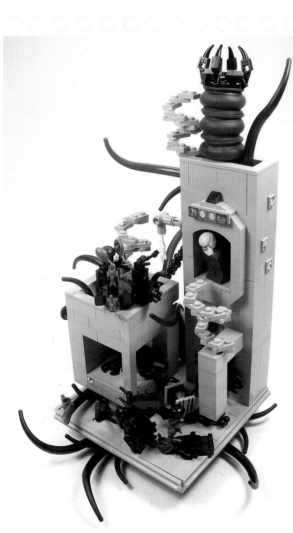

(LEFT) **Kevin Fedde's nightmare model clearly comes from his imagination.**

(BELOW) Kevin Fedde's intricate "Castle Caravel" model revels in the classic realm of swords and sorcery.

Castle

Castle first hit store shelves in 1978. Its central theme involves the epic struggle of good versus evil in a medieval land that resembles the legendary Europe of King Arthur. Wizards, kings, and later dwarves are the protagonists, while a variety of unambiguously villainous skeletons, dark knights, trolls, and evil sorcerers oppose them. As with City products, we rarely learn the names of individual characters, and usually only leader types receive any distinguishing accessories. Buildings and vehicles are the true stars of the line, with fortifications, huts, boats, and siege machinery taking attention away from the minifigs. For builders, though, this makes sense, because the experience of building requires structures more than minifigs.

At the tamer end of the spectrum are sets like the Medieval Market Village that suggest a combination of City and Castle. Just as City offers a slice of typical European life with fire trucks and police stations, Medieval Market Village depicts a market square packed with wagons, shopkeepers, houses, and soldiers. Notably absent are the fantastical trappings common to the Castle theme. Forget trolls and necromancers; the village could well be a real medieval town square.

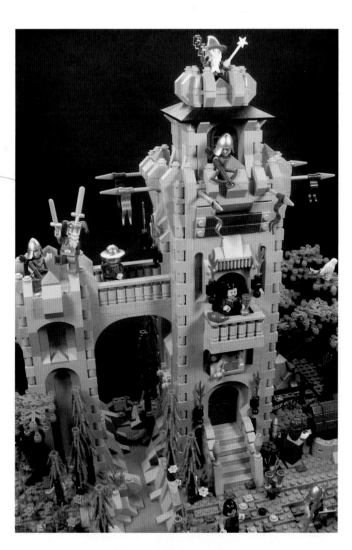

(RIGHT) **Brian Darrow's "BLACKTRON Intelligence Agency" took 1987's BLACKTRON theme and expanded upon it, creating an entire city filled with minifigs and vehicles.**

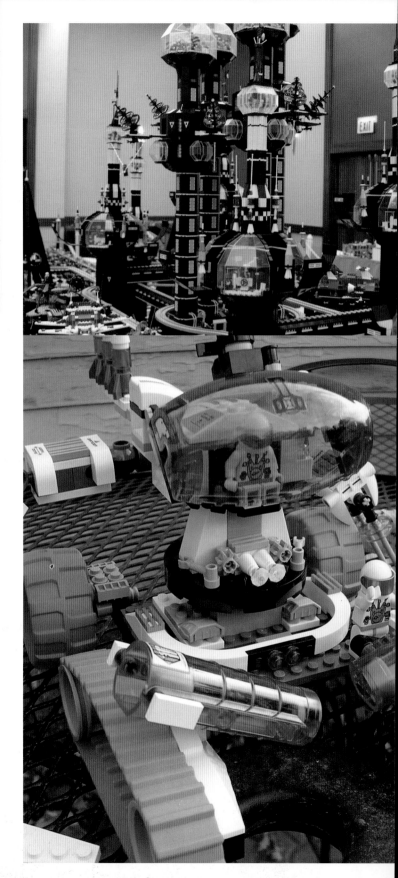

Space

Released the same year as Castle, Space offers a science-fiction angle that has been a favorite ever since. At first, the sets followed a theme that involved rather simple but arguably realistic interpretations of what real space bases might look like: domed structures, moon buggies, and rockets. Perhaps the concept of space exploration was so novel that such blatantly fictional elements as aliens and starships weren't needed. As with Castle, many of the sets could be City set in a different time period.

In 1987, the line took an edgy turn with BLACKTRON, a classic Space set with a certain moral vagueness and sinister appearance. Astronauts were dressed in black, piloting ships with names like Renegade and Invader. It was an immediate favorite among fans, so much so that when the Space line moved on to other themes, fans kept building models using the set's distinctive black and yellow style, most notably Brian Darrow's "BLACKTRON Intelligence Agency."

As LEGO Space continued to evolve, even more creative ideas came to the forefront, including alien-themed sets like 1997's UFO and 1998's INSECTOIDS, though ultimately they were aberrations in a very consistently human-centric

line. LEGO Space was discontinued when LEGO Star Wars was produced because of concerns that they would compete. The last LEGO Space sets were the LIFE ON MARS sets in 2001, which set the stage for the LEGO Group to return to space years later.

A new product line for 2007, MARS MISSION explored many of the same themes as Space, though with a more martial angle. The story tells of an innocent (though heavily armed) band of miners digging Martian ore, when "aliens" attack. LEGO Group's marketing arm tells the story through a series of fake blog posts, written by one of the miners.

"Things changed up here. Instead of just collecting crystals we are now at the same time fighting an enemy we hardly know. Who are these aliens? Why don't they like us? I think it has something to do with crystals — they are constantly trying to steel [sic] the crystals we find, which makes it harder for us Miners and certainly more risky!" Soon, all-out warfare with tanks, lasers, and fighters ensues. Are these aliens Martians defending their homes? Are they also, like the humans, invaders from another world? With few answers forthcoming from the LEGO Group, fans are free to form their own stories.

The line offers an excellent variety of models including sleek rockets (both alien and human) as well as buggies, planes, and bases. Oddly, the orange-and-white human vessels come equipped with stasis tubes to hold captive aliens, but to what end? Indoctrination? Experimentation? The largest base model even has an "examination table" to study the aliens. The black-and-green alien ships pack firepower similar to the human fleet's and seem utterly inscrutable in their missions, besides simple destruction.

MARS MISSION, although not an official Space product, features many themes that are similar to those of Space, as well as the requisite science-fiction angle. Space officially returned with the arrival of the SPACE POLICE theme in 2008. In this case, the future is one where space travel is common and, as a result, so is crime. Conflict is presented as a simple clash between good and evil, with armored police officers in white spaceships chasing after the black alien criminals.

(LEFT) **The MARS MISSION "Clawtank" featured giant lasers, missiles, and stasis tubes for holding captured aliens. Just what every miner needs!**

(BELOW) **The best place to hide your treasure is under the watchful eyes of your worst enemy! This pirate-themed model by Kevin Fedde illustrates the imaginative possibilities of the line.**

Pirates

Notwithstanding the iffy nature of MARS MISSION's moral compass, typically the LEGO Group tries to forge a clear distinction between good and evil in its lines. Heroes aren't undead or monstrous, and villains wear their wickedness on their sleeves.

However, the PIRATES subset of Castle involves slightly more ethical vagueness than the norm. Most larger LEGO sets feature a protagonist and an antagonist. For instance, if there's a police station, there will be a criminal in a holding cell. Human astronauts have evil aliens opposing them. In PIRATES, the lovable but indubitably villainous buccaneers serve as the stars of the largest and most detailed sets, and their hapless opponents, the vaguely European colonial troops, barely have a presence except as foils for the title characters.

The packaging of the "big set" of 2009, an opulently detailed pirate galleon dubbed *Brickbeard's Bounty*, shows the pirates making a young woman (called "the Admiral's daughter") walk the plank. As the girl teeters above the ocean waves, her would-be rescuers struggle with pirates over a chest of booty. Interestingly, the scene may represent the first threatened execution depicted in an official LEGO product.

Perhaps the popularity and clearly fictionalized nature of the pirate phenomenon allows the LEGO Group to sidestep the moral implications of its sets. Everyone likes pirates, and the clichéd sight of a young woman being forced to walk the plank lacks the punch it otherwise might have.

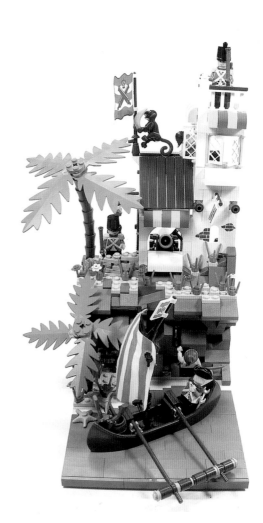

Underground and Underwater

Every few years, the LEGO Group comes out with an earnest, well-executed, but ultimately short-lived underground or underwater theme. The concept seems ripe for exploitation. Imagine all the fantastic models that could be designed around submersibles, domed cities, and burrowing machines. The sets often feature specialized parts such as giant drills and transparent bubbles that can't be found in most of the LEGO Group's lines.

Unfortunately, none of these themes has survived beyond a couple of years. One reason may be that the concepts occupy a kind of middle ground between science fiction and reality: Much of the technology is plausible, or at least only slightly unrealistic. Or perhaps the lack of a story line and cool characters has limited the appeal. Whatever the reason, the LEGO Group's "under" lines have found little success. (As we write this, the LEGO Group has launched a new underground theme, POWER MINERS, as well as ATLANTIS, a new undersea line, demonstrating its persistence in exploring this avenue.)

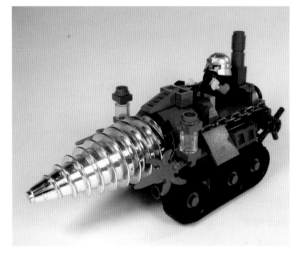

(ABOVE) **This dwarf-operated vehicle makes use of a drill element from the LEGO Group's POWER MINERS line.**

Mecha

Fans have focused on vehicles since the first LEGO wheels were sold, usually realistic ones such as fire trucks or police cars. However, builders have always created outlandish vehicles that cannot work in the real world like *mecha*, the giant robots featured in comics and science-fiction tales. Imagine a robot so big that human pilots can ride inside. Many people associate the genre with Japanese movies and animated television programs, recalling such imports as 1985's *Voltron*, a children's show featuring leonine robots piloted by teens.

The LEGO Group has produced mecha themes as late as the close of the 1990s in an attempt to cash in on the giant robot craze. The first two lines, ROBORIDERS and THROWBOTS, lasted only a year, but their successor, BIONICLE, has proven to be one of the company's enduring successes of the past decade.

(BELOW) **This delicate but sinister arthropod exemplifies the Japanese phenomenon of mecha while avoiding the humanoid form.**

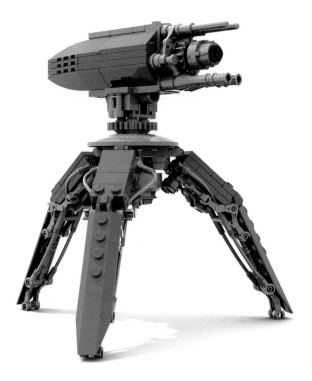

(LEFT) **Nannan Zhang's elegant tripod features sophisticated detail in a small model.**

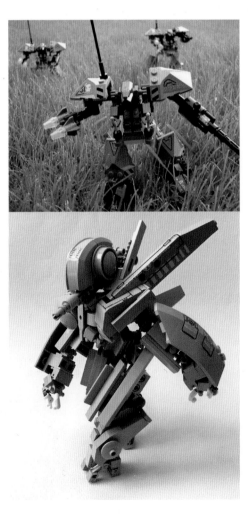

(LEFT TOP) **Andrew Summersgill's EXO-FORCE remix shows troopers from a robot army.**

(LEFT BOTTOM) **Giant robots need not make for giant models. This microscale mecha packs a lot of detail while using very few elements.**

130

EXO-FORCE

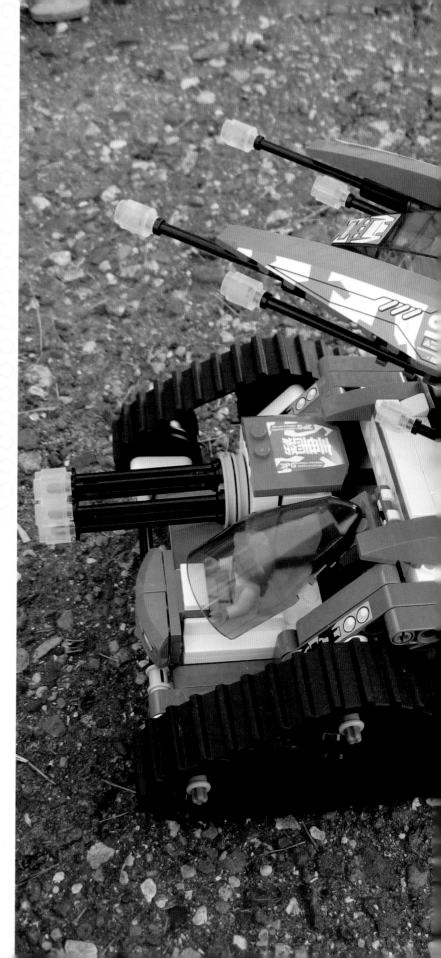

(RIGHT) **EXO-FORCE's "Hybrid Rescue Tank" splits into three vehicles: the bottom a ground-hugging rover, the turret a jet plane, and the assembly at the top an insectlike drone.**

Like many LEGO product themes, EXO-FORCE seemed to have everything going for it. The line offered sophisticated models that could be combined into super-robots, and it included fun value-adds such as light-up elements, internal gearboxes, and detachable drones. The minifigs featured brightly colored bouffants, and each had its own name and history. Novels, comics, and short movies backed up the models, much like BIONICLE.

Apparently, though, something was lacking. Builders claimed that the playability of the models suffered from poor balance and construction, and the complexity of the sets commanded higher retail prices. Whatever the reason, 2008 saw an abrupt cancellation of the line, proving that a product's apparent success doesn't always correlate with the level of investment that the LEGO Group puts into a new product line.

On the other hand, the LEGO Group's other mecha line, BIONICLE, has found a clear niche. Compared with EXO-FORCE, the two lines have little in common besides giant robots. BIONICLE's bots are relatively simplistic and include fewer parts. There are no minifigs; the robots serve as the main actors. The line's main advantages are simple: The models are easy to build, and each has a unique biomechanical look that's reminiscent of the works of fantasy artist H. R. Giger, who designed the title creature for the classic 1979 movie *Alien*. BIONICLE's robots pack fluorescent eyes and absurdly gigantic

(BELOW) **BIONICLE's unique elements, sophisticated multiyear story line, and category-defying style combine to make the line a success.**

WARNING
PLASMA CORE ENGINE

weapons, and they don't fall apart very easily, thus offering a playability on par with traditional action figures. There is also a collectible aspect to the sets, with each model having a mask element available only in that set, encouraging fans to buy and trade them.

The BIONICLE story details an epic battle between good and evil, dating back to primeval times when the evil god Makuta conquered the universe. Courageous robots called the Toa battle Makuta's monstrous goons. As each year's models were introduced, new layers of legend were added to the story until the mythology took on a complexity rivaling many other toy lines like G.I. Joe or Pokémon. It has become so convoluted there's even a book that details all the ins and outs of the BIONICLE story. Called *Bionicle Encyclopedia* and written by Greg Farshtey, the book contains entries on the characters, locations, and story lines of the saga for fans who have lost track of its intricacies.

Although the set's core demographic consists of preteen boys, one of the most prominent BIONICLE builders is Breann Sledge, known as "Breannicle" for her love of the product.

Sledge loves everything about BIONICLE, from the story to the individual models. "I buy all the new BIONICLE sets when they come out. I like to assemble them and then play with them until I am bored of the set itself." Once she's finished playing with a set, she rebuilds the model into a smaller version of itself and throws the remaining parts into her parts bin. "I like how Bionicle parts snap together. The ball joints offer some great articulation, and you can create just about any poseable figure that you'd like."

But Sledge's work stands out because it goes well beyond merely playing with the line's official products. She repurposes BIONICLE's unique elements to create completely new models, most of which evoke a ferocious, fantastical feeling with BIONICLE's repurposed baroque spikes, wickedly barbed blades, claws, and other warlike elements. Sledge's "Kukorakh"

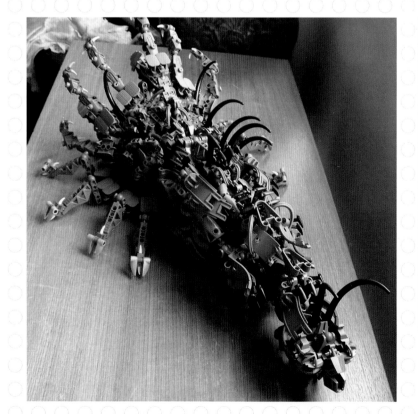

(LEFT) **This "Pit Scourge" model demonstrates a classic Breann Sledge aesthetic—monstrous models that make use of BIONICLE elements.**

(MIDDLE) **Breann Sledge's models use BIONICLE elements, but the results only vaguely resemble the line's giant robots.**

(RIGHT) **Sledge's "Bionic Fridge" model shows that not all BIONICLE creations need be monsters! They can be monstrous kitchen appliances.**

dragon model demonstrates both her skill and the flexibility of the BIONICLE parts. A gigantic black, green, and chrome dragon, Kukorakh threatens with metallic claws, fangs, and black, hose-like tendons that stretch from its lacy wings. Could the same model have been made using only System bricks? Highly doubtful, and even if was built in System, it would certainly lack the model's skeletal structure and sinister appearance.

Sledge's "Bionic Fridge" is an elaborate model of a demonic refrigerator door covered with ornate detail such as chrome blades and bonelike ivory protrusions. A sinister red eye threatens anyone who would snatch food from inside.

Sledge may have an unabashed love of BIONICLE, but not all LEGO fans feel the same way. To begin with, the line's clearly violent air makes some people uncomfortable. Most LEGO sets involve a certain amount of conflict, like the interspecies rivalry in MARS MISSION. But even in those sets, the fighting doesn't take center stage; the models focus on the vehicles and bases. In BIONICLE, most sets consist of a single robot warrior and its weapons, which include swords, axes, chainsaws, and missile launchers. The line includes some vehicle sets but no buildings, and all products center around the Toa-Makuta battle.

Some fans wonder whether BIONICLE is truly LEGO. The parts are completely incompatible with System bricks, lacking the iconic LEGO studs that most people associate with the toy. Instead, BIONICLE uses TECHNIC pins, which make for more durable connections that enhance playability. Still, many builders think BIONICLE has moved too far from the mainstream of the LEGO line.

Although there may be truth to these accusations, in the end builders such as Breann Sledge prove that the line's story and models are merely a starting point. Like all LEGO, BIONICLE's potential is limited only by the builder's imagination.

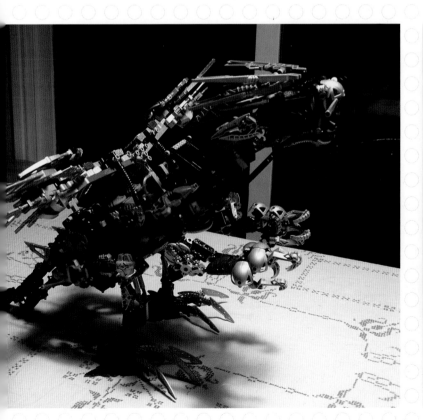

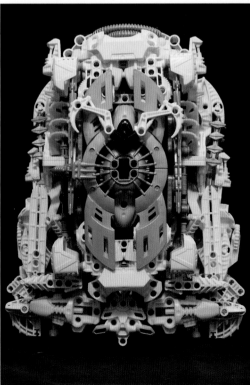

Breann Sledge shows off a BIONICLE model.

Building with BIONICLE

"When I build a model, I tend to come up with an image of how I want it to look in my head, or I will think of a particular technique I'd like to try in certain colors. I keep my parts sorted by color for ease of finding things. I will usually build for a few hours or more at a time when I am really groovin'. I always start with the head. I come up with a base structure that moves like a skull, jaw, and neck should, and then I build in the teeth and face. From there, I will usually build the spine all the way to the end of the tail and stiffen the spine at the body hard points like the torso and hips, leaving some suppleness where flex is needed. Then it's a matter of building from that spine and getting a frame made that will support a lot of weight and be proportionate to itself.

"Being a toy collector and hobbyist, I could not resist this awesome action-figure building system. I wouldn't mind seeing some new connectors, liftarms, and other pieces, though, and pins/axles in black again. One of the main problems I see is getting proportions right. Bad proportions can totally kill a BIONICLE model—no matter how skillfully built, the odd proportions will stick out noticeably.

"After getting a solid, proportionate frame built, I will start to fill out the body, giving it its main and accent colors over the base color of the frame. This gives the model a lot of texture, which I am fond of. Color layering is something I have been working at for a long time, and it is very difficult to do it well with BIONICLE pieces.

"Every model I build is a learning experience. Building big isn't easy, and there are plenty of learning curves, some of which I am still getting over."

Steampunk: Pure Fan

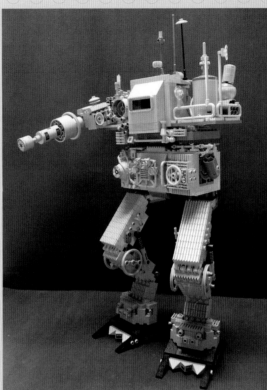

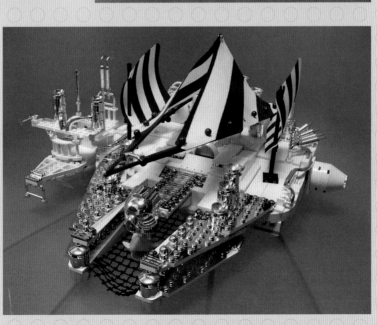

(TOP) **This magnificent monstrosity takes mecha and puts a steampunk spin on it. The model's intricate details make it stand out from the legion of giant robots.**

(BOTTOM) **What's even better than steampunk?** *Star Wars* **steampunk. This re-creation of the Millennium Falcon in white and chrome adds more than a dash of Victorian sensibility.**

136

Belching steam and sporting giant guns, this one-wheeled vehicle rolls at the command of a monocled gentleman.

Steampunk, the combination of Victorian sensibilities and cyberpunk style, is a purely fan phenomenon. There are no official LEGO steampunk models.

In his 1880 novel *The Steam House*, Jules Verne introduced the idea of a walking, steam-powered elephant, and H. G. Wells's *War of the Worlds* featured villainous aliens riding ambulatory vehicles. Steampunk is a subgenre of speculative fiction that has also been described as *Victorian Science*: a historical era that never was, where the gas combustion engine now used by machines was never made. Instead, steam power advanced, resulting in unusually advanced steam-based gadgets wielded by 19th-century gentlemen with top hats and monocles. The phenomenon has taken on such a devoted following that real-world gatherings such as the Steamcon convention and Burning Man draw attendees outfitted in neo-Victorian costumes.

Guy Himber, a LEGO builder and steampunk fan, explains the attraction this way: "In a modern world where everything is mass-produced and looks like it came from IKEA, steampunk is much more interesting to me."

The greatest challenge for steampunk builders is in creating the period detail that fans love. Most builders begin with a particular color palette, "big on brown and reddish brown, many

shades of gray, oodles of pearl-colored parts in gold and silver," said Himber. But choosing the right elements is also important. "I freely scramble DUPLO, TECHNIC, BIONICLE, and standard bricks," Himber said. "I like taking parts that most other builders overlook or consider 'junk' and making them into something interesting."

Stovepipes, dials, valve wheels, and exhaust ports become important parts of the machines, but ornamentation is important, too. Most builders try to depict polished brass and hand-carved wooden scrollwork in their models.

Unlike many other LEGO model-building genres, steampunk often requires research. "If I am going to build a giant crab," Himber explained, "I am going to be looking around the book collection and do some Photoshop proportion studies before I start throwing the bricks around." True, mechanical crabs may not have existed in Victorian days, but a builder will want to make the buildings, clothing, and other props seem authentic.

One of the most appealing aspects of steampunk is the opportunity to re-create *any* story in steampunk. Some builders have depicted the Axis forces of World War II as Victorian evildoers, while others focus on redefining popular movies. One of the most enduringly popular subgenres is that of "SteamWars," which mixes elements of the *Star Wars* movies with steampunk. Imagine monstrous Imperial Walkers belching steam and packing Gatling guns and gunpowder cannons, or X-Wing fighters as prop-driven biplanes. Matt Armstrong's steampunk Millennium Falcon transforms the classic vessel into an ornate white-and-chrome steamship complete with billowing sails and a net holding a captured shark.

Guy Himber's "Clockwork Coconut Crab" makes masterful use out of unexpected elements, including **TECHNIC** and **BIONICLE** claws that fit seamlessly into the model's look.

ApocaLEGO

Amid the ruins, heavily armed and armored forces battle over the remaining resources. Oblivious to the carnage, flowers grow between pieces of wreckage.

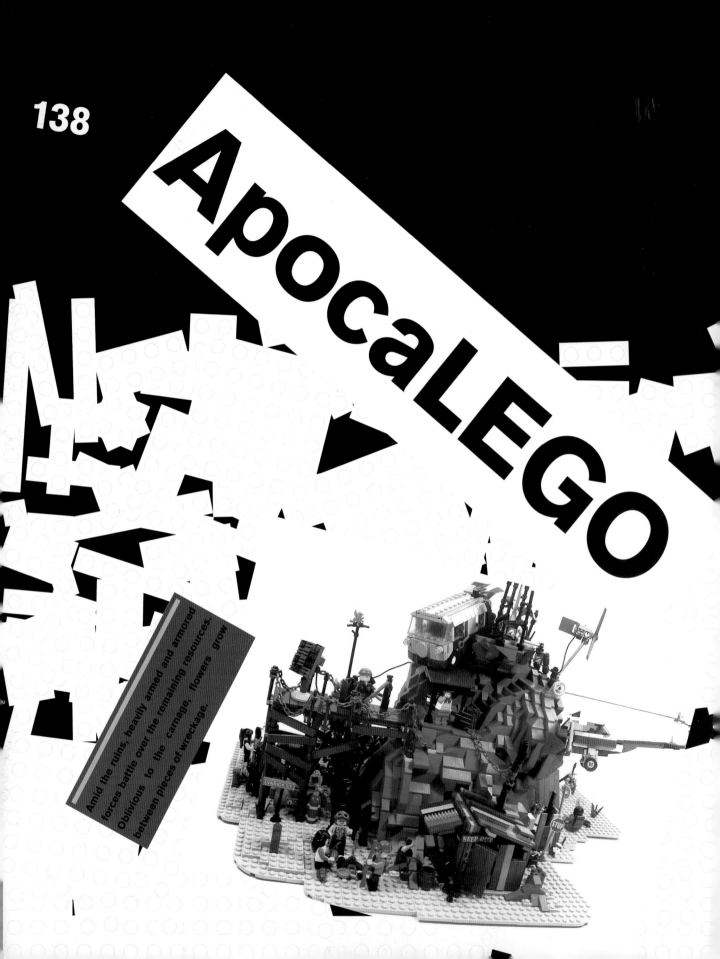

Steampunk is pretty crazy, but what could be more "out there" than imagining the apocalypse? Although the end of the world is not a theme commonly found among children's toys, depicting it in LEGO form offers the opportunity to create some outlandish scenes.

ApocaLEGO builders typically show crumbling urban scenes populated by militaristic survivors defending the last vestiges of civilization from the usual ruthless bikers, maniacs, and zombies.

Of course, before builders can create a model, they have to imagine how the apocalypse came about. World War III with nuclear winter? Robot uprising? Global famine?

Details are extremely important. Building a structure to look like it has crumbled or creating a gigantic crack in the pavement takes a great deal of skill. Subtle touches, such as a grey bird lazily watching a street battle, can often make the project.

One of the most well-known apoca-LEGO builders is 17-year-old Kevin Fedde, who goes by the name Crimson Wolf in the online LEGO community. He started sharing his creations on the Internet in July 2008, and his work was rapidly recognized for its intricacy and elegance.

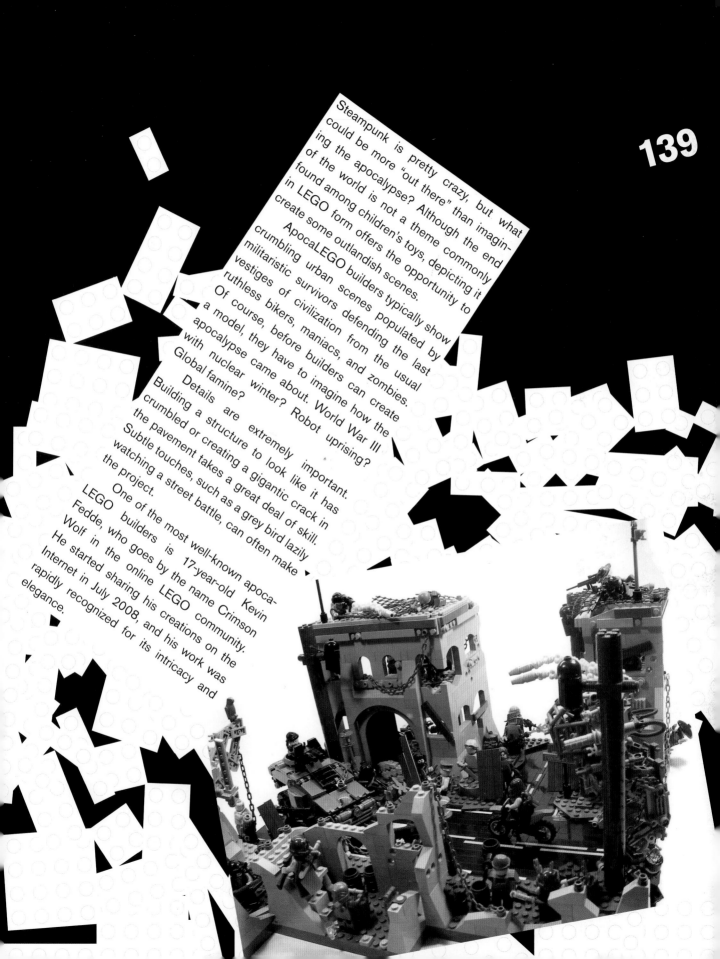

"My favorite details to add are to put things in that no one expects," Fedde explained. "Like a fire hydrant in the middle of the desert or a pink flower in a bomb crater."

Fedde's apocaLEGO models demonstrate serious thought and creativity, with tantalizing details hinting of a bigger story beyond the combat. One model has makeshift wind turbines and solar panels set next to old street signs and crushed buses. Statues and the arched entryway of a former bank, ignored by the desperados, tell of past grandeur. Meanwhile, a defender crouches next to a detonator, waiting to set off a booby trap.

If the final chapter of our planet is the apocalypse, surely visualizing this catastrophe is the last word in imagination.

LEGO Art

Most of us have a hard time defining the boundaries of art. Imagine the skeptical visitor squinting at one of Mark Rothko's abstract paintings, muttering how his "kid could have done that," and wondering how it merits being in a museum. When does a scribble become worthy of being hung in a gallery? And, more to the point, can an assembly of LEGO bricks be classified as art?

One's immediate thought might be no, LEGO is a child's toy. Of course, it can't be compared to Vincent van Gogh's oils or Henry Moore's granite. It can no more be a masterpiece of art than a Speak & Spell, right?

But perhaps that's changing. In the past decade, numerous artists have begun to dabble in LEGO art. Some use the bricks as a sculptural medium, while others depict LEGO images in more traditional formats. One thing is for certain: LEGO has found its way to museums and galleries, and it's not leaving anytime soon.

Olafur Eliasson's Collectivity Project

What if the artistry inherent in LEGO bricks came from the act—rather than the results—of building?

In 2005, installation artist Olafur Eliasson arrived in Tirana, Albania. He set up shop in the town square and poured three tons of white LEGO bricks onto a series of tables, inviting passersby to come and play for 10 days in what he called the *Collectivity Project*. Eliasson wanted them to build the future Tirana.

Albania, the second-poorest nation in Europe, found itself cut off from the rest of the world by an oppressive Communist dictatorship lasting more than 50 years. It wasn't until 1990 that democratic freedoms such as the right to set up opposition parties were obtained. Furthermore, the infrastructure was in ruins, and the government was rife with corruption. Albania needed help finding its way.

"Being able to think spatially and formulate your ideas through a space-based process is an important aspect of realizing and defining your identity," Eliasson wrote in his artistic statement. He saw the white bricks as a simulation of what the people of Tirana went through every day: visualizing the society they wanted and how they fit in it.

Schoolchildren, taxi drivers, and pensioners gathered around the tables of LEGO to play, building up structures, altering them, and tearing them down. "Blending the past and future," Eliasson's statement continues, "and metaphorically renegotiating where you currently stand and who you are as an individual, can be clarified by a spatial awareness of your surroundings." If you create a LEGO tower, in other words, it remains until someone destroys it. If you tear down your neighbor's structure, he'll have to rebuild it.

Eliasson (known primarily for *New York Waterfalls* in 2008 and his well-received *Weather Project* featured in London's Tate Modern in 2003) specializes in environmental art where museumgoers immerse themselves in such oddities as indoor sunsets and waterfalls that flow up. Eliasson wants visitors to do more than simply observe art; he wants them to be a part of it and be aware of the artistic process. In the *Collectivity Project*, the models that resulted weren't the art—the act of building them was.

Who Decides What Is Art?

As LEGO makes its way into galleries, it's sure to provoke a reaction from visitors who don't think it belongs there. Conversely, the artists featured in this chapter obviously disagree. Who is right?

Unfortunately, there's no easy answer. Scholars have debated the definition of art for centuries and continue to do so to this day. However, most theorists agree that art involves three criteria: form, content, and context. Roy Cook, a LEGO fan and professor of philosophy at the University of Minnesota, wrote an essay (see *http://www.twinlug.com/2009/02/commentary-lego-as-art/*) arguing that LEGO, by this definition, can clearly be called art. He uses the following criteria:

Form refers to the medium and the skill used to manipulate that medium, Cook's essay explains. A work must typically display masterful technique to be considered art. Surely numerous models demonstrate a high level of skill. As with any technically demanding medium, there will always be works that stand out as being exemplary.

Content is the statement the piece makes or the meaning behind it. Even if this message is so obscure that only the artist can grasp it, there has to be some sort of thought behind the piece. It seems like a given: If artists desire to make a statement with a LEGO model, they can do it.

Context refers to the culture and artistic tradition into which the work is placed. Andy Warhol's soup cans outside the context of Pop Art probably would not have been considered art. As Cook points out in his essay, there is no widespread artistic tradition surrounding LEGO. Just as novels were considered trash literature in the 18th century and graphic novels battle for legitimacy today, LEGO simply doesn't have the acceptance it needs to be considered legitimate art. That doesn't mean that LEGO can't be art; there simply is no long-standing body of formal, accepted LEGO art to place a model within.

Douglas Coupland Ponders Time and LEGO

Like Eliasson, author and artist Douglas Coupland sees LEGO as more than simply a building medium. There's symbolism inherent in the bricks thanks to their status as a cultural icon. In *I Like the Future and the Future Likes Me*, a 2005 exhibition in Toronto's Monte Clark gallery, Coupland included a feminized space suit, meteorites sitting atop bricks of bronzed ramen noodles, and images of LEGO *Star Wars* models.

In his exhibit, Coupland takes that quixotic futurism and turns it around. One work, *Piss Cruiser*, consists of a LEGO *Star Wars* X-Wing fighter embedded in a lump of amber-like substance, representing "a corrupted form of architectural space" and "a fossil of a future that never existed to begin with," according to his statement. "Our fantasies about the future, about time and space, the universe, the epic grandeur of a *Star Wars* era are put on display for our descendants."

But why didn't Coupland use more traditional movie images of *Star Wars* fighters instead of LEGO? Coupland seems to acknowledge LEGO's status as a means of construction, a medium that can be used to depict our fantasies and wishes. In the past, this might have been depicted with a retro ray gun or spaceship. In the present, though, our views—as well as our designs—have changed. He embraces our ability to "predict" the future with such a temporary construct as a LEGO model, which, if it were on a child's shelf, would surely fall apart within a week.

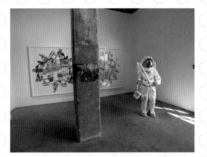

Douglas Coupland explores the intersection of present and future in a 2005 exhibition.

AME72's LEGO Graffiti

What happens if you take the LEGO iconography out of its context? Surely a LEGO model built right from the box is not art. But what if you take those same bricks and paint them on canvas or sculpt them out of clay? Is that art?

LEGO finds itself in a unique cultural position in that most people are familiar with it and have played with LEGO at some point in their lives. As such, its imagery strikes a chord in most people who see it.

One painter who employs LEGO iconography in his art is Tel Aviv–based graffiti artist AME72, who prominently features minifigs in both street-based works and pieces housed in galleries.

The artist, whose real name is Jamie Ame, depicts self-referential LEGO minifigs clutching cans of spray paint, gleefully looking over their shoulders as they lay down tags. Called "the LEGO Guy" by his peers, Ame uses minifigs in his work to symbolize the innocence of childhood. For Ame, the happy face of the LEGO minifig evokes the cheer and innocence of a child's toy. "When you're a kid, you don't have to worry about paying the mortgage or losing your job," he said in an interview. "Most of the little LEGO guys I paint represent the inner kid that just wants to have fun." His is a Peter Pan sensibility very much in keeping with the graffiti scene.

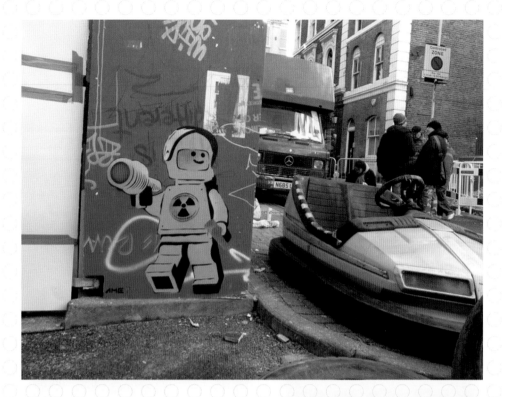

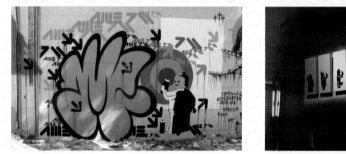

For artists like AME72, LEGO bricks and minifigs serve as symbols as well as objects.

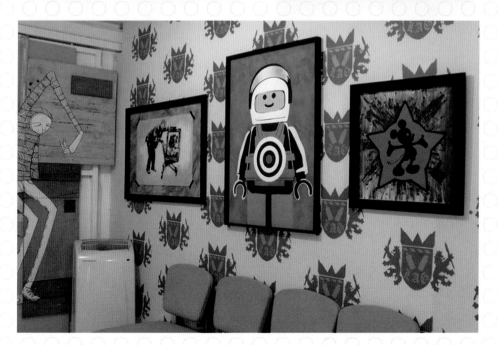

Ego Leonard

Ego Leonard places himself (as represented by a giant minifig) in the cultural context of New York City.

Dutch painter Ego Leonard doesn't simply paint pictures of LEGO minifigs; he assumes the identity of his figures. Keeping his real name and biography secret, the enigmatic artist claims to actually be a minifig explorer from the "virtual world," ignoring questions that probe too deeply into that fiction.

"My name is Ego Leonard and according to you I come from the virtual world," his website explains. "A world that for me represents happiness, solidarity, all green and blossoming, with no rules or limitations."

In 2007, Leonard's work became known worldwide thanks to a well-executed prank involving an eight-foot minifig sporting the mangled English phrase, "No Real Than You Are." Bathers at the Dutch resort of Zandvoort saw the figure floating ashore, hauled it out of the water, and set it next to the refreshment stand. Reporters wrote fevered articles about the mysterious sculpture, and ultimately the story hit the international press.

The giant figure ended up outside the door of an Amsterdam gallery featuring Leonard's show. His art depicts himself (as embodied by the figure) exploring the world and encountering society's hypocrisies and contradictions. Most of his paintings show American themes, colored by a profound criticism of post-9/11 sensibilities. For instance, in *Bragging*, a quintessentially American minifig stands next to a Hummer, with "It's not bragging if it's true" emblazoned on its chest. Another piece shows a minifig with a plaid shirt and cowboy hat finding itself tied to an oil derrick, while another painting depicts a New York cop minifig urging docile citizens to "wait here for further announcements."

Meanwhile, the giant minifig hasn't given up its antics. It washed up on a Brighton, England, beach in October 2008 in a re-creation of the Zandvoort stunt, later appearing at a London gallery show.

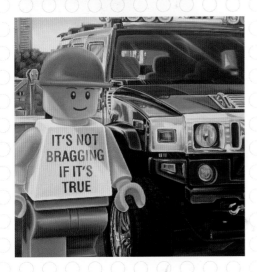

An Interview with Ego Leonard

In your piece *Conceit* you show a minifig cowboy tied to an oil derrick. Why do you use LEGO minifigs in place of people in your art?

The works of art are a translation of how people in general think, walk in line, and feel the same. People play with the smaller mini figures to get agitated. I am inspired by people.

How do you feel about the LEGO minifig's yellow coloration and androgyny—is it able to transcend race and gender? Do more recent designs that provide lipstick for "female" minifigs and approximations of real skin colors take away from minifigs' universal appeal?

Yellow is just a color. Just play and be happy, I tell everybody.

Tell me about the event where the big minifig "floated ashore" at a beach. That was all over the news in Europe and, to a lesser extent, the rest of the world. What was that all about? Publicity? Performance art?

That is still the biggest mystery.

Tell me about the message "No Real Than You Are," written on the figure's shirt.

"No Real Than You Are" tries to make a question mark to everybody in the virtual world. Is the appearance of a giant LEGO-man in this world not just the same as people making an appearance in the virtual world?

Where is the figure now?

I am in the Netherlands right now. Nice people, very open minded. I have got a lot of invitations from abroad, so maybe I'm going to travel to another country later this year. If you want to make my statement stronger, please don't see me just as a figure.

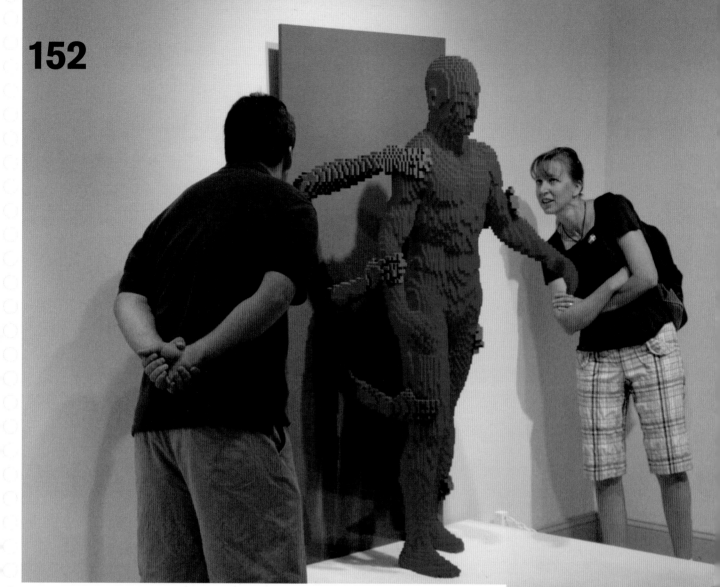

Nathan Sawaya's The Art of the Brick

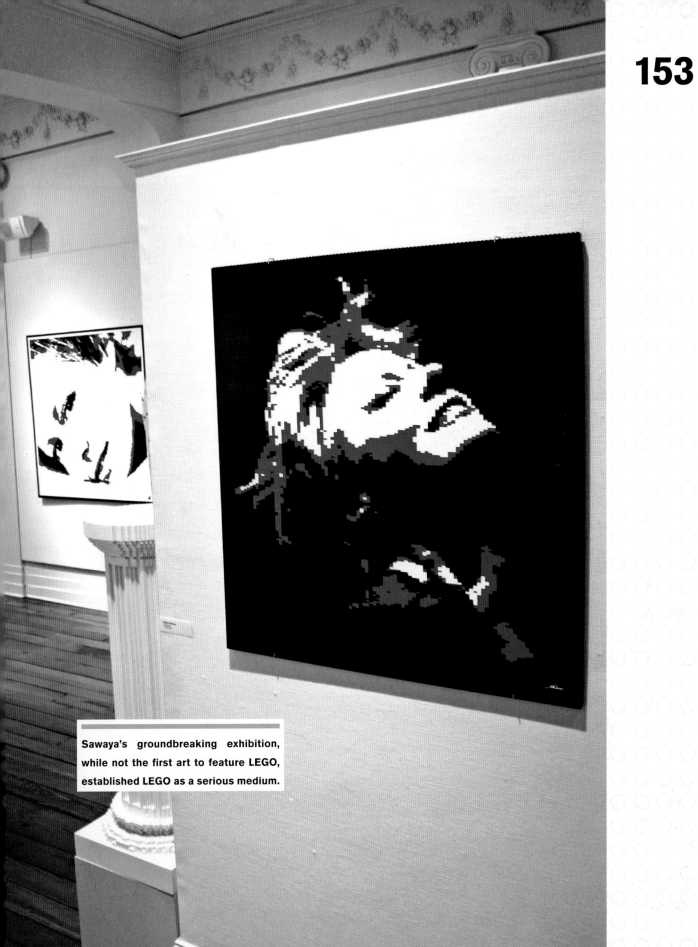

Sawaya's groundbreaking exhibition, while not the first art to feature **LEGO**, established **LEGO** as a serious medium.

While such "recognized" artists as Coupland and Eliasson make waves by incorporating LEGO into their artwork, no one has done more to advance the concept of LEGO as its own artistic medium than Nathan Sawaya. Sawaya convinced the Lancaster Museum of Art to let him run *The Art of the Brick*, and it became the first museum exhibit to consist solely of LEGO creations.

The show debuted in April 2007 and quickly was signed to exhibitions in Illinois, Wisconsin, Connecticut, and Florida. *The Art of the Brick* has run continuously since its debut, exhibiting at modern art museums and galleries as well as malls and skyscraper lobbies.

Sawaya, a former lawyer turned LEGO Certified Professional, makes a living from his LEGO creations, with well-heeled clients requesting brick sculptures of themselves or their products. He built a half-sized Chris-Craft speedboat for the 2005 Seattle Boat Show and a working air conditioner for Carrier. The 2008 Neiman Marcus's holiday catalog featured Sawaya-built LEGO sculptures selling for $60,000 each. His work has even been featured on *Extreme Makeover: Home Edition* as well as *The Colbert Report*.

The Art of the Brick is a whole different category than such commercial projects or even the creations of a hobbyist. Forget models of bridges and office towers. This show features surrealist statues; featureless, monotone humanoids that claw their way out of boxes or explode from the floor; disembodied hands the size of llamas; portrait mosaics; and abstract geometric shapes. LEGO isn't just a part of the show; it *is* the show.

Although some might see *The Art of the Brick* as something of a gimmick, it undeniably exposes us to the notion that LEGO can be a serious artistic tool. Some brick artists have broken into the gallery scene, but none has brought such legitimacy and mainstream appeal as Sawaya.

All the artists detailed in this chapter recognize that LEGO carries with it a cultural currency that makes it intriguing. "I have sculpted with more traditional media such as clay and wire," Sawaya said in an interview, "but LEGO is something that I enjoy working with because people relate to my sculptures in some way. Most folks don't have large slabs of marble in their homes, but they have played with LEGO bricks at some point. They can relate to this toy and are amazed by what can be done with it."

When a visitor sees a Monet, such talent seems unattainable, but we can relate to a sculpture or mosaic built out of LEGO bricks. We can take it apart in our heads and visualize the individual bricks. Sawaya deliberately reinforces this by using classic System bricks in his sculptures and avoiding more oddly shaped and uncommon elements. He *wants* museumgoers to see those familiar 2×4 bricks they played with as children.

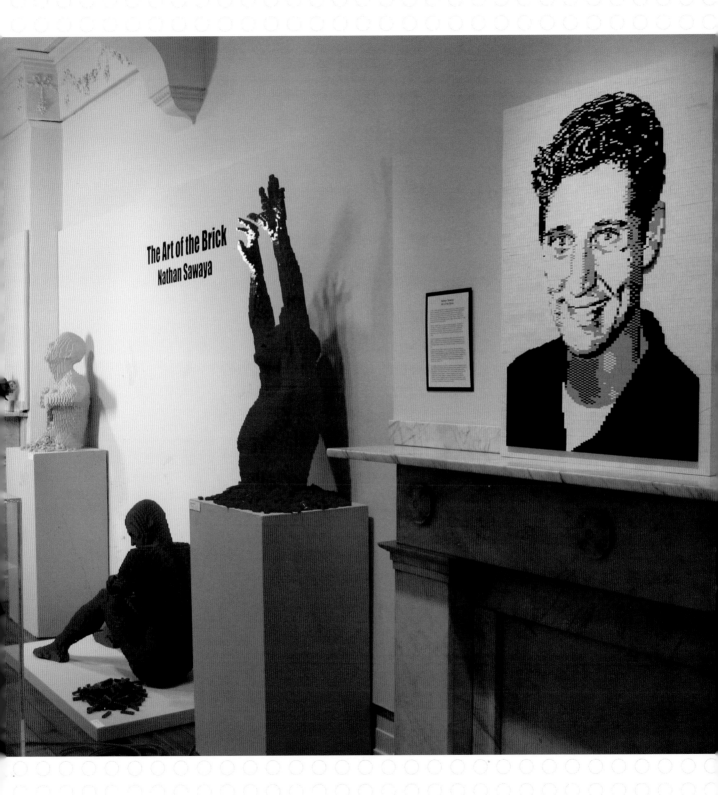

156

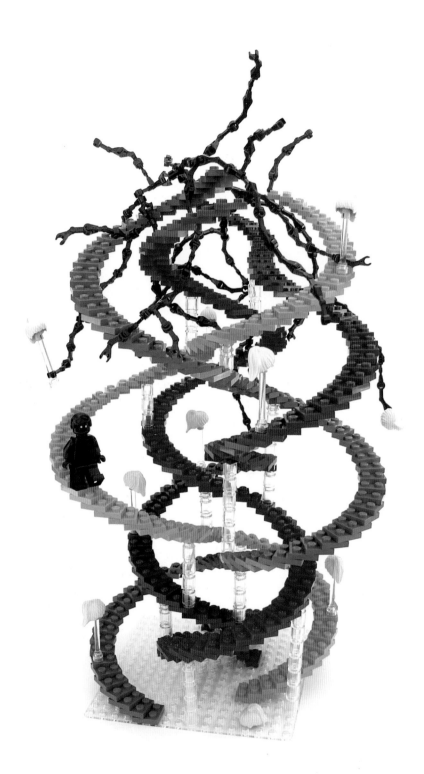

Sublime Building

When does a masterful LEGO model become art? Medical student Nannan Zhang combines incredibly precise builds with surrealism worthy of Max Ernst or Salvador Dali. When questioned about his motives for building, Zhang talks about letting loose his dreams and ideas about the medium he knew best: LEGO. "It is a way to express my ideas, channel my emotions, and construct the images that I see and dream," he told *BrickJournal*. "In surrealism, I am free to create anything, and the lesser sense it makes, the more it looks right."

Zhang creates dark, confusing visions of torment and violence, like Hieronymus Bosch's nightmares in brick. *Cry of Dreams* depicts a futuristic grey city populated by featureless humanoids experiencing a variety of torments. One figure stands at a precipice, about to leap, while another falls victim to crimson scorpions. Meanwhile, a burst of tentacles pulls the figures to a different doom. *Distortion* features a complicated sculpture consisting of multiple interlocking spiral staircases. Biomechanical tentacles hover over the entire assembly.

Zhang's creations contain so much symbolism that it's tempting to parse each and every detail. He has admitted mixing the deeply personal with more universally significant imagery in his creations, making any sort of analysis problematic. In fact, the very surreal theme he employs is something of a happenstance. "My first creation in surrealism came by accident," Zhang told *BrickJournal*. "I tried to build a staircase but ended up with a set of stairs that looked more like a ribbon." From that starting point, he began to explore, eventually branching out into a category he calls "Black Fantasy"—sinister mechanisms swarming like an infestation of robot spiders, every model pitch black except for peering orange eyes.

While Zhang may lack the credentials of established artists and LEGO might not have the prestige of oils, it could be argued that Zhang's perfectly constructed models and immaculate photography stand out as genuine works of art.

When does a masterfully executed LEGO model become art?

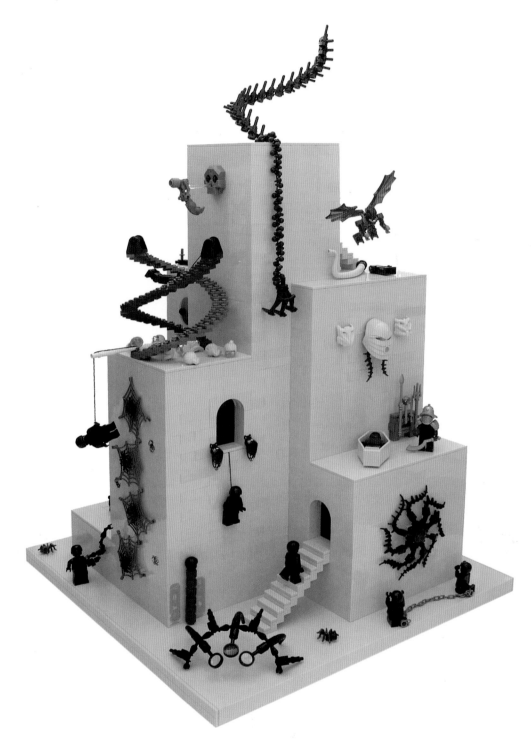

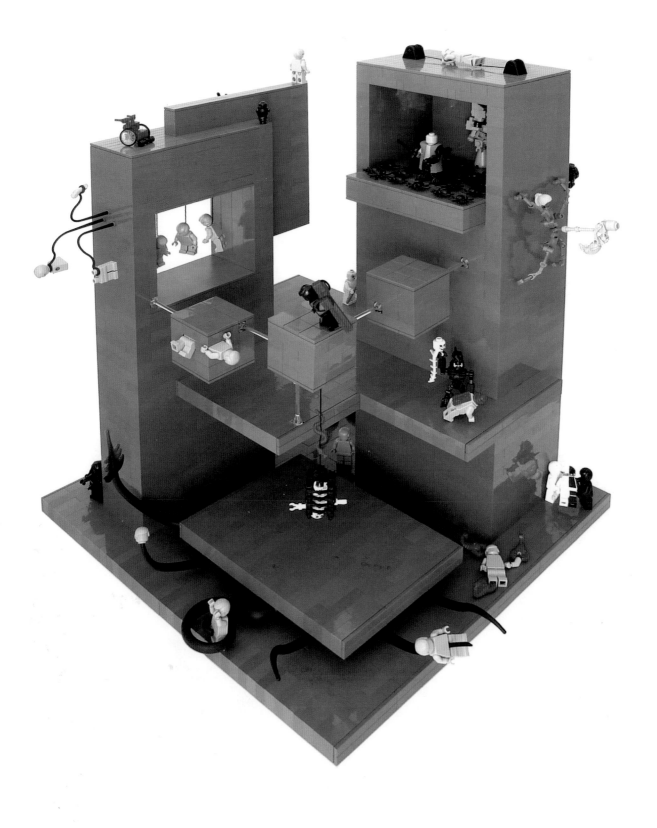

Zbigniew Libera's LEGO Concentration Camp

Zbigniew Libera's fake sets make a statement by juxtaposing the innocence of a child's toy with the horrors of genocide.

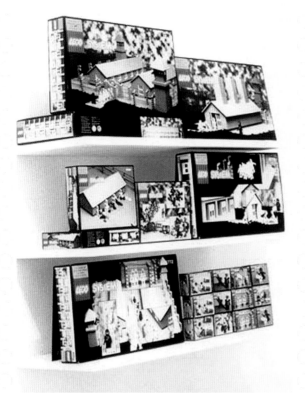

No matter how they use it, artists who use LEGO in their work face the reality that LEGO is a toy. It therefore carries an innocence about it that can startle when it's used to depict something horrible.

Take the work of Polish artist Zbigniew Libera. *Konzentrationslager*, Libera's most notable work, consists of fake LEGO packaging depicting a rather shocking product line: a Nazi concentration camp. His mock sets explore every ghastly aspect of a death camp. One package shows long grey blockhouses with sinister black-clad guards. On another box, skeletal prisoners (he uses undead minifigs from the Castle line) stare blankly through barbed-wire fences. Another shows a figure being strung up on a gallows, while on another package, captives are tortured by skull-faced physicians wielding electric probes. Crews of captives drag the bodies of the dead into a crematorium while other victims are buried in a mass grave. The packages feature authentic-looking LEGO markings like warning labels and logos and include text claiming that the LEGO Group sponsored the art. (The LEGO Group did donate the bricks.)

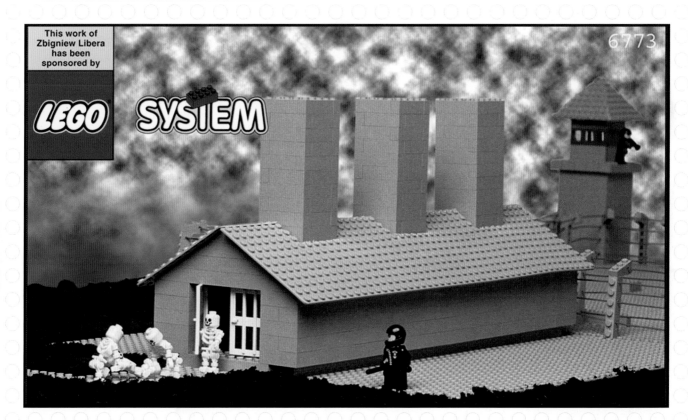

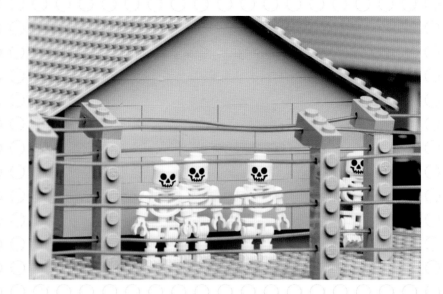

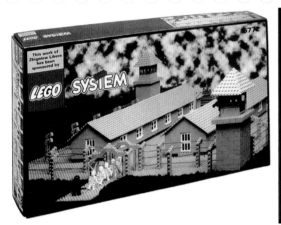

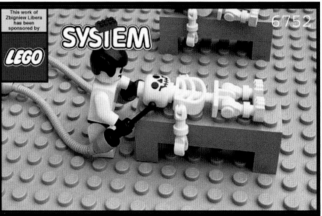

From the beginning, *Konzentrationslager* caused a huge sensation, with viewers split on whether it was an important work or a travesty. Depicting genocide with a toy made people uncomfortable. Some Holocaust activists saw the work as trivializing the experiences of survivors, while others disagreed. The Jewish Museum in New York City displayed the sets for several months in 2002 as part of an exhibit on Nazi imagery in modern art.

Even the LEGO Group joined in the criticism, complaining that Libera hadn't told the company what he was intending when it donated the bricks and that this contribution didn't constitute sponsorship as implied by the packaging's labeling. The LEGO Group tried to get Libera to stop displaying the work, backing down from its pressure only after the artist hired a lawyer.

In 1997, Libera was invited to attend the Vienna Biennale, the century-old contemporary art exhibition that is considered one of the most prestigious in the world. However, the invitation came with a catch: He had to leave *Konzentrationslager* behind. That left him in a quandary.

On one hand, the Biennale was one of the most important exhibitions in the world and a huge honor to attend. However, Libera, who had spent a year in a Cold War–era prison for drawing cartoons lampooning Communist leaders, had a heartfelt opposition to censorship. After a sleepless night, he decided that if he couldn't choose which works to bring, he wouldn't attend the Biennale.

**Telling
Stories**

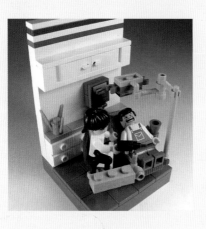

In the tiny canvas of a vignette, Big Daddy Nelson tells a story.

In Chapter 6 you saw how artists use LEGO bricks as a medium to channel their imaginations. Although most builders don't have "big-A-art" intentions, the result is the same: They imagine something and use LEGO to create their vision. Many such models lack any particular meaning. When you build a house, it doesn't have to be Grandpa's rickety old Victorian with a ghost in the attic; it can be merely a house. But some builders use LEGO to do more than simply make an object. They want their model to relate an emotion, to recount a legend, or to inspire viewers to imagine what happens before and after the frozen moment depicted in the model. In short, they want to tell stories.

(1) **Some vigs cheat a little with the footprint restriction. This excellent model tells a great story while allowing elements to extend beyond the traditional boundaries.**

(2) **Two copies of a map make for an interesting confrontation when the treasure hunters meet.**

(3) **This model features the classic vignette elements: an 8×8 baseplate and a story.**

(4) **This vignette employs a technique called a *MOC box*, where the entire model is contained inside a transparent box.**

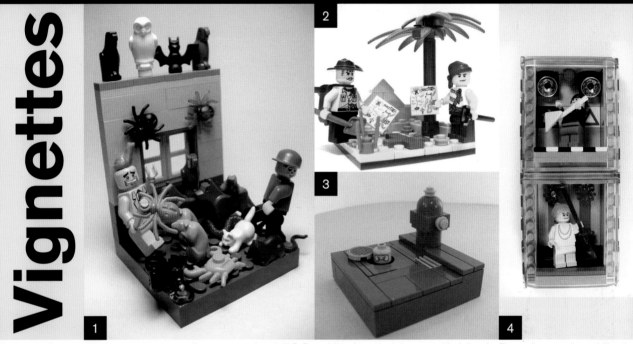

Vignettes

Perhaps the most elegant way to tell a story using LEGO bricks is to build a *vignette* (often called a *vig*), a tiny LEGO model that serves up a single snippet of drama.

Vignettes started in Japan and quickly spread to the rest of the adult building scene in just a few years, debuting on Brickshelf.com in September 2004.

The footprint of a vignette is usually a six-stud by six-stud or eight-stud by eight-stud square. Within this footprint, a builder creates a scene or a slice of life. In this respect, a vignette is like a one-panel cartoon. As with any voluntary set of rules, however, buy-in varies from fan to fan. Some vig builders see the footprint restriction to be inviolable, while others retain the 6×6 or 8×8 baseplate but allow parts of the model to hang over the edge.

Vigs are designed to make it easy for anyone to create a scene. Their small size makes it easy to get the needed parts and to take the finished models to events. However, the critical element of the vig is the story told, by necessity,

with a bare minimum of bricks. In Peter Lewandowski's vig (above #2), two rival treasure hunters arrive at the big red X on the ground, both sporting copies of the same map.

Although a vig's footprint is restricted, there is no height constraint, so many a vig has shown multiple levels, whether by building tall towers or cliffs or building deep caves or sea bottoms. In Big Daddy Nelson's two-level vig (above #4), a woman bangs on the ceiling with a broom, while a young man practices on his electric guitar in the apartment above.

Many vigs are humorous in nature. There has been a series of vigs based on Gary Larson's cartoons, as well as on the misadventures of Joe Vig, a hapless minifig who is typically depicted right before some terrible fate befalls him. Other vignettes have been historical in nature, capturing famous moments. Still others are built for fan themes or LEGO themes, with spacemen or knights, or even horror.

Back Stories

Sometimes the stories builders imagine exist only in their heads and merely serve as inspiration while building. Frequently, however, the story takes on such importance with creators that they actually make the effort to write it.

When Adrian Florea created a floating castle model he felt compelled to explain how such a thing could exist: "'Lapis volat banalis' is a species of rock that floats only after all water dries out of it," his description reads.

Other fans see the back story as an integral part of any project, adding a deeper level of detail and plausibility that can't be put into the model. The builder may provide mere technical details of the imagined construction, such as what guns a giant robot sports. Beau Donnan describes the mechanical defects his steampunk "OctoWalker" model

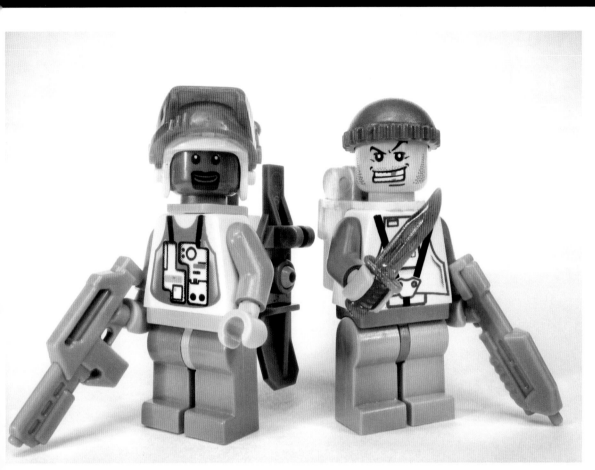

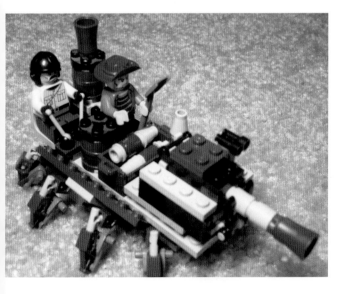

(TOP) **"It's been a decade and a half since the Ice Planet was found, and the explorers have come to realize they weren't prepared for all the dangers of this frozen world."**

(BOTTOM) **"[T]his vehicle can navigate difficult terrain and take up firing positions on steep ground while keeping the platform stable…the slide-rail-mounted cannon may be easily turned 360 degrees and fired against distant targets when stopped."**

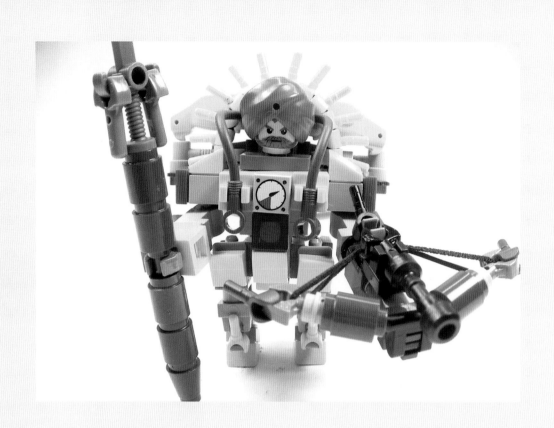

"In the distant future, sports like Cave Racing, Cyborg Racing, and Mech Racing were not the only extreme sports to rise from futuristic boredom. Here and there across the earth, people compete in tournaments and single combat in hardsuits...."

would suffer if it were real—"slow and prone to breaking down." Whereas Kevin Fedde imagines his Ubermann Hardsuit model as some sort of sporting equipment used in a futuristic society where regular sports have lost their appeal. Others aim to add emotion to a plastic model. Don Reitz's cryptic black spider robot loses its cuteness when you read the back story: "Ever present, ever watchful, they continually search for some distant inconceivable goal."

Regardless of the reasoning behind the storytelling, for those who indulge in this creative outlet, these back stories are just as vital to the building process as stacking one LEGO brick on the next.

(TOP) **"They roam in droves, aimlessly, in numbers far too great to mention; striding across the hell torn landscape of the apocalypse tormenting the minds of survivors with the mere sound of their unrelenting march."**

(BOTTOM) **"Nedleh point was discovered 40 years ago. A place of military importance, being situated at the crossroad of two of the largest empires and the Stoneguard, it is also dangerously close to the Orc-held territories."**

Comics

Some fans tell stories by assembling a model and then explaining it; other builders take the opposite approach: They write a story and then illustrate it with LEGO models. Take a photo of a minifig or small scene and throw a voice bubble on it, and you're telling a story. Thanks to economical design programs like Comic Life, even the least arty LEGO fan can get started.

Ironically, many of these comics have little in the way of complex LEGO scenery and feature only simplistic models. For these builders, the minifig provides all the inspiration needed to spin a tale. One advantage to this ease of entry is that a LEGO fan eager to tell a story need not invest much time and effort into putting out the result. Often, the entire strip can be told in one diorama, with changes to minifigs' positions representing the majority of the rebuilding.

Conversely, more advanced—or ambitious—builders go all out with their comics, putting as much work into the backgrounds of the individual panels as more traditional builders put into their convention-bound models. Creations taking days to design and build show up for a single frame, and specialized parts are purchased by the bucketful to accomplish a brief effect.

The following are some examples of LEGO comics.

Grunts

Artist:

Andrew Summersgill
(Doctor Sinister)

Site:

http://www.tabletownonline
.com/grunts.php

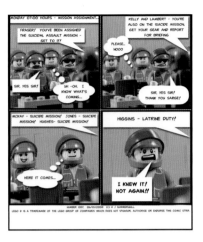

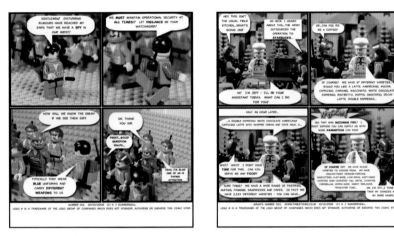

Andrew Summersgill's *Grunts* tells "everyday stories of army folk" serving in Baker Platoon, Easy Company, 1st Battalion, 44th Infantry Division of the armed forces of Tabletown, his fictional LEGO city. Summersgill finds inspiration from his day job, serving as the military history editor of *Armchair General* magazine, a periodical devoted to military war games.

Reading a little like *Beetle Bailey* meets *G.I. Joe*, Summersgill's comic provides a humorous twist on the drudgery and danger of military life. One strip has soldiers pinned down in a firefight, arguing over whether *clip* and *magazine* are synonymous. In another, the men hear the news that the Tabletown navy has purchased two new super-carriers, so the grunts will be getting skateboards instead of jeeps and tanks. Like many LEGO web comics, *Grunts* isn't afraid of switching things up, occasionally telling the stories of Tabletown's medieval days or introducing us to the city's evil overlord, Dr. Sinister.

Summersgill has taken *Grunts* to a level most amateurs never see, selling a 64-page printed compendium of the comic, with profits going to a military history museum.

Derek Almen's *Nerds in Space* has a simple premise: a talk show hosted by Almen's alter ego, Captain Redstorm, with guests invited from the ranks of LEGO fans mixed with assorted fictional characters. Sometimes they talk about fan-centric matters such as steampunk building and vignettes; other times they enjoy more esoteric — one might even say absurd — topics. In one strip, minifig versions of video game character Super Mario and his nemesis Wario wrestle next to Redstorm's desk. In another, Redstorm gets sucked away from the talk-show set and finds himself in the present day (the talk show is set in the future) and has to find his way back to his time. Typically, Almen's four-page episodes devolve into silliness long before the final frame.

Nerds in Space

Artist:

Derek Almen

Site:

http://www.tinyurl.com/ nerdsinspace/

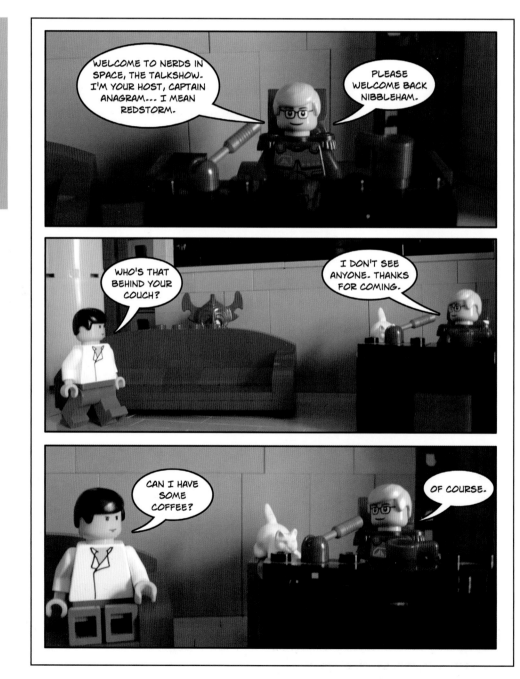

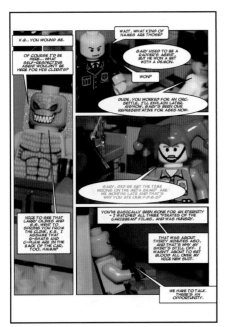

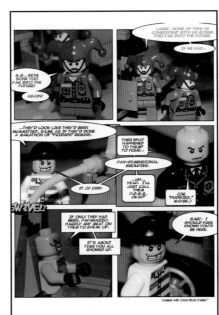

173

Meta Gear

Artist:

Lich Barrister

Site:

http://www.tinyurl.com/metagear/

A schoolteacher calling himself Lich Barrister was already a veteran of the LEGO comics scene with his *Advent Calendar* comic, which played off of the annual LEGO holiday sets. With *Meta Gear*, he took a different approach, deliberately evoking a sense of literary murkiness with a multithreaded plot involving the Time-Genre Secretariat, an office that specializes in "genre policing." The author explains, "There's no play, no change, no innovation. Of course shielding against plot twists would be mandatory—but once twistiness becomes standard, then there's no shielding against it."

From the beginning, Barrister wanted a complex story. However, when he was faced with the limitations of the comic format, he was forced to employ Captain Exposition, a Secretariat official whose job is to explain the ins and outs of the plot, but instead of making everything clear, he spins a lengthy tale involving cross-dimensional Shakespearean actors and their improbable off-stage careers.

Mr. Amperduke

Artist:
Bob Byrne

Site:
*http://www.clamnuts.com/comics/
amperduke/*

Bob Byrne's *Mr. Amperduke* is a rarity among LEGO comics. It features drawn representations of LEGO minifigs rather than photos of real ones. In Chapter 2 we saw one example of this format, *AFOLs*, which depicts the adventures of LEGO fans drawn as minifigs. Byrne's comic describes the adventures of the title character, an elderly humanoid who creates Amperville, a city of LEGO-like miniature people in his basement.

One day, Mr. Amperduke's grandson Scampi comes to visit. "After a misunderstanding he takes revenge on his grandfather by throwing a vicious insect into Amperville," the artist's website explains. "The tiny citizens must battle against the rampaging monster while Amperduke rushes home to save them. Can he make it home in time? What is the mysterious secret weapon laying in wait and ready to battle?"

Byrne, based in Dublin, grew frustrated trying to navigate the comic book industry and self-published *Mr. Amperduke* as a graphic novel. Available on the artist's site, the book contains more than 2,000 frames of action but without a single line of dialogue. The story is told in pictures only.

(ABOVE) **Andrew Becraft's "Extra-ordinary Rendition" makes a cutting comment on the US government's practice of kidnapping wanted people without regard for laws and rights.**

Political LEGO

Looking at vignettes and other brick creations, it's easy to assume that all stories told with LEGO are of a fictional sort. Some builders, however, take advantage of the handy medium to make a point about the real world with statements far more meaningful than mere LEGO building.

Andrew Becraft, editor of the fan website The Brothers Brick (*http://www.brothers-brick.com/*), builds models to express his opinions on matters ranging from race relations to gay marriage. He makes a statement about controversial topics simply by building a model and sharing it with the world. Some would rather that certain subjects go away, but simply by creating models that make a statement, Becraft keeps the discussion going.

Sometimes, however, he hesitates. In the vignette shown above, Becraft depicted an event delicately described as a "rendition" — US agents apprehending a wanted man in another country, without regard to laws or treaties.

He debated sharing the vig for a long while. "One reason I've held off posting this is that it just feels wrong," he wrote on the creation's Flickr page. "That's because what it represents is wrong. Kidnapping people — no matter how evil some of them may indeed be — and shipping them off to 'friendly' third-world countries for extrajudicial imprisonment or even torture is abhorrent."

Diorama Storytelling

While vig builders cram an incredible amount of information into a small footprint and enjoy the challenge of limiting themselves to an 8×8 plate, other builders let the model be the size it needs to be to succeed. This category of building is called the *diorama*.

Some viewers, mindful of the mastery shown in vignettes, might accuse the builders of these larger scenes of skimping on the detail, but the best of these models show just as much detail and story, if not more so; with more space, builders have more story they can tell. Ultimately, one method is no better than the other. Regardless of how big the model ends up, builder expertise trumps all.

Zombie Apocafest

Sitting on the opposite end of vignette, the "Zombie Apocafest" was a giant model that came about as a collaborative building event at BrickCon 2008, sponsored by The Brothers Brick fan website with prizes awarded to various models.

The Apocafest featured upwards of 30 participants, with dozens of vehicles and buildings created in the scene, as well as hundreds of zombie and human minifigs scattered around in a gigantic cannibalistic melee.

As with any giant model, countless tiny details make for a fascinating story. One enterprising individual has harnessed a zombie to a rickshaw, with a jar of brains dangling in front of the monster to urge it along. On one street, valiant soldiers driving armored personnel carriers hold off a grey tide of undead, while on another, a flamethrower-mounted semi (winner of the "Best Zombified Vehicle" prize) sweeps aside attacking cannibals. On the roof of the biggest and most gothic building in the diorama, a zombie Joker stands with Batman's head on a pole. In a mall-turned-war-zone, zombies chase shoppers, who desperately try to escape into the LEGO store.

There's a quarantine camp complete with tents and walls made of stacked cars and barbed wire. On the roof of the parking garage, elite soldiers prepare the final solution, a mysterious yellow crate with radiation symbols painted on it.

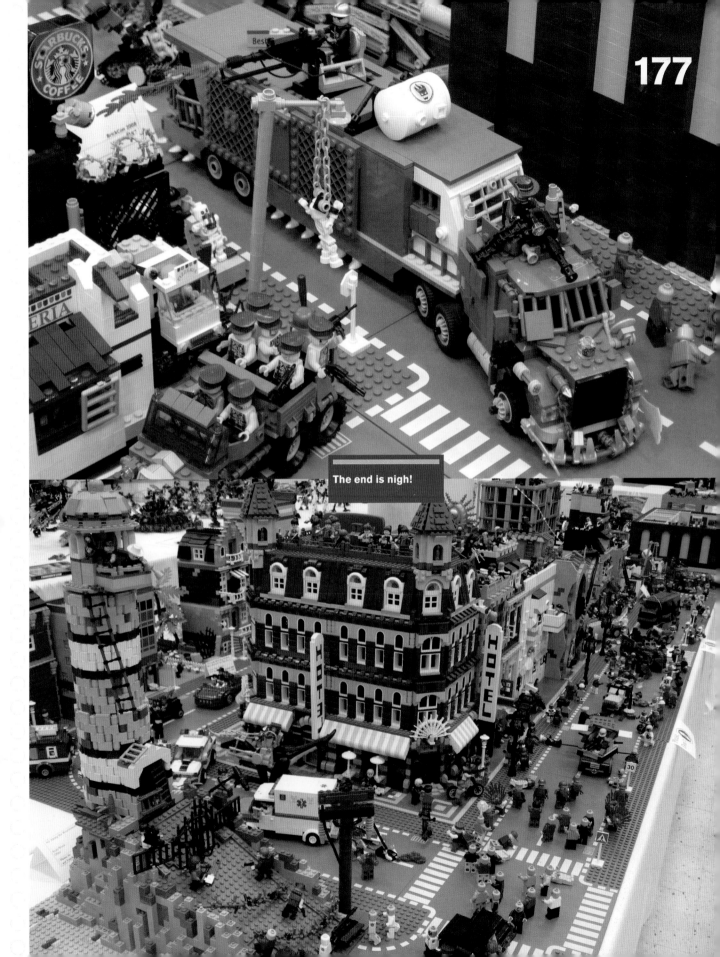

The end is nigh!

Vig builders can't build out, so they build up. Kevin Fedde borrows that technique for this model.

Club Zora

Telling multiple stories in one creation isn't just the province of gigantic scenes like the Apocafest. In "Club Zora," Kevin Fedde takes one of the coolest aspects of vignettes, building *up* rather than out, and tells separate interlocked stories. He skips the usual footprint limitation common to vignettes, going with a 16x16 plate that gives him a little more room. In addition to the titular establishment, there's a street scene outside and, more intriguingly, a gang of hobos camping out in the sewers.

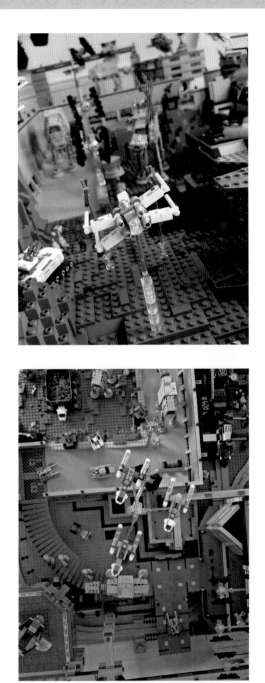

The diorama serves as the opposite of a vig. However, it can still be crammed with detail.

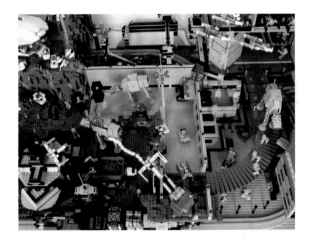

Mustaneer

As we saw in the "Zombie Apocafest," combat makes for great diorama building because there are so many stories to be experienced. Tim Goddard's "Mustaneer" diorama tells the story of an epic *Star Wars* battle, all in microscale. Wee Y-Wings strafe miniature AT-ATs, while pint-sized X-Wings and TIE Fighters square off. Here and there we see the results of the battle: An Imperial walker burns; a rebel fighter wobbles and dives, leaving a trail of smoke. Packing so much information into a sub-minifig scale is impressive, and the fact that it's true to the *Star Wars* canon adds to the accomplishment.

Not every villain can boast a creepy-looking lair, but these sure can.

Tower of Torment

A rickety, leaning tower perches on a dangerous precipice. It has all the atmosphere of a haunted house: dead vegetation, chains, and even a prisoner held in a cage. Meanwhile, a pair of villains drag a young woman into the tower.

Lewis and Clark

Not all dioramas involve LEGO landscapes; sometimes builders take advantage of the natural environment by placing minifigs or other elements into that setting.

Andrew Becraft visited Washington's Cape Disappointment State Park in 2007, the 202nd anniversary of the conclusion of Meriwether Lewis and William Clark's epic trek. Being a LEGO fan, Becraft had little choice but to commemorate the occasion by retelling Lewis and Clark's story in bricks.

In the resulting photo set (*http://www .tinyurl.com/becraft/*), Becraft's minifigs underwent a number of historical and decidedly nonhistorical travails — walking the beaches of Cape Disappointment, getting chased by an oversized pug, and then experiencing visions while relaxing on enormous psychedelic mushrooms. Further reinforcing the story, Becraft supplements the Flickr photos with humorous captions from the explorers' viewpoint.

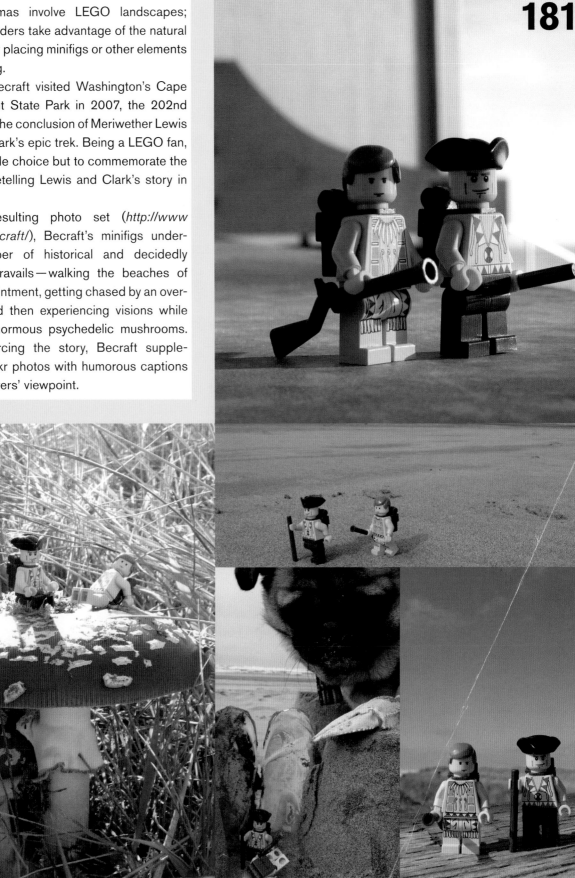

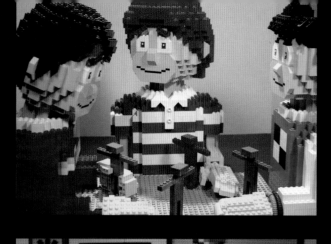

These stills from David Pagano's *Little Guys* shows the fantastic detail possible in a LEGO-animated film.

Brick Flicks

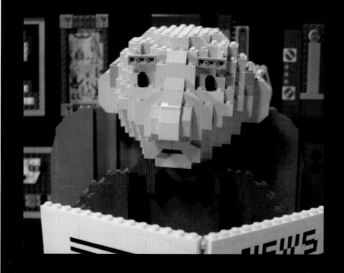

Some builders' urge to tell stories with their LEGO models becomes a hobby unto itself. Take brick flicks, home movies filmed on LEGO sets with LEGO figures serving as actors. With the advent of cheap movie cameras and inexpensive stop-motion software, LEGO fans have begun to act out their visions in short movies.

Brick flicks are a natural extension of LEGO play. All kids—and even some adults—move minifigs around as if they're alive and can talk. These videos simply record that story-telling play. Of course, recording wouldn't be possible without the help of inexpensive video cameras. With quality units sometimes available for less than $100, almost anyone can make their own brick flick. Aside from the benefits of cheap technology, the greatest boon to filmmakers has been the ability for creators to show off their work on video-sharing websites like YouTube and fan sites such as *http://www.brickfilms.com/* and *http://www.bricksinmotion.com/*.

Despite the ease of entry, however, there are still formidable obstacles to filming your own LEGO movie. Technical challenges such as stop-motion techniques, voice acting, audio and video F/X, and background music all can add to the complexity of the project. And even without these challenges, you still need to have the storytelling skill to communicate a coherent plot. One of the most surprising challenges is to acknowledge that the bricks are the medium, not the message. Filmmakers must ignore that they're working with LEGO and simply concentrate on telling a story as coherently and skillfully as possible.

As with many fan phenomena, the LEGO Group took note of these videos and made an attempt to cater to the hobby with 2001's Steven Spielberg's MovieMaker set, a 433-brick LEGO studio complete with a webcam, software, director's manual, and sound stage. The camera, while poor in quality, sported the sensible feature of being covered in LEGO studs, allowing it to be built into the model the same as any other LEGO element. Although a noble attempt (it won a Parents' Choice Award for facilitating kids' creative expression), the set was a one-time product that made only a nod to the efforts of brick flick fanatics.

Go Miniman Go

In 2008, the LEGO Group once again proved its ability to perceive and cash in on fan initiatives. The company threw a LEGO video contest coinciding with the 30th anniversary of the patenting of the minifig, offering prizes in association with Gizmodo, a technology website, with a variety of categories.

To inspire entries, the company filmed its own ode to the minifig, an all-digital—and 3D!—web video reminiscing about events of the past 30 years such as the fall of the Berlin Wall, the popularity of disco, and the epic USA-USSR Olympic hockey game of 1980.

While production values and expertise put this flick well beyond the capabilities of most brick filmmakers, many considered it an ideal to be emulated. Watch the video at *http://www.gominimango.com/*.

David Pagano Picks 'Em

Brick filmmaker David Pagano grew up playing with LEGO bricks and found them the perfect medium for storytelling when he started experimenting with video cameras in middle school. A graduate from New York University's animation program, Pagano is currently working for Little Airplane Productions as an animator on the television series *3rd & Bird*. He also worked on the LEGO Group's *Go Miniman Go* film commemorating the minifigure's 30th anniversary. Pagano describes some of his favorite pictures:

Robota

http://www.tinyurl.com/brickflickrobota/

"Created by Marc Beurteaux, Robota is the film I've been most inspired by and is really a crowning achievement. It's a story that could have been told with any medium but just happens to have been done in LEGO. Great animation, great design, and a great sense of humor."

Brick Flick Resources

Want to try the director's chair? The following resources will help you make your vision a reality:

Advice—Beat the learning curve at Bricks in Motion and Brickfilms.com, the two biggest LEGO filmmaking websites.

Hardware—Pretty much any digital camera will work. Choose either still or video depending on your filmmaking goals.

Software—Compile stop-motion footage with iStopMotion or Anasazi Stop Motion Animator. Video can be edited using such programs as iMovie or Corel VideoStudio.

Tutorials—Bricks in Motion offers video tutorials on animation techniques. Find them at *http://www.tinyurl.com/bricksinmotion/*.

Sound FX—*http://www.brickfilms.com/resources/* offers free downloadable sound effects.

Share—Show off your project on video-sharing sites like YouTube and Vimeo.

The Magic Portal

http://www.tinyurl.com/brickflickportal/

"It has the distinction of being the earliest known fan-made LEGO film and was shot completely on film in the late 1980s by a guy named Lindsay Fleay."

Star Wars: The Great Disturbance

http://leftfieldstudios.com/TheGreatDisturbance.htm

"A wonderful mishmash of *Star Wars* fandom, pop-culture references, humor, and some surprisingly good animation. I believe it also clocks in as the longest known LEGO fan film, at something like 80 minutes total running time."

LEGO Sport Champions

http://www.youtube.com/user/LEGOsports/

"The earliest officially commissioned LEGO animated film. Produced by Budapest-based Vianco Studio in the late 1980s, LEGO Sport Champions is comprised of seven different sport-themed shorts."

History of the Minifig

http://www.tinyurl.com/minifighistory/

"My first reaction when I saw that film was, 'Man, this is way better than mine!' Nathan Wells is a huge talent in the LEGO animation community. I've spoken with him on a couple of occasions, and it's pretty incredible what he's managed to accomplish thus far, between his own films and the work he does in terms of tutorials. I'd love to have the opportunity to work with him on a LEGO animation project in the future. I think we'd come up with something really unique!"

See David's work at his website: *http://www.paganomation.com/*.

If you have a story to tell, there's any one of a multitude of ways to tell it with the LEGO brick. Film, comics, vignettes—all have become means for builders to share narratives. What's exciting is that this is only the beginning for the community, and as long as there are stories to tell, there will be old and new ways of telling them.

Micro/Macro

Joe Meno's microscale aircraft carrier uses the bare minimum of elements yet expertly evokes the original vessel.

Conversely, Malle Hawking's USS *Harry S. Truman* took a year to build, uses 200,000 bricks, and stretches over 16 feet in length.

What kid hasn't ever looked at a pile of LEGO pieces and thought it'd be a good idea to build a giant model with *every brick*? Usually these creations are a glorious mess, with pieces added for no reason other than that they are available, with every color represented in the patchwork of bricks. Still, when done well, nothing impresses like a gigantic LEGO model.

Knowing this, the LEGO Group packs its LEGOLAND theme parks full of colossal models like re-creations of historical landmarks or well-known vehicles. Builders talented enough to find their way to mainstream attention—such as professional LEGO artist Nathan Sawaya, featured in Chapter 6—invariably build big, because of that very wow factor. Even hobbyists go to great lengths to make the same impact. German LEGO fan Malle Hawking's obsession with building the USS *Harry S. Truman* aircraft carrier in minifig scale turned out to be a Herculean task requiring months of labor and countless orders of bricks. In the end, his project provoked worldwide fascination and has gone on tour throughout Europe.

Maybe these huge creations captivate because most people lack the tens of thousands—or in some cases, hundreds of thousands or even millions—of bricks that go into these models. And more than simply the inconvenience of *having* them, those bricks cost a lot of money. For example, on the LEGO Group's Pick A Brick online store, a classic 2×4 yellow brick costs just over 15¢, which translates to about $9,000 for a 60,000-piece model. Few children, except the most indulged, could spend thousands of dollars on LEGO elements. Even most adults would find the expense difficult to justify.

On the flip side, there are those builders who find challenge in building as small as possible. How small could one build a LEGO model of a car before it stops being identifiable? That's the challenge of microbuilders.

Far from Sawaya's multithousand-brick masterpieces, mini- and microscale builders strive to build a complete model with as few bricks as possible. Less than 20? Less than 10? If a brick is extraneous, it's axed.

Most microbuilders work out of the limelight—their projects rarely make the same splash that the giant models do despite the skill and precision needed to execute them. Nevertheless, although mainstream attention may be lacking, these models have tons of fans among LEGO aficionados who view this quixotic miniaturization as both admirable and challenging.

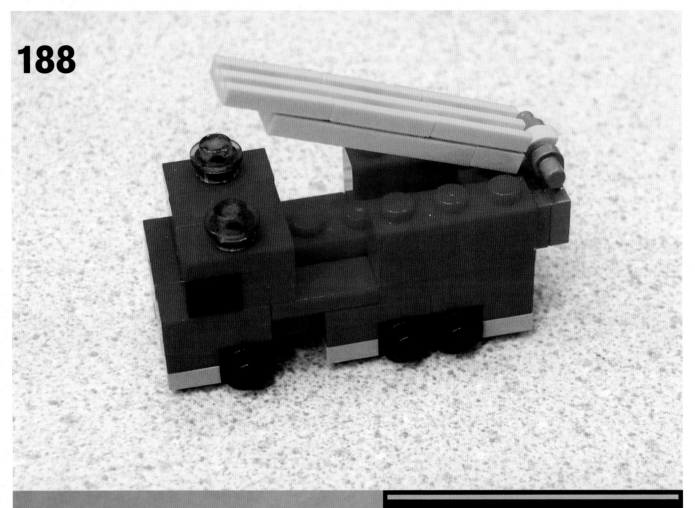

(ABOVE) **Could the brick count on this micro fire truck be reduced any further?**

(BELOW) **Andrew Becraft's microscale fighters are instantly recognizable as Colonial Vipers from the *Battlestar Galactica* television show yet are formed out of only a tiny number of bricks.**

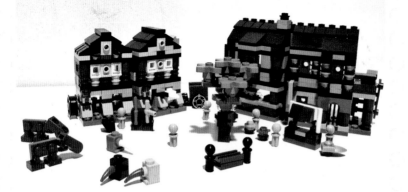

(LEFT) **Erik Smit's microscale village is an ode to the LEGO Group's 10193 Medieval Market Village set.**

Microscale

In Chapter 3, we talked about minifig scale, the measurement used to assign scale to models. Minifigs have all the advantages in the LEGO universe—everything from tank treads to bananas are sized to their scale. If fans build micro, however, they must create every single detail from scratch. Even minifigs get ditched—microbuilders typically represent people with tiny elements like 1×1 round bricks, often yellow to evoke minifigs' skin color.

However, building micro isn't all about the challenges—there are advantages as well. Although the technique requires very precise usage of bricks, the builder simply doesn't need very many of them. Well-heeled builders often speak of ordering in bulk from the LEGO Group for a special project, but one doesn't need a giant brick collection to build in microscale. Of course, each brick needs to be the *right* brick.

The greatest weapon in a microbuilder's arsenal is a viewer's familiarity with what the micromodel represents. If it's the Empire State Building, a viewer's mind fills in the blanks when viewing the creation. There's an "a-ha!" moment when the he or she realizes what that handful of bricks is supposed to depict.

One aspect of this phenomenon has builders re-creating familiar LEGO sets in microscale. Builder Erik Smit of Utrecht, Holland, re-created the LEGO Group's Medieval Market Village from the company's 2009 Castle line, transforming a minifig scale into microscale without losing any of the charm. Smit represents the town's citizens with round-ended pegs, a bowl of produce with a green 1×1 round plate on top of a brown one, and a table made with two 2×1 plates stacked atop each other. The fact that the model re-created a recognizable, official model produced a special impact.

Microbuilding is more than a specialized technique used by expert builders. It's also the theme of an official LEGO product. The company capitalized on the fad with 2005's LEGO Factory sets, which gave fans the bricks and instructions to build micro versions of an airport, an amusement park, and even the Statue of Liberty (designed by Nathan Sawaya). Ironically, the largest set, Skyline, cost $135 and contained more than 2,700 bricks, which is kind of a lot of bricks when the idea is to use as few bricks as possible.

Builders who create giant models sometimes find themselves in an odd place when determining scale, and the temptation to build at minifig scale can quickly take on absurd implications. Such creations often require thousands of bricks and take a great deal of space and money. Minifigs alone add to the costs. Say a builder decides to make a fabulous 8-foot castle. He needs to buy hundreds or even thousands of minifigs at more than a dollar each on the Pick A Brick site, never mind the cost of the bricks to make the castle.

Conversely, microscale allows builders to depict gargantuan structures without using a lot of bricks and, typically, no minifigs at all. Frequently the resulting creations fit onto a single tabletop. And, not surprisingly, the models are easy to handle and transport.

The following dioramas depict gigantic creations on a very small scale.

Microdioramas

(RIGHT) **Sean Kenney's Yankee Stadium model combines awe-inspiring size with minuscule detail. His representations of people, shown here, reduce the human form to an abstract, yet still recognizable, level. The build took three years, 45,000 bricks, and the help of a very lucky grade-schooler.**

Yankee Stadium

Even gigantic projects can involve microscale elements. Sean Kenney's Yankee Stadium model (shown in more detail in Chapter 4) uses more than 45,000 bricks yet features fantastic micro attendees, tiny service trucks, and other details. Built at 1:150 scale, minifigs simply aren't an option, so Kenney made fans and ballplayers using 1×1 bricks with round plates on top. It's not the smallest scale imaginable — some microdioramas simply use 1×1 round plates for people — but it is right for this scale.

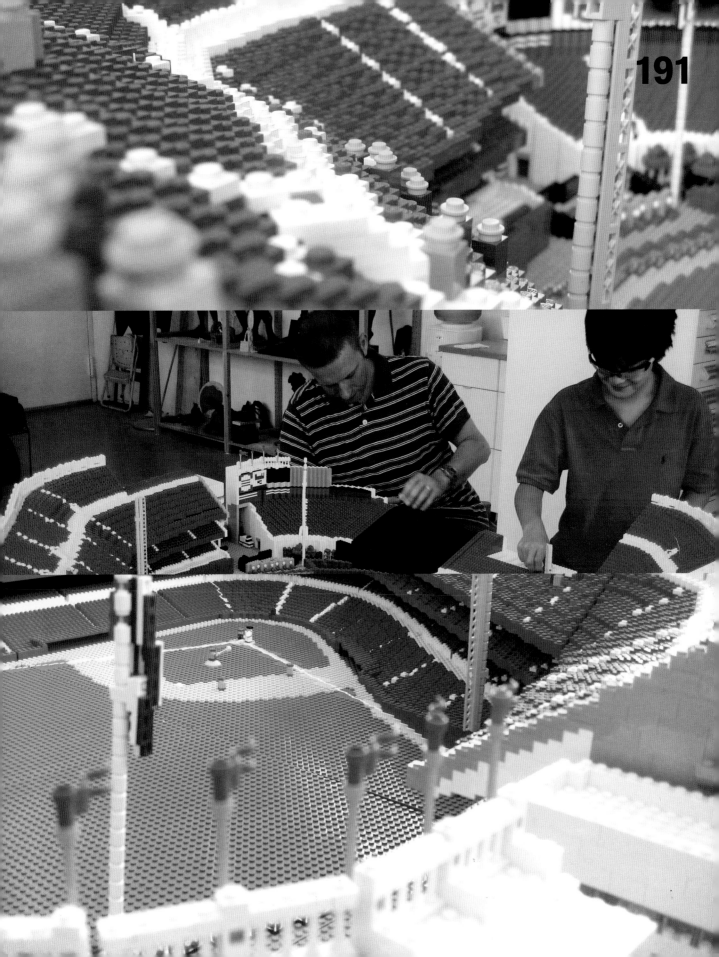

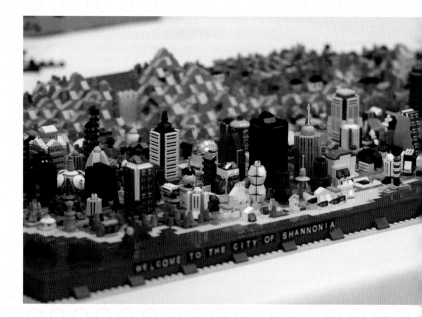

Shannonia

Shannonia, a diorama by LEGO microbuilder Shannon Young, depicts a vast, modern city at the edge of an ocean. At Young's scale, people and even cars are invisible, leaving the buildings—office towers, churches, and even dive bars—as the stars.

Young began the project as a microscale skyscraper and then built a couple of city blocks to accompany it. "I never intended it to keep growing like it did," Young said in an interview. "I always take my LEGO creations apart to reuse the pieces in other things. But I liked my little chunk of city well enough to build another…then another…then another."

In the works for more than three years, the incredibly detailed diorama uses different techniques and colors to depict each structure, making for a cityscape as complicated as any found in the real world. Young has even provided stories behind some of the various buildings on his MOCpages.com web page. For instance, for a seedy hotel, he says, "The Sunset Hotel. Don't let the snazzy paint job on the exterior fool you—this place is an absolute dump. The ambience in the Apollo Lounge, on the top floor, is best described as one of 'quiet desperation.'"

Ironically, Young began Shannonia because he wanted to build micro. "I was trying to do all these large projects and kept either running out of pieces or losing interest halfway through." He wants to double the size of the city, adding an industrial zone to accompany its existing residential and commercial districts, but for now he has set aside the project, because he just doesn't have enough space to fit the layout.

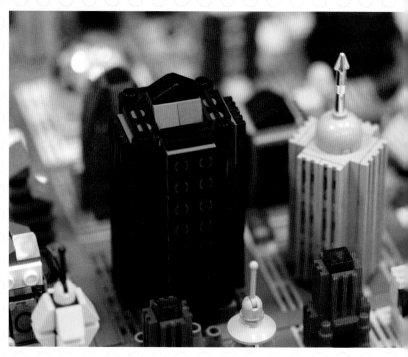

(ABOVE) **Shannon Young's Shannonia diorama uses such a minuscule scale that multistory office buildings are depicted by models the size of cigarette lighters.**

Traffic Jam

Shannonia's scale may be such that cars are invisible, but Matt Armstrong's traffic jam makes them the diorama. The model depicts 10 lanes of highway, with 5 lanes going in each direction.

Armstrong's traffic jam shows the incredible diversity possible in even a tiny model. Some vehicles have smooth plates on top, while others proudly sport LEGO studs. There are construction rigs and police vehicles and an ambulance. A double-decker bus goes in one direction while a black car looking suspiciously like the Batmobile travels the other way.

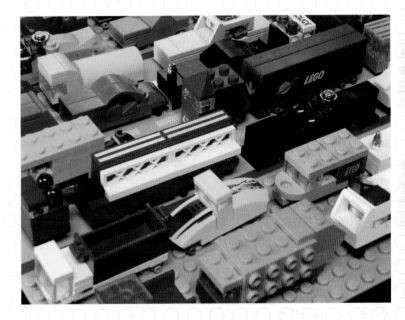

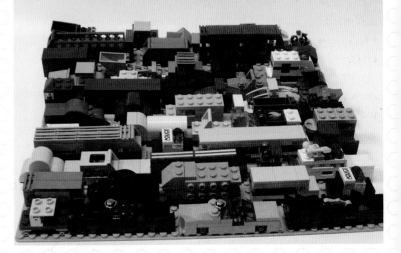

(RIGHT) **Matt Armstrong's traffic jam fits in the palm of your hand.**

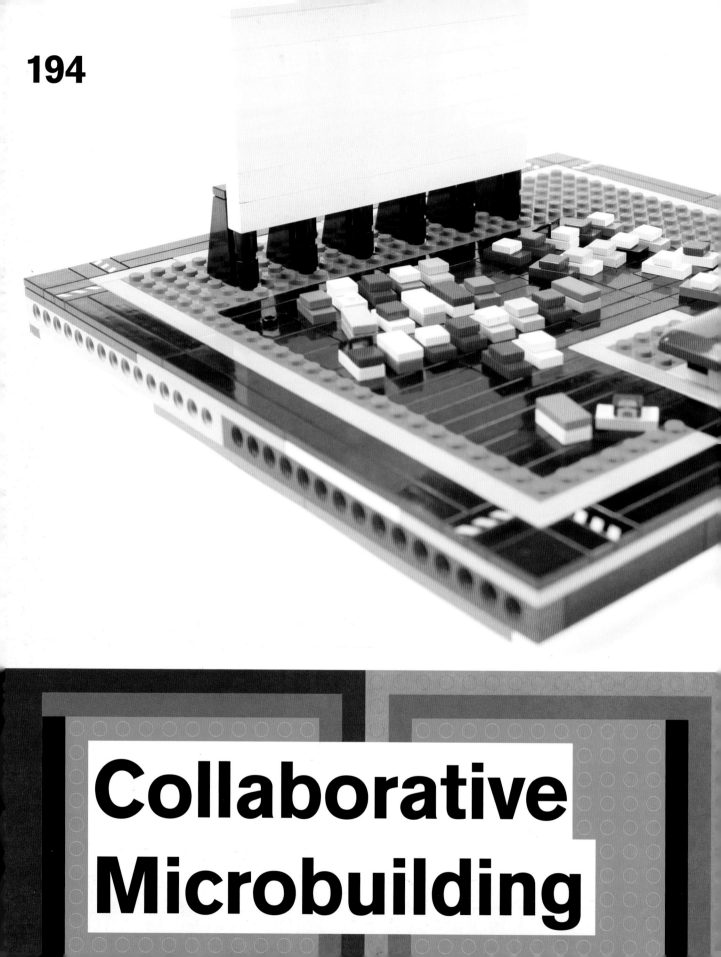

Collaborative Microbuilding

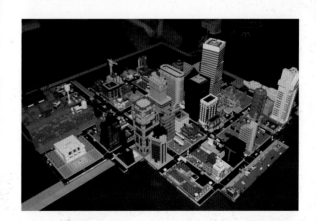

(ABOVE) **Matt Holland's Micropolis modules display all the diversity and life of a real city. His elegant two-element cars are immediately recognizable.**

(RIGHT) **Micropolis, the fruit of several builders working separately, comes together as one unit.**

Micropolis is an open-ended, collaborative micro project by members of the Twin Cities–based TwinLUG builders' group. (See Chapter 11 for more on LUGs—LEGO Users Groups.) The project's goal is to create an infinitely expandable city, with participants creating elements independently and then assembling the model when the group meets. The project shows how the Internet has revolutionized LEGO fan interaction. Fans living far apart can share photos and compare building tips and then meet at conventions to see the results in person. In the case of Micropolis, the builders wanted their microscale buildings to fit together as if the models had been built by one person.

The key to this collaboration is the builders' agreement on standards: Streets are a certain number of studs wide, city blocks another amount, and so on. Without such guidelines, one builder's sidewalk might not match up, or the scale might be wrong, with one 10-story building looming over another. With specific rules in place, builders who don't even know each other can build segments of the same city and expect them to fit together seamlessly.

The following rules represent TwinLUG's microcity standard:

- All structures are composed of 16-stud by 16-stud "modules," equivalent to 5-inch by 5-inch squares.
- A city block is two modules long by two modules wide and is ringed by a two-stud road. Sidewalks are one stud wide.
- The height of a standard brick is equal to 9 feet.
- The base of each module consists of a plate covered with a layer of bricks and another plate. Modules connect to each other with TECHNIC pins.

There are other guidelines for collaborative building besides TwinLUG's. For example, LEGO Space aficionado Bram Lambrecht created a Micro Moonbase standard to allow the building of collaborative lunar cities. People are represented by 1×1 round plates, and the first level is one plate above the base. The second level of each module begins at a height of 11 plates (a plate equals one-third the height of a classic LEGO brick), and the third level is at a height of seven bricks. Modules connect using tube-like corridors built with stacks of 2×2 round bricks.

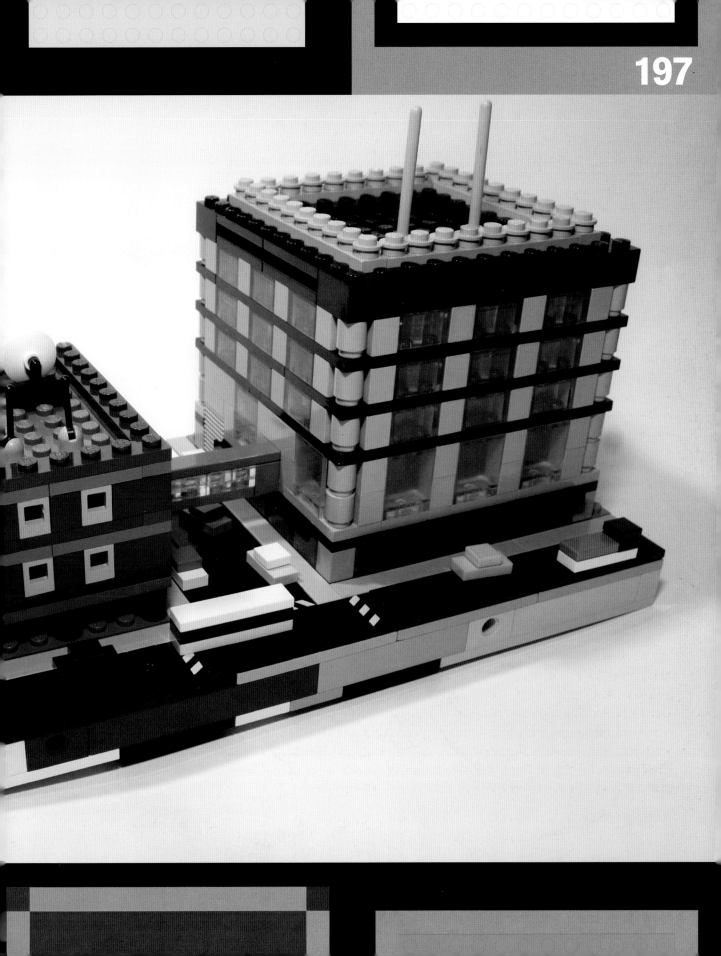

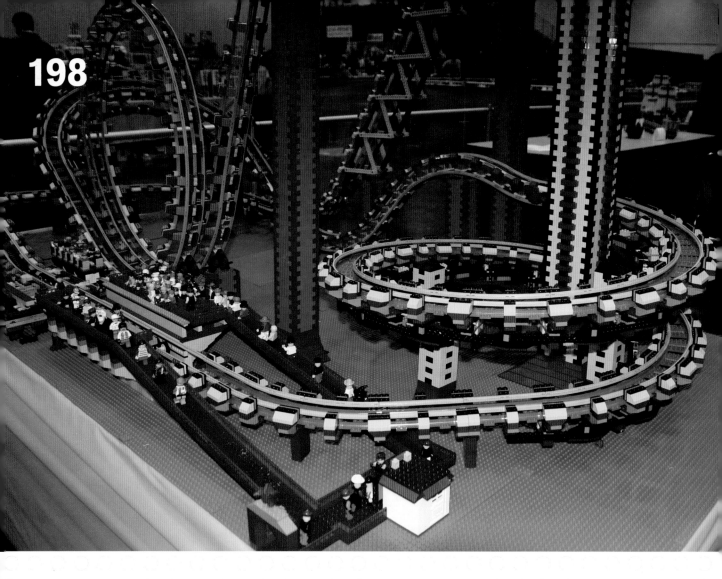

Matthew Chiles's minifig-scale roller coaster uses standard **LEGO** train tracks to form the coaster's rails.

Building Big

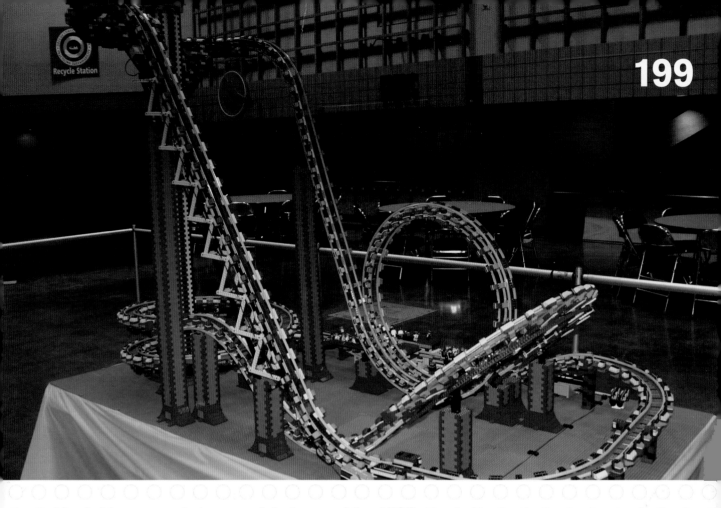

Microbuilders are a select group, admired among fellow LEGO fans but often overlooked by the mainstream. The average reader of gadget blogs and online news sources hears about gigantic LEGO space ships and million-brick towers, not about a police car depicted in eight bricks.

To the average person, models that use thousands of bricks are just plain impressive. When presented with a giant LEGO model, viewers frequently ask how many bricks it took to build. Even official LEGO products display brick counts as a measure of complexity and to justify their price. And LEGOLAND theme parks are stocked with countless huge models of famous buildings, statues, and vehicles, and the LEGO Group retains professional builders to create and maintain them.

For a macroscale project to be successful, it must still display expert building techniques and an imaginative use of LEGO elements. In fact, so much detail goes into these macroscale creations that in many cases individual parts of the model contain as much detail as numerous smaller projects.

The models that follow demonstrate both fantastic skill and the use of a lot of bricks.

Roller Coaster

This fully functional, minifig-scale LEGO roller coaster features three cars holding four minifigs each, stands 55 inches tall (or about 175 feet in scale height), and uses 124 sections of LEGO train tracks. It moves at a scale speed averaging 65 mph, ranging up to a scale of 140 mph at the bottom of the first hill.

"Before I began building, I decided I was not going to attempt a LEGO roller coaster unless I could successfully do a loop," Chiles wrote on his website. "So I got out a bunch of 4.5V track and began experimenting." Once he got the loop to work, he designed the other parts of the coaster, playing around with the curves' proportions until it worked. The model debuted at the Great American Train Show in 2002 and has been shown several times since. After letting the model sit in his barn for a few years, Chiles built an even bigger coaster and renamed it "The Phoenix."

Battleship Yamato

Building anything large at minifig scale is always a challenge, but what about a huge battleship at minifig scale? Jumpei Mitsui spent more than six years building this faithful re-creation. The ship, which weighs 330 pounds and uses 200,000 bricks, packs incredible detail. There's an Imperial chrysanthemum emblem on the bow and a magnificent brick-built Japanese flag flying overhead. When standing far enough back to view the entire ship, it's easy to overlook the minifig sailors attending to their duties or the countless anti-aircraft batteries peppering the deck. Mitsui's model briefly held the world's record for largest LEGO model of a ship; however, as is often the case, another builder built a bigger model. The current record-holder is René Hoffmeister's container ship using 400,000 bricks and stretching 7.29 meters, or nearly 24 feet.

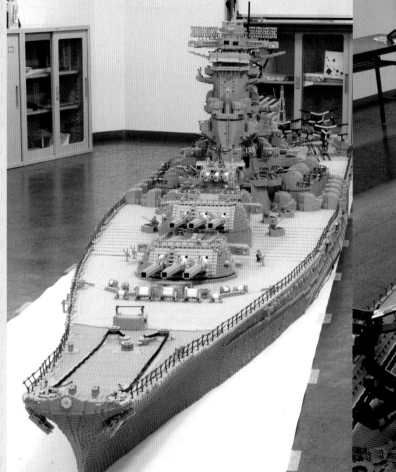

Jumpei Mitsui, known as JunLEGO in fan circles, built this 22-foot re-creation of the World War II battleship *Yamato*.

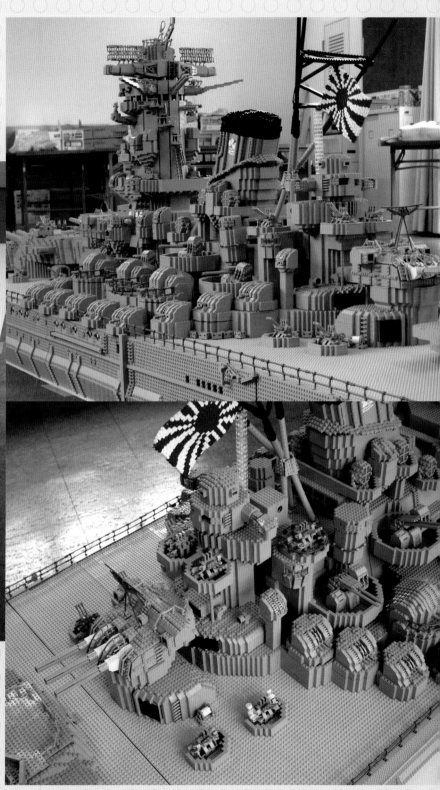

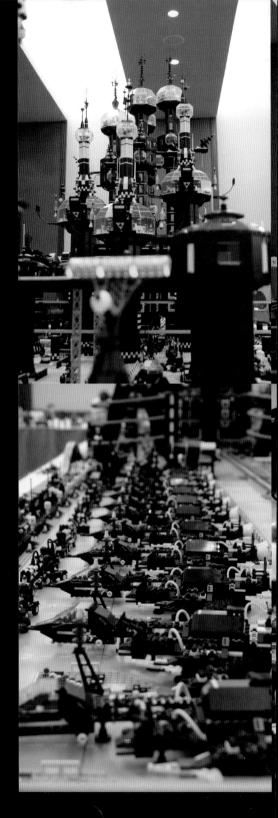

Blacktron Intelligence Agency

In October 2003, Indianapolis's IndyLUG received an intriguing invitation to participate in the city's Parents and Children's Expo the following year. The group decided to build a collaborative moon base for the event, with each member supplying a module.

"I knew right off what I wanted to build," IndyLUG member Brian Darrow told *BrickJournal*, "a module based upon my favorite space theme: BLACKTRON I." The theme, introduced by the LEGO Group in 1988, consists of black and translucent yellow elements and depicts a militaristic, distinctly villainous space force and their mysterious dealings. One of the original sets, the Message Intercept Base (#6987) shows some sort of intelligence-gathering facility, and Darrow cites this set as his inspiration.

Since the convention, Darrow has been hard at work expanding his original moon base module, transforming it into an entire science-fiction city run by black-clad spooks. He's rebuilt the model multiple times since its creation, adding new elements with every version. He's added towers, fleets of vehicles, and armies of minifig soldiers. There's even a monorail transporting workers around the layout, its track curling around various structures.

The project has taken up more than five years of Darrow's life, but he's not finished. Since its inception, the Blacktron Intelligence Agency has experienced seven separate versions and has grown to mammoth dimensions. The full model takes 10 hours to set up, stretches 8 feet tall and 34 feet long, uses 245 feet of monorail track, and features more than 1,200 minifigs. Darrow has lost track of how many bricks it uses or how much money he's spent on it thus far.

Brian Darrow's epic spy agency comes with sinister black towers and fleets of vehicles.

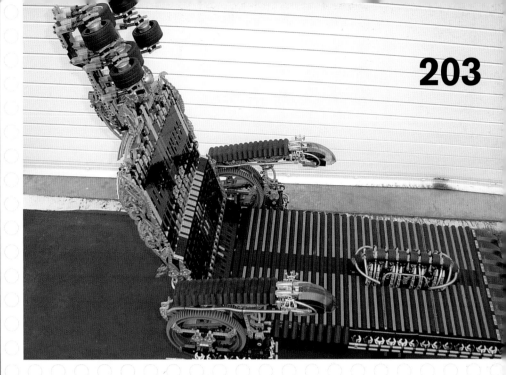

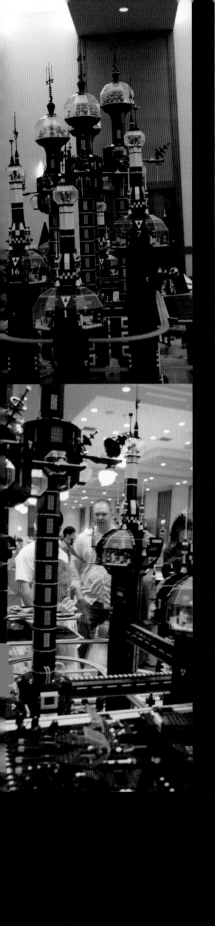

LEGO Chair

Steve DeCraemer wanted to build a LEGO chair. The first challenge he faced was determining whether such a model was feasible. He also wanted to make it as thin as possible while still supporting his weight. The result, which DeCraemer calls his "Amish zipper installer," took 15 months to construct and weighs more than 50 pounds.

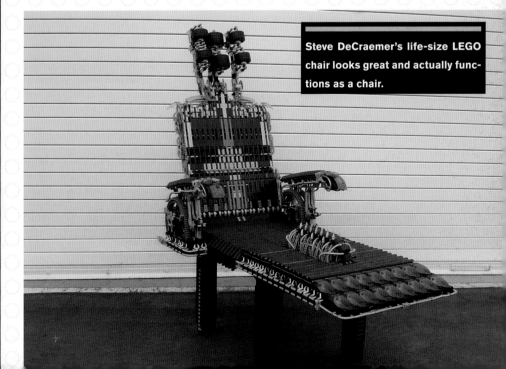

Steve DeCraemer's life-size LEGO chair looks great and actually functions as a chair.

(RIGHT) **Nathan Sawaya's 20-foot** *Tyrannosaurus rex* **is supported by guy wires and held together with glue.**

T. Rex Skeleton

Nathan Sawaya's *The Art of the Brick* exhibit (described in Chapter 6) features many "serious" works of art such as abstract forms, portraits, and geometric shapes. However, one thing was missing: a sculpture just for kids. Sawaya decided to build a model of a *Tyrannosaurus rex* skeleton. He researched dimensions of real tyrannosaurs and even bought a small model to use as a reference piece.

The resulting model was 20 feet long, used 80,000 bricks, and took an entire summer to assemble. Unlike many large brick models, it completely lacks a steel framework inside, relying on glue and support lines to keep it standing.

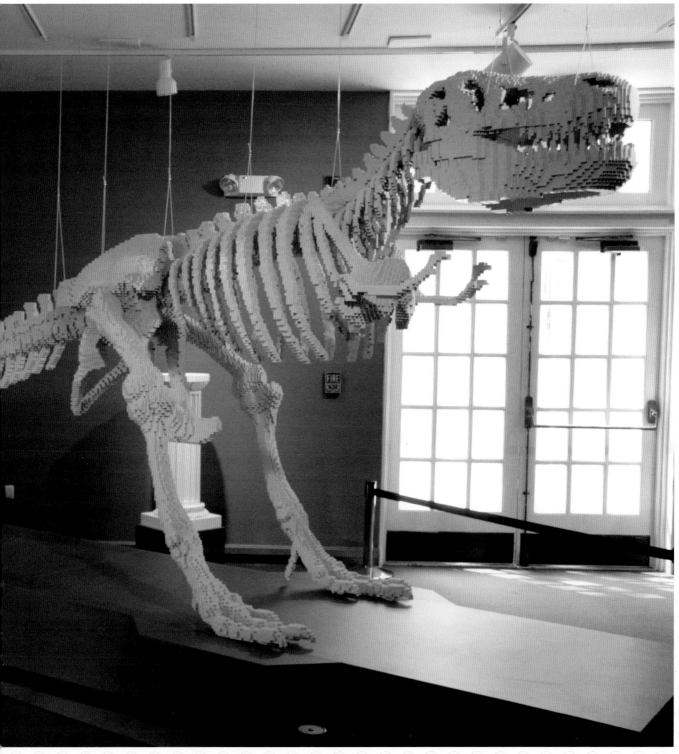

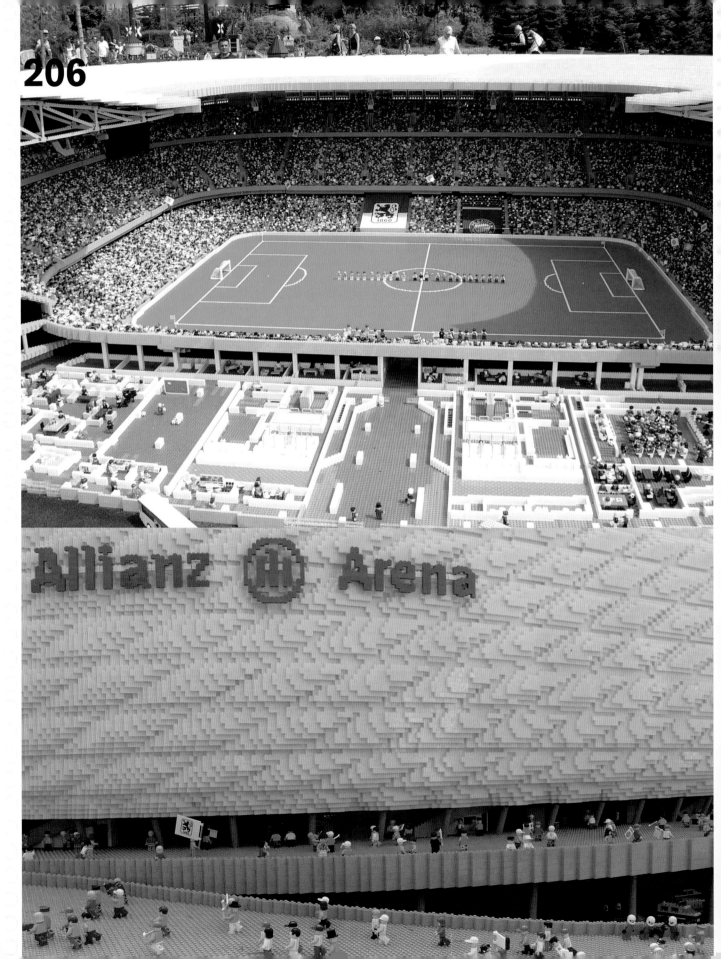

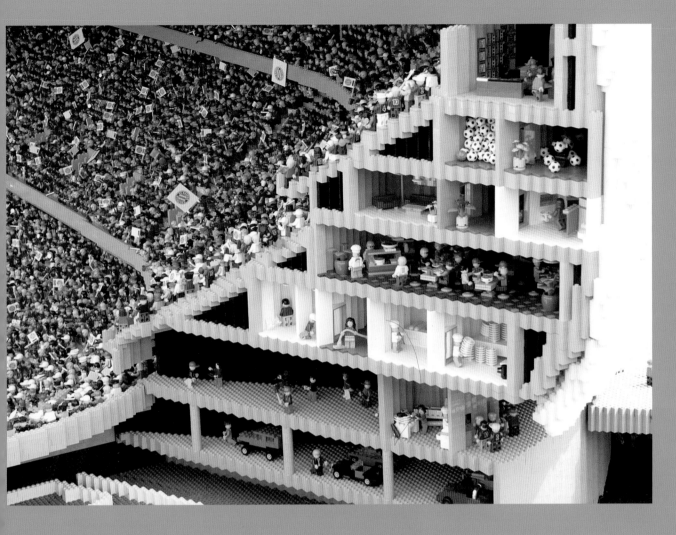

(OPPOSITE AND ABOVE) **This LEGOLAND Deutschland model stadium holds 30,000 minifigs!**

LEGO Allianz Arena

This model, located in Günzburg, Germany's LEGOLAND Deutschland theme park, shows how over the top the models are at the LEGO Group's parks. It's a gigantic, minifig-scale soccer stadium built from 1.3 million bricks, weighing 1.5 tons, and holding an astounding 30,000 minifigs. A cutaway section shows the goings-on in the stadium's guts—an equipment room, a press area, executive skyboxes, and even a small garage for service vehicles. At night, multicolored lights illuminate the stadium just like the real one.

208

Angel Sculpture

Seattle software engineer David Winkler's angel statue is more than just a pretty model. In many ways, it represents how 21st-century technology aids builders in creating their dream projects.

Winkler based the project on *Bringer of Light*, an Italian statue that was imaged by a specialized 3D scanner built for Stanford University. He downloaded the scans from Stanford's website, used custom software to slice the three-dimensional shape into more manageable parts, and determined which elements he'd need to build the statue in LEGO.

In the spirit of the university's generosity, Winkler provides blueprints and building instructions for the angel, allowing other builders to re-create his work.

Gluing Lego

Builders tackling a giant model face not only aesthetic and financial challenges but also a distinct mechanical difficulty. With LEGO's classic stud and tube connection system, bricks simply lack the gripping strength needed to keep large-scale creations from falling apart. Many builders are forced to glue elements together if the creation must be moved more than a few feet, a practice that is anathema to many fans who look down on any creation that contains non-LEGO elements and can't stand the thought of bricks being altered or damaged. However, many professional builders have no choice but to glue since they don't always have the time to continually fix broken models.

Designed with the help of a computer, David Winkler's LEGO angel looks like a carved statue.

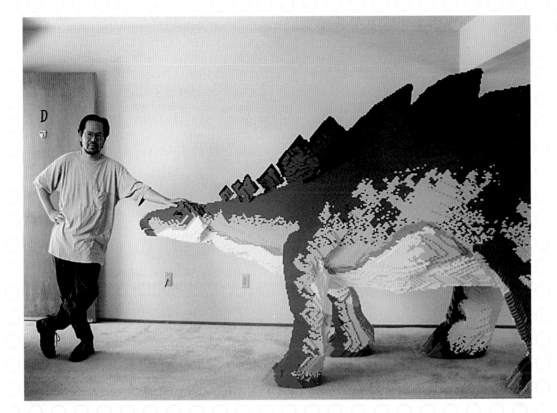

(ABOVE) **Henry Lim poses by his baby stegosaurus model. When asked what possessed him to build such a gigantic model, he replied, "Can insanity be classified as 'motivation'?"**

Life-Size LEGO

Henry Lim wanted to build a dinosaur — a life-size one. And it was not just any dinosaur but a stegosaurus, a species that averaged around 30 feet in length. Building it in his living room, he simply didn't have space for the full-sized beast, so he compromised by building a baby stegosaurus, half the size. His model took more than 120,000 bricks and seven months to assemble.

Beyond the economics of buying all the elements, however, building life-size, or 1:1, models represents an additional challenge: Your building materials are small plastic bricks. There's no way to precisely replicate the curve and tone of skin or the fluffiness of hair.

Many builders accept the fact that no matter how cunningly assembled, no LEGO model will be truly lifelike; they simply build as faithfully as possible and hope the viewer appreciates the artistry of their work.

Perhaps the greatest challenge of building a representation of a living being is the portrait. Like the builders described in Chapter 3 who obsess over representing real people with minifig models, a tiny subset of master builders assemble life-size re-creations of people. One notable artist is Dirk Denoyelle, a Belgian LEGO Certified Professional who specializes in busts and mosaics. However, the most famous portraitist is probably Nathan Sawaya, who has appeared on numerous television shows with replicas of such luminaries as Rachael Ray and Stephen Colbert.

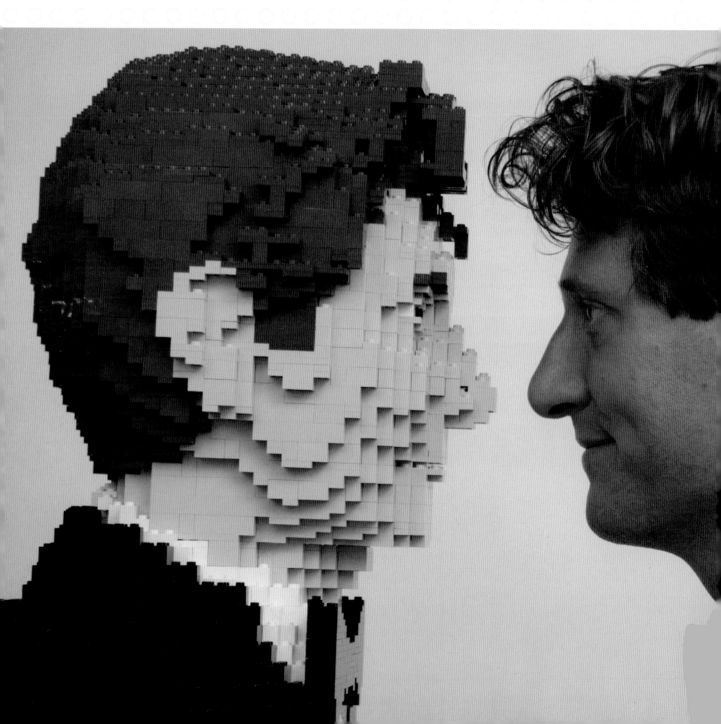

For wealthy LEGO lovers, Sawaya will even create their LEGO likeness for a fee. The customer sends Sawaya photos and measurements, and Sawaya creates the likeness in LEGO with some of the 1.5 million bricks he keeps in his New York studio. The statues are glued, boxed, and shipped for a price based on the complexity of the project but typically starting in the mid-five digits.

(BELOW RIGHT) **Nathan Sawaya poses next to his life-size Stephen Colbert model and** (BELOW LEFT) **faces off against his mirror image.**

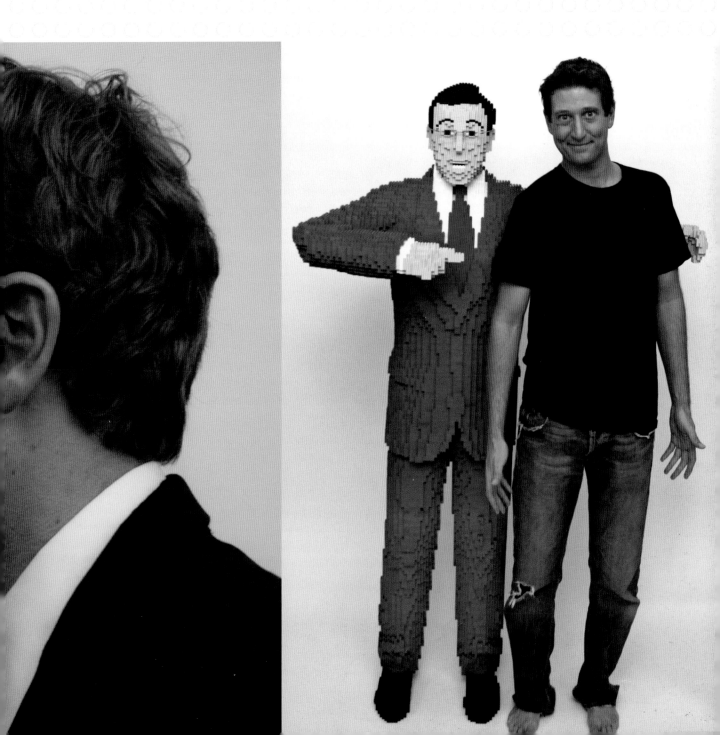

For many fans, microscale building symbolizes the pinnacle of skill. And yet, we live in a world where bigger and costlier is always more fascinating to the casual fan than smaller and simpler. The thinking goes that *anyone* can build a model with only 12 pieces, but one with 100,000 elements is beyond most fans' means. Rightly or otherwise, people who keep track of such things care mainly about big, bigger, and biggest. The following examples illustrate the scope of world-record LEGO structures. As with any list of records, the honor roll changes all the time. You can find the latest LEGO records at *http://www .recordholders.org/en/list/lego.html*.

LEGO Records

Tallest Tower

The LEGO Group has become keenly aware of the PR advantages of record-breaking towers and has built over a dozen towers since 2002, each construct eking out another record by a foot or so. The current world record for a LEGO tower was built in April of 2011 in São Paulo, Brazil, and it stands at 102 feet 3 inches. The towers are all built alike, with the bricks placed around a metal support with guy wires keeping it vertical.

Longest Train Track

If extended in a straight line, this train track, built by the Pacific Northwest LEGO Train Club in August 2000, would extend 3,343 feet — more than 1 kilometer.

Tallest Crane

A scale model of a Liebherr LR-111 200, Alvin Brant's record-setting creation, extends 20 feet into the air.

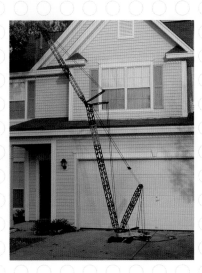

(LEFT) **This 95-foot-tall tower was built in 2007 for the Canadian National Exhibition in Toronto, breaking the record at the time.**

(LEFT) **Measuring more than 3,000 feet, this record-setting train track fits in a convention hall only by laying out the rails in tight coils.**

(RIGHT) **Alvin Brant's record-holding crane model has never been shown to convention-goers because of the difficulty in transporting the delicate creation.**

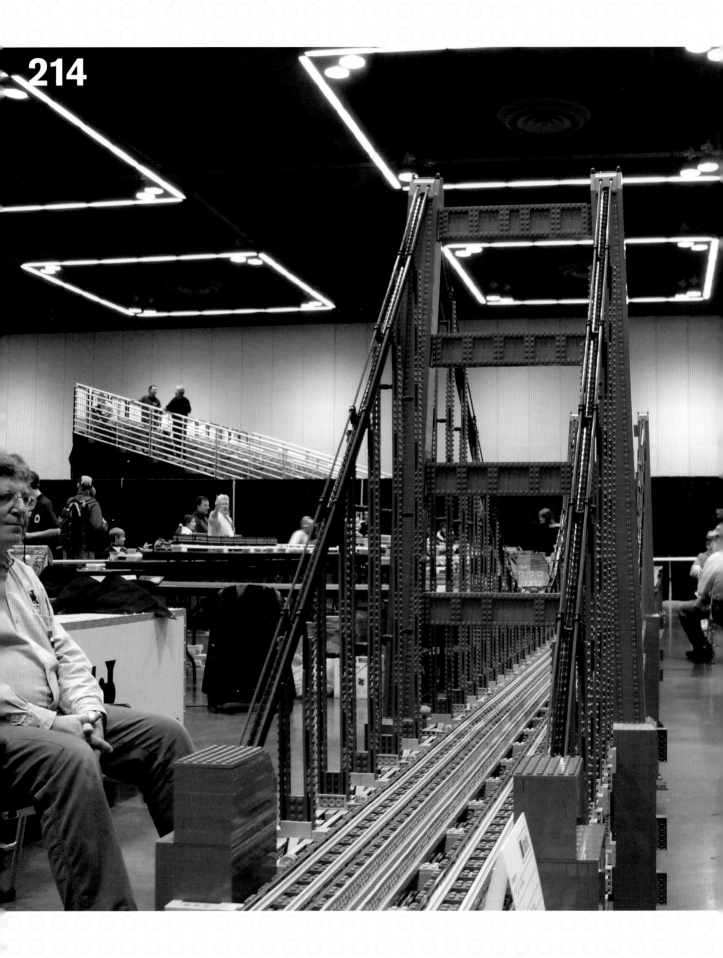

(LEFT) **Ted Michon's scale model of a suspension bridge was designed to accommodate multiple train models on separate tracks.**

Longest Train Bridge

Built by Ted Michon, this 20-foot bridge was shipped from Louisiana to Portland's BrickFest 2009 convention as a complete model, packed into a custom-built shipping container. It is a fully functional, double-decker model train bridge.

Largest Castle

A castle made from 1.4 million bricks and 2,100 minifigs was built at the Toy and Plastic Brick Museum in Bellaire, Ohio.

Biggest Car

The LEGO SuperCar was built by LEGO Group designers in Chicago. Life-size, the car uses 650,000 elements and weighs more than a ton. The car is actually a 10 times re-creation of a LEGO TECHNIC model, reversing the usual paradigm of model makers creating small versions of large objects.

Longest Chain

This chain was built by Swiss schoolchildren in 2003. It was 1,854 feet long, consisted of more than 2,000 links, and was made from 424,000 bricks.

Largest Ship

Built by 3,500 school children led by René Hoffmeister using 513,000 bricks, the resulting container ship was 25 feet (7.6 meters) long, easily beating out Hoffmeister's own record-setting container ship of 2009 and *Queen Mary 2* replica from 2008.

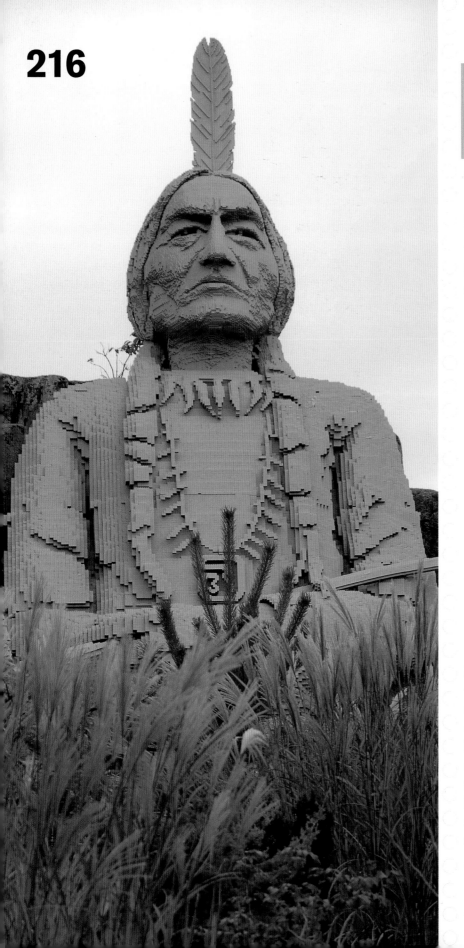

(LEFT) **This magnificent Sitting Bull statue, found in LEGOLAND Billund, holds the world record for largest statue.**

Biggest Statue

The statue of Sitting Bull found in LEGOLAND Billund stands 25 feet tall and uses 1.5 million bricks.

Micro and macro — at first glance, these two building styles could not be any more different. If you think about it, however, it makes sense. In both cases, the builders seek out the extremes of their craft, to build with either the fewest elements possible or the most. And in both instances fans seek to build the smartest, most beautiful model they can. The only difference is how many bricks get used.

Digital
Brickage

In the chapters thus far, we've seen how LEGO products have infiltrated nearly every aspect of our lives, appearing everywhere from paintings in art galleries to homemade iPod stands on our desks. It should come as no surprise, therefore, that LEGO has found its way to the digital world as well.

Since the beginning, the LEGO Group's corporate management has eagerly embraced technological innovation, constantly seeking out new products—even those that duplicate current successes. One area they have been consistently keen to explore is that of computer programs and games.

In 1997 the company created its first computer game, *LEGO Island*, an innovative nonlinear racing game that included elements of building and customization, a very natural theme for the LEGO Group and one that it has returned to repeatedly over the years.

Building brick structures, of course, is the LEGO Group's core competency. Numerous software programs, published both by the LEGO Group and by third parties, allow users to create and build virtual LEGO models. These design programs feature vast libraries of LEGO brick shapes, including rarities and customized, fan-created bricks that the LEGO Group may never produce. With programs such as LDraw or the LEGO Group's own Digital Designer, users can create virtual models, rotate them, and output image files for use in web and print projects.

The LEGO Group's latest entry in the digital world is *LEGO Universe*, an MMORPG akin to *World of Warcraft*, populated with multitudes of minifig avatars. As in other multiplayer online games, players have adventures, solve puzzles, and interact with one another.

Video Games

(TOP) **A minifig Dark Knight? This extension of the LEGO brand has been met with enthusiasm from LEGO gaming fans.**

(MIDDLE) **In *LEGO Star Wars*, you can build any *Star Wars* character you want from virtual mini-fig parts. Darth Greedo anyone?**

(BOTTOM) **In *LEGO Harry Potter*, players get to reen-act scenes from the movies while striving to graduate from wizarding school.**

To date, the LEGO Group has released more than 30 LEGO-based video games, covering a diverse range of themes. Many of these games take on non-LEGO genres, such as auto racing and sports, with graphics that include LEGO elements whenever possible. For instance, in 1999's *LEGO Racers*, players build their own minifig drivers, and the racecars look like they're made out of LEGO elements. *LEGO Batman*, released in 2008, has players collect LEGO bricks found throughout the levels, gaining points as they do so. When objects are destroyed—for instance, if a player smashes a trashcan to get at a power-up—they explode in a shower of LEGO parts. More constructively, players must locate heaps of elements in the levels and use them to build ramps, winches, and gears to get past obstacles. Players who have beaten several levels earn a bonus that lets them build their own heroes out of minifig parts.

Several BIONICLE-themed games have been released as well, typically overlapping and reinforcing the line's books and comics. Much like the models themselves, BIONICLE games focus on action and de-emphasize construction aspects. For example, *BIONICLE Heroes* (rated T for Teen) was criticized in reviews for its shallow carnage, for including few opportunities for LEGO building, and for featuring a landscape that was not very reminiscent of LEGO. In many ways the game is like a first-person shooter with LEGO elements slapped on.

In other games, however, the LEGO Group makes better use of the customizable nature of its toy, often for comedic effect. For example, in *LEGO Chess*, players can choose a Wild West theme with "cowboys" on one side and war-painted "Indians" opposing them. In *LEGO Star Wars*, players can mix and match minifig elements, putting Greedo's head on Han Solo's body, for example, and arming him with a light saber. In *LEGO Football Mania*, players can field soccer teams with minifigs from any LEGO theme, so a skeleton might play alongside a ninja and face off against a pirate.

While LEGO sports games that feature scampering minifigs may entertain, they're arguably missing LEGO's core strength: building. Many of the LEGO Group's video-game offerings manage to include both action and construction. In *LEGO Stunt Racers*, players can create their own racetracks, adding loops and other obstacles. The *LEGOLAND* game, which is similar to Maxis Software's *SimCity*, allows you to build a virtual theme park and control its operations. In *LEGO Battles*, players build brick forts and conduct skirmishes using classic LEGO themes, often mixed and matched in amusing ways: pirates and wizards and aliens on one side and astronauts and dragons on the other.

A primary reason for the LEGO Group's involvement in the video-game industry is surely to sell its non-software products. Their licensed toy lines, notably *Harry Potter*, *Batman*, *Indiana Jones*, and *Star Wars,* all have corresponding video games. When a kid has fun playing the *LEGO Harry Potter* video game, one has to imagine that same kid will be intrigued by a LEGO Harry Potter model. However, many of the company's games are successful products in their own right—*LEGO Batman* earned high praise from game reviewers and has sold over seven million copies to date.

LEGO Group's *Creator* games give fans the joy of building without the need to buy bricks.

Building Games

In addition to "action" games that feature the occasional opportunity to build, the LEGO Group also produces the *Creator* series, which offers players the ability to build and manipulate models on-screen. While classified as a game, *Creator* offers only a smidgen of plot, action, or puzzles, focusing on the joy of building instead.

In *Creator*, players begin with a stripped-down play area and a menu of bricks with which they can build furniture, terrain, and structures. Minifigs and animals populate the space and wander around until the player clicks on them. The original *Creator* game serves only as a sort of virtual sandbox, but a sequel, *LEGO Creator Harry Potter*, includes minor puzzles (these primarily function as tutorials for learning the *Creator* interface rather than entertainment). The game also includes more interactivity, such as wizards, witches on broomsticks, customizable weather, and the chance to drive the Hogwarts Express train.

The LEGO Group offers *Creator* models as well, but they're not tied in to the video games. Instead, they consist of packages of generic System bricks that can be built into multiple models.

Computer-Aided Building

There is a serious side to the *Creator* software that fascinates adult LEGO fans. Some builders actually create digital models using computer-aided design (CAD) programs similar to those used by engineers and architects but optimized for use by LEGO fans. This CAD software works by providing a library of 3D brick shapes, allowing users to build models on-screen, either for prototyping eventual projects or simply for creating virtual constructs that couldn't be built otherwise because of expense, size, or lack of bricks. These virtual bricks consist of 3D shapes that mimic the dimensions of real LEGO elements, and the software used to manipulate them simulates building.

Allen Smith's Bricksmith combines James Jessiman's LDraw library with a Macintosh's ease of use.

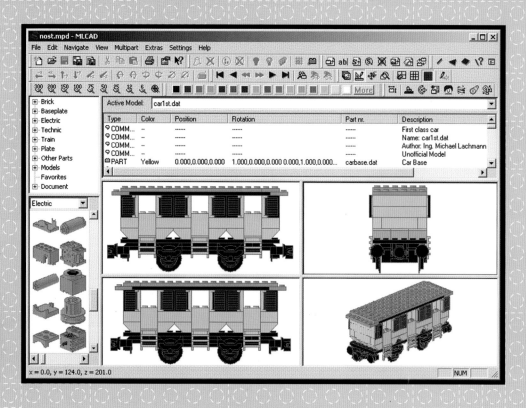

MLCad's interface includes windows showing the model as well as a library of customizable bricks.

LDraw, the Grandfather of LEGO CAD

In 1995, an Australian named James Jessiman set about to create the first LEGO modeling program, LDraw (*http://www .ldraw.org/*). His first attempt was relatively primitive by today's standards, lacking a graphical user interface; building commands were typed into the computer line by line, without the ability to see the result until the program was run. Further, it had only three elements in its library: 2×2, 2×3, and 2×4 bricks.

Jessiman's creation, however, proved to be the beginning of a new way of building with LEGO. As the years passed, hundreds of bricks were added to the LDraw library in a slow and methodical process that required new elements to pass a series of rigorous reviews from LDraw's volunteers. Most of these new shapes corresponded with official LEGO products, but fan-created bricks not found on store shelves also made it into the library, highlighting one of the strengths of the digital medium.

As the library grew, versions for Mac OS, Linux, and Windows were developed to manipulate the parts. Allen Smith's Bricksmith program (*http://bricksmith.sourceforge .net/*) mated the LDraw library with a slick Macintosh-like interface, allowing builders to scroll through menus of elements and simply drag them onto the building area to be placed on a model.

Once an LDraw model is complete, renderings can be output or assembly instructions can be generated (using the program LPub, developed by Kevin Clague) so the model can be made for real.

MLCad (*http://mlcad.lm-software.com/*), created by Austrian software developer Michael Lachmann, is another interface designed to make use of the LDraw library. Like Bricksmith, the program offers a graphic interface to its library of LDraw bricks. Parts are selected from a menu that shows a preview of how the brick will look, along with related elements. From there the bricks may be dragged into the building area or rotated, flipped, colored, and then added to the model. Each of the four viewing panes can be customized to show the creation from a different angle, allowing elements to be easily added to the back or side of a model simply by dragging them into the appropriate window. MLCad is compatible with Windows and supports eight languages.

LEGO Digital Designer

However, LDD sports several features that the fan-produced software can't match. For one thing, LDD's elements snap to fit onto studs for a more faithful re-creation of the actual building process. And for builders hoping to output instructions to go with their virtual models, LDD makes it easy by creating the steps simultaneously with the online build, allowing the user to make changes on the fly. And, of course, LDD can easily and authentically re-create bricks, coming out with all-new elements far more quickly than LDraw's volunteers can.

Not to be outdone, the LEGO Group has released its own virtual LEGO software: Digital Designer (*http://ldd.lego.com/*). Available for Windows and Mac OS and packing more than 1,000 elements, LDD (as it's known) can be downloaded from the LEGO website free of charge. As in MLCad or Bricksmith, users can build virtual models by dragging elements from a menu. Models can be flipped and rotated, built to practically any size, and then output as a rendering to be shared.

LDD also stands apart by offering users' models as physical products. The Design byME service packages up the parts needed to build the model, outputs building instructions, and even lets the fan design the packaging. While more expensive than the LEGO Group's ready-made models, the Design byME offerings are much more diverse, and the service allows fans the opportunity to purchase one another's LDD creations.

LEGO Digital Designer offers all the functionality of the fan-built CAD programs, with an extra dose of polish.

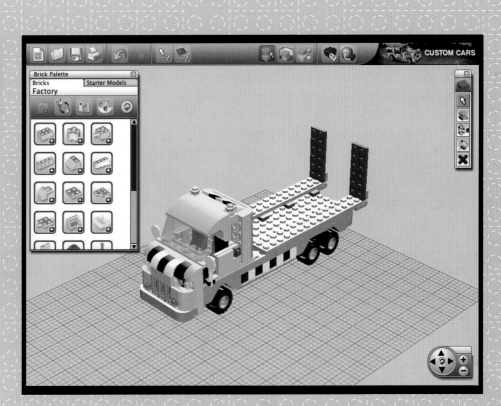

PicToBrick

PicToBrick (*http://www.pictobrick.de/*) offers a different angle on the CAD phenomenon. Instead of helping users build models brick by brick, PicToBrick takes a scanned image and converts it to brick "pixels" for the purpose of making photorealistic mosaics. Created by Tobias Reichling and Adrian Schütz while they were students at Siegen University in Germany, the program uses algorithms to help builders find the truest colors as well as the best-fitting elements. The human eye simply cannot choose a color as well as PicToBrick. "It uses the surrounding squares and has automatic error diffusion," Reichling says. "The resulting color for each square is distributed pro rata to the next squares and so on to improve the quality." The programmers also implemented features to suggest watercolor or Pop Art effects, as well as different brick and plate orientations that can be used to create more detailed mosaics. More than just a tool for converting digital images to little squares of color, PicToBrick works only in LEGO elements to find the best combination of bricks for each project.

Wanna create your own LEGO mosaic? PicToBrick offers the easiest in.

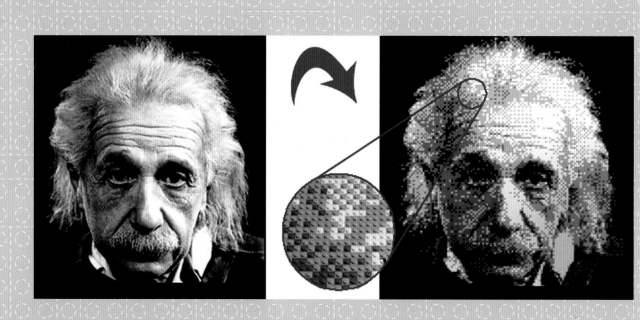

LEGO Font

Urs Lehni and Rafael Koch's LEGO font looks like it's built out of bricks.

When Swiss designers Urs Lehni and Rafael Koch looked at LEGO, they saw a font waiting to be created. They noted that the modular format of the bricks may be stacked into letterforms as easily as a car or house, so why not digitize that idea in the form of a font? The designers created two individual LEGO-inspired typefaces, LEGO AM and LEGO PM—essentially the same concept turned at different angles—and sell them through the Swiss font foundry Lineto.

For those who don't want to license the font (it costs 100 Swiss francs, or about US$90), Lehni and Koch provide another resource: the LEGO Font Creator (*http://www.lehni-trueb.ch/Lego+Font/*). This web-based Shockwave application, created with the help of Urs's brother Jürg, allows users to manipulate the font on-screen without installing it, and also provides a library of LEGO-like objects. The resulting shapes can be exported as vector graphics that can be manipulated by such programs as Inkscape and Illustrator.

(OPPOSITE TOP) **While Andrew Plumb's 3D-printed brick wouldn't fool anyone, the CAD-to-printer technology offers intriguing possibilities.**

Print-Your-Own Bricks

With CAD models of LEGO elements combined with the rapid proliferation of 3D printing technology, fans like Andrew Plumb are now able to "print" their own LEGO-like bricks. An electrical engineer from Ottawa, Ontario, Plumb bought a hobbyist 3D printer, a MakerBot CupCake CNC. One of the first things he printed was a classic 2×4 LEGO-like brick designed by Viennese hobbyist Philipp Tiefenbacher. The result was bumpy, fragile, and not terribly authentic, but still compatible with actual LEGO bricks.

Not content simply with the role of printer, Plumb quickly decided to design his own bricks, creating a 2×2 round plate in Google SketchUp. He output the element on his MakerBot and also used the professional prototyping service bureau Shapeways, which printed Plumb's files in plastic as well as in bronze-infused aluminum.

So just how well does a MakerBot's output compare to the LEGO bricks' legendary quality? For the time being, not very well. The printer lays down layers of plastic rather than molding solid pieces. "The MakerBot-printed pieces are as strong, and painful when stepped on, as the real thing," Plumb said in an interview. "Because the fabrication process is laminar—built up one layer at a time—the pegs are the weakest points, most likely to shear off if stressed."

While both MakerBot and LEGO molds fashion elements out of ABS plastic, 3D-printed bricks simply can't compare either in terms of beauty or durability. That said, does the LEGO Group have anything to fear from this new tech? Its experience with knockoffs like MEGA Blok might provide a clue. As mentioned in Chapter 1, the LEGO Group's patents have expired, allowing competitors to produce plastic bricks that are completely compatible with LEGO—as long as they don't use the company's trade dress or copyrights. The same should apply to 3D-printed bricks.

Plumb agreed. "With each expired patent more old-school, mass-produced, LEGO-compatible competitors have entered the mix," he said. "They don't infringe on the LEGO trademark, they're cheaper—and often of lesser quality in the examples I've seen—and yet the LEGO brand is stronger than it has ever been."

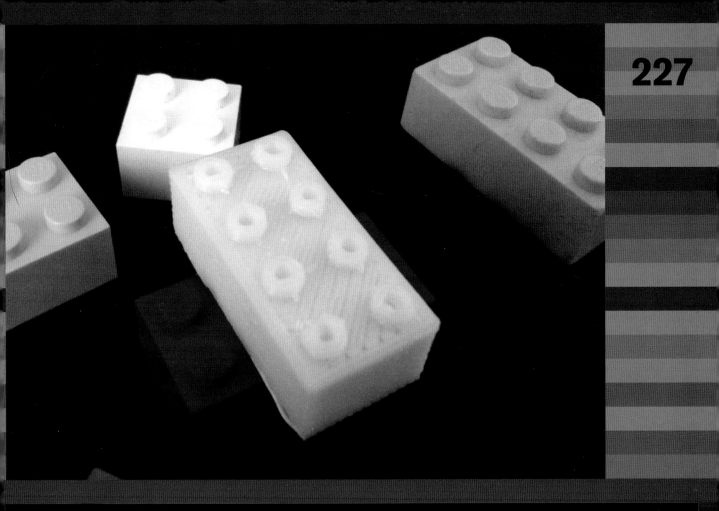

Andrew Plumb designed LEGO-like elements in Google SketchUp and then output them on his 3D printer. The results can be seen along with a real LEGO plate and professionally output versions.

228

Sites like **Brickshelf** (TOP) **and MOCpages .com** (BOTTOM) **brought the LEGO fan commu-nity together by allowing builders living far apart to share their work.**

LEGO Fan Resources

From LEGO CAD to 3D printing, digital technologies have made amazing leaps in the last few years. But don't forget the vastly more important role computers and the Internet have played for adult LEGO fans: allowing them to share their work across great distances.

In the digital domain of the Internet, there are many places that builders and others visit to see LEGO creations. The largest online gallery of LEGO models and fan photography is Brickshelf (*http://www.brickshelf.com/*), a free image-hosting site dedicated to LEGO fan building. More than 3 million photos of models, events, and fans can be found in the over 200,000 folders in the site. Photos of the newest sets can be found as well as images of models built around the world, making Brickshelf probably the best sampling of the international LEGO fan scene. However, the site only holds images and tags. Descriptions and credits must be placed on other sites, such as LUGNET (*http://www.lugnet.com/*), a website that seeks to index all of the LEGO groups of the world.

While Brickshelf's longevity has made it a major fan site, other services offer more functionality. MOCpages.com (*http://www.mocpages.com/*), a website created by professional LEGO builder Sean Kenney, has become the biggest second-generation fan gallery site,

now surpassing Brickshelf in web traffic. Using community-based features such as comments and groups, MOCpages.com not only shows off models but allows for discussions as well.

However, there are more user-friendly resources that appeal to the casual fan. Sites such as The Brothers Brick (TBB; *http://www.brothers-brick.com/*) display the best of the LEGO fan community in an accessible blog format. Every day, TBB's stable of writers presents several models that are outstanding in some way.

Other sites offer pure information rather than artistic inspiration. The folks at Peeron (*http://www.peeron.com/*) obsessively catalog every single LEGO model they can get their hands on, photographing the parts and supplying a PDF of the set's building instructions. Peeron's European counterpart, Brickset (*http://www.brickset.com/*), adds a few more features, such as a news feed.

Finally, the popularity of *wikis* (user-editable encyclopedias) has given rise to such LEGO fan sites as the Brickipedia (*http://lego.wikia.com/*), which offers more than 2,500 articles on various fan topics, ranging from obscure elements to the ins and outs of the BIONICLE universe. Which sets have a Darth Vader minifig? Brickipedia will tell you.

LEGO Universe

Video games such as the *Creator* series, which allow players to take on the role of a minifig, merely scratch the surface of what is possible. With *LEGO Universe*, the LEGO Group went to the next level, creating a massively multiplayer online role-playing game (MMORPG). Design began in 2006, with the game drawing inspiration from Blizzard Entertainment's *World of Warcraft*, an MMORPG featuring clans of warriors doing battle in a fantasy realm.

Initial concept art for *LEGO Universe* showed a largely stud-free, natural terrain but with a fantastic twist: gigantic vegetation modified to serve as pathways, bridges, and houses. Themes from LEGO sets were present as well. For instance, one illustration showed a traditional Japanese garden with LEGO ninja minifigs standing guard. Other drawings depicted LEGO-brick monsters, pirate ships, and fantastic tree houses.

Denver-based NetDevil took on the responsibility of developing the game system, working with the LEGO Group and selecting members of the fan community to create content and test the game. While NetDevil worked on creating the game resources and universe, LEGO fans were invited to help build the environments. First building with real bricks and later with virtual elements, the fan community had a major influence on the look of the game. NetDevil also enlisted the help of local children to test the game as it was being developed. As *LEGO Universe* approached completion, beta testing was opened to users of all ages and nationalities.

However, the scope of *LEGO Universe* was a major challenge. Creating an online world where players can easily build and share models is a monumental task, and the release of *LEGO Universe* had to be delayed three times. But in October 2010, the game was finally released to positive reviews: As one would expect from the LEGO Group, *LEGO Universe* was described as child friendly, closely moderated, and very fun.

The game story describes a world beset by the Maelstrom, a spiderlike being of dark imagination that transforms its victims into zombies called Stromlings. Factions of minifig characters oppose the Maelstrom's machinations, battling its minions and accumulating treasure. Each *LEGO Universe* player takes the role of a minifig with his own unique outfit, equipment, and wealth. Unlike other MMORPGs, in which characters gain experience points and level up, *LEGO Universe* uses equipment to determine skill level. Players can acquire better equipment—thereby improving their statistics—by going on quests, solving puzzles, and "smashing" monsters in battles. Defeating villains earns the player coins and imagination orbs. Spending coins nets the player tools and weapons for his minifig character, while "imagination" is spent building objects out of LEGO bricks.

The LEGO Group's exploration of online play, not to mention its long-term commitment to the console video-game market, shows the company's eagerness to expand beyond its core products and embrace this new way of creating.

(TOP LEFT) **Characters can find objects in their travels and sell them to stores or trade them to other characters.**

(BOTTOM LEFT) **Though a relatively new MMORPG,** *LEGO Universe* **has multiple worlds; characters travel throughout these lands in a variety of vessels.**

(TOP RIGHT) **True to its source,** *LEGO Universe* **involves a lot of building with authentic LEGO bricks.**

(BOTTOM RIGHT) **Combat is a part of the game as well. Characters' chief enemies are dark beings called Stromlings.**

Nexus Tower World Map

Nexus Tower is your launching point to Crux Prime and new adventures to come!

LEGO Robotics: Building Smart Models

In Chapter 9 you saw how the LEGO Group had boldly explored the medium of console and computer games, using these digital diversions to sell its core product line while tapping into a demographic more interested in the couch and controller than building with plastic bricks. In the same vein, the company has always been keen to explore robotics as a natural extension of LEGO models. But more than simply "roboticizing" LEGO, the company wanted to redefine its own core product line and move away from the brick as the primary element—a daring move for a company whose bread and butter was that very brick.

The LEGO Group has released multiple robotic products over the years, many of which were considered failures with runs lasting only a single year. One of these, however, proved a dazzling success. Called MINDSTORMS, this product soon became the core LEGO robotics product and has sold more than a million sets in the decade since its launch.

(OPPOSITE) **LEGO MINDSTORMS, a robotics system completely separate from its core product line but that nevertheless became a remarkable success**

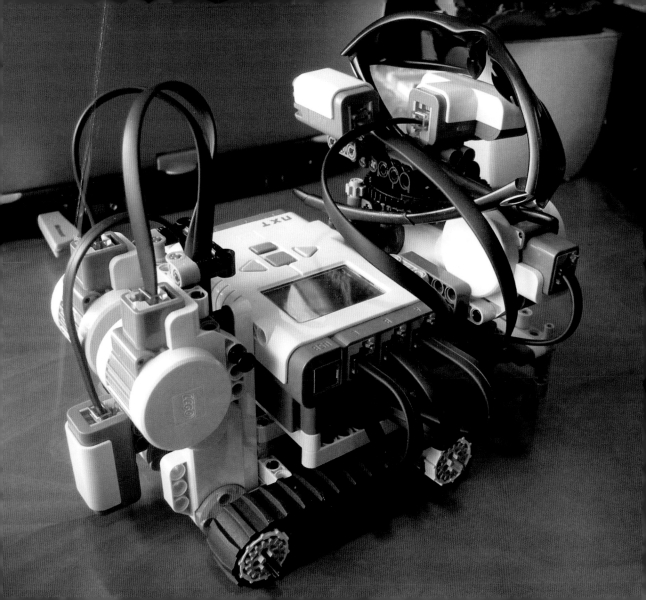

MINDSTORMS

Though the LEGO Group has released several robotics sets over the years, there is only one of significance: LEGO MINDSTORMS, a full-fledged robotics kit.

The LEGO Group introduced MINDSTORMS in 1998, calling it the MINDSTORMS Robotics Invention System. The core of the product was the RCX brick, a user-programmable microcontroller covered in LEGO studs.

In 2006, MINDSTORMS became MINDSTORMS NXT. The core of this refreshed product was a more powerful brick, the NXT. Then, in 2009, MINDSTORMS NXT received an upgrade that the company announced with great fanfare, calling the set NXT 2.0 (though some critics suggested that 1.2 might have been more accurate).

MINDSTORMS has become the LEGO Group's most successful single product ever. It has its own conventions and competitions, books of techniques and building instructions, and legions of adult fans. Without a doubt it has broadened the company's reach to include consumers who otherwise couldn't care less about LEGO but who do care about robotics. And, perhaps most importantly, MINDSTORMS has brought powerful robotics to neophytes and nontechnical people. The set includes the following elements.

(ABOVE) **The latest version of the LEGO Group's phenomenally successful MINDSTORMS line, the NXT 2.0 set includes sensors, motors, a microcontroller, and enough TECHNIC bricks to build a variety of models.**

(RIGHT) **The original MINDSTORMS intelligent brick, the RCX had both TECHNIC and System connectors to let builders integrate the unit into their models.**

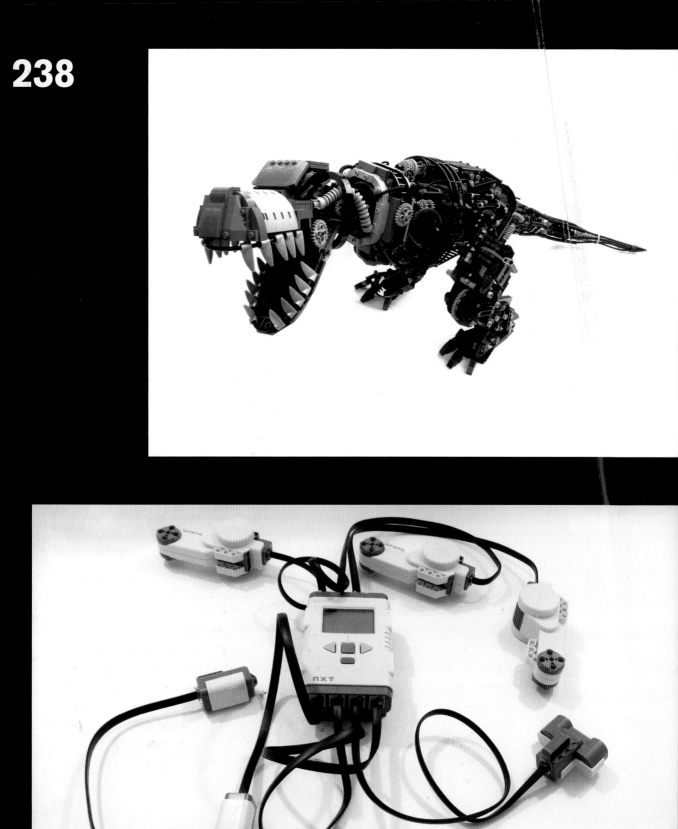

(OPPOSITE TOP) **Remi Gagne used TECHNIC elements structurally and decoratively to build this fantastic model of a robot *T. rex*.**

(OPPOSITE BOTTOM) **The NXT brick surrounded by its sensors, connected to the bottom of the unit, as well as motors plugged into the top—together these elements can add robotics to any model.**

TECHNIC Elements

The nonrobotics parts of the NXT set consist almost exclusively of TECHNIC elements. The classic stud and tube connections of System bricks simply don't have the strength to keep mobile, animated models from falling apart. Using beams held together with multiple pins, models made with TECHNIC elements are easier to transport, and they seldom fall apart, at least compared to their System cousins. But more importantly, TECHNIC offers the mechanical capabilities needed to make robots — most notably, a variety of gears, belts, and axles that can be used to make creations that move, grab and lift objects, and do other robotlike things.

The NXT Intelligent Brick

The TECHNIC elements are clearly a critical part of MINDSTORMS, but the most important element in the NXT set is the NXT brick, a battery-powered microcontroller with input and output ports, Bluetooth connections, and buttons that allow it to receive data from a variety of sensors and send commands to the robot's servos that control its motors.

Just about anyone can program the NXT brick using drag-and-drop programming software called NXT-G. Creations made with NXT are programmed to follow certain commands, react to stimuli, and then operate autonomously. Third-party companies have developed add-on modules, ranging from accelerometers to infrared sensors, adding to the capabilities of an already robust system. The NXT brick is peppered with TECHNIC peg holes, allowing it to be incorporated into models just like any other element.

When the robot is complete, the builder connects the NXT brick to the computer and sends the program to it.

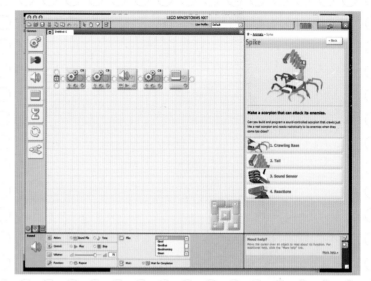

(RIGHT) **NXT-G commands, represented by colorful icons, can be pulled from a library and dropped into place.**

NXT-G

Although NXT-G serves as a fine entry into programming, expert users often abandon it for more powerful alternatives. For instance, a programming environment called NeXT Byte Codes (NBC) uses assembly language syntax to program the brick, while Not eXactly C (NXC) and RobotC use variants of the powerful C programming language.

Sensors and Actuators

The NXT brick is the robot's brain and serves as an intermediary between the various modules that do the real robotic work. Ranging from servos that turn gears to light sensors capable of distinguishing between light and dark, these modules provide the true functionality of the system.

Although the NXT set includes many of the classic TECHNIC sensors, several independent companies offer their own modules to expand the system's possibilities including ones to measure temperature, RFID, infrared, and so on.

For instance, HiTechnic produces a line of MINDSTORMS-compatible modules including a gyro sensor with a spinning gyroscope inside that informs the NXT brick when the robot tilts. This sensor allows builders to create robots that stabilize themselves when crossing bumpy terrain. The HiTechnic touch sensor multiplexer allows builders to add additional touch sensors to a robot, exceeding the usual limit of four sensors on one NXT brick.

(ABOVE) **If the NXT brick is the brain of the robot, these motors—called *servos*—are its muscles.**

(LEFT) **The HiTechnic color sensor reads reflected light and determines its color. Want a robot that will pick up only green balls while ignoring the red ones? You'll need a sensor like this one.**

Robotics Also-Rans

Although MINDSTORMS is the most successful, the LEGO Group has released several robotics products over the years. Many were fine products that somehow missed the mark. The following are some highlights.

Spybotics

Spybotics was a simplified version of LEGO robotics aimed at a younger demographic. Kids built robots that could perform "missions" such as run obstacle courses or grab objects, using light and touch sensors to navigate. The LEGO Group allowed builders to download new missions and upload their scores to the Internet, but only four models were released, and the line never really took off.

Power Functions motors add movement to a project, but their inability to be easily controlled by the NXT brick limits their usefulness in some robotics projects.

Cybermaster

Cybermaster was an attempt to market computer-controlled models to younger kids. The line offered fewer options than MINDSTORMS with a shallower learning curve and included a video game on CD-ROM. Cybermaster had a central processing box called the Pbrick, which resembled a car's chassis with two motors, tachometers, and speedometers. The Pbrick could be controlled via a low-power radio link. When linked to a PC, programs could be run on the Pbrick via the PC, over that radio link. Cybermaster saw very limited release in the United States and was on the market for only one year.

Scout

Scout offered a simplified processor brick that could be accessed without a separate computer interface. Unfortunately, the brick wasn't as versatile as the RCX, and it was discontinued.

Micro Scout

Micro Scout featured a simplified processor brick shaped like a car chassis, packing a built-in light sensor and motor. Each processor had seven preinstalled programs, but additional instructions could be sent in coded pulses through the light sensor. (This wasn't the first time that a LEGO set could be programmed with light; Code Pilot used bar codes to program the truck model built with its set.)

Power Functions

The Power Functions line features all the elements that one associates with the NXT product line — such as motors, batteries, and lights — but it lacks a microcontroller. Despite this seeming disadvantage, Power Functions remains popular with robotics builders because it includes elements such as dedicated battery packs and infrared receivers that are missing from the NXT set. And although there is a certain degree of overlap with NXT, Power Functions components can't be controlled directly by the NXT intelligent brick, which limits one's ability to use both sets in the same project.

WeDo

WeDo is a simplified robotics set aimed at elementary-school kids that includes motors, gears, and levers, as well as a motion and tilt sensor. WeDo's most notable omission is its lack of a microcontroller: The robot remains tethered to a computer at all times, and children program it through a simple drag-and-drop program like the MINDSTORMS NXT-G software (discussed earlier). WeDo focuses primarily on the education market, and it even comes with lesson plans for 12 two-hour building sessions.

LEGO Robotics Projects

MINDSTORMS isn't merely regular LEGO with motors. At its most basic level, it serves as a platform for inventing and prototyping computer-controlled machines. As the following examples illustrate, you can create pretty much anything with the NXT system.

Autopilot

When *Wired* editor in chief Chris Anderson learned about the HiTechnic gyro sensor, his thoughts went immediately to his hobby of making drone aircraft. He created a small assembly that fit inside a model plane's fuselage. When activated by radio control, the NXT brick took control of the plane's rudder and turned the plane back to its point of origin, using the gyro sensors (one for pitch and one for roll) to keep the aircraft stable.

(1) **Sometimes a MINDSTORMS assembly takes the place of more traditional electronics. Chris Anderson's autopilot is one example.**

(1) **Steve Hassenplug's LegWay senses the ground with a proximity sensor and adapts to remain upright.** (2) **Many LEGO fans have built Rubik's cube solvers, which compute solutions to mixed-up cubes and then solve them.** (3) **Need more ink for your LEGO MINDSTORMS printer? Buy another pen.** (4) **This ATM is jam-packed with NXT sensors and actuators, to the point where the model closely mimics the functionality of the real machine.**

Self-Balancing Robot

Most people have heard of Segway inventor Dean Kamen's self-balancing personal transporter. MINDSTORMS fan Steve Hassenplug created a LEGO version that he calls the LegWay. His model uses an RCX to control its servos, taking input from two HiTechnic proximity sensors that tell the LegWay how close it is to the ground. Checking every 50 milliseconds, the LegWay corrects an imbalance by tilting the other way.

Automated Teller Machine

Ron McRae's LEGO automated teller machine (*http://www.youtube.com/watch?v=L0Z-ym0k89Q*) does an amazing job of simulating all the functionality of a real ATM. It accepts bills and authenticates them against stored banknote profiles. It stores customer data in flash memory and uses RFID-equipped debit cards secured with PINs to validate accounts. Don't have a card? Just insert bills, and the machine makes change, dispensing the coins in a tray.

McRae built this model over four months. It uses 2 NXT bricks programmed with 1,800 lines of code, 5 servos, 3 touch sensors, 6 light sensors, 1 Codatex RFID sensor, and more than 8,000 regular LEGO elements.

Rubik's Cube Solver

Place a scrambled Rubik's Cube on Hans Andersson's Tilted Twister (*http://tiltedtwister.com/index.html*) and it scans each face with a light sensor, computes a solution, and then solves the puzzle by turning and twisting the cube's faces. The Twister's algorithm typically solves a given cube in 60 moves and takes about six minutes. There are faster cube solvers out there, some that solve the cube in less than a minute, but many require a laptop's superior computing capabilities, use consumer webcams for faster scanning, or use multiple NXT bricks and servos. Andersson's Twister, constructed from a single MINDSTORMS set, holds up well against these competitors.

Pen Plotter

Anders Søborg's pen plotter (*http://www.norgesgade14.dk/plotter.php*) uses MINDSTORMS servos to manipulate an ordinary pen, controlled by a RobotC program. The robot draws using the pen, following a path computed by the NXT brick.

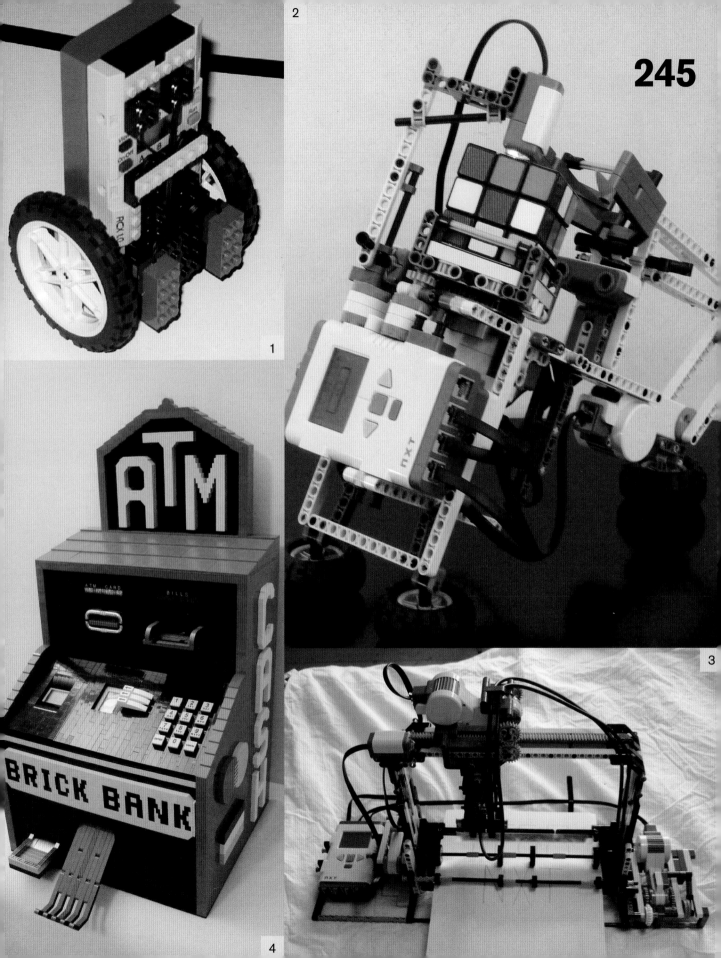

(1) **NeXTSTORM's dancing robot blinks its eyes, bops its head, and stars in its own music videos.** (2) **Need some chips? This MINDSTORMS vending machine will dispense a bag.** (3) **Philo's 3D scanner uses reflected laser light to measure the dimensions of a three-dimensional object.**

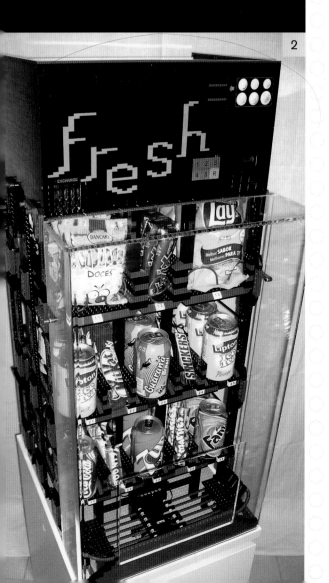

3D Scanner

French electrical engineer Philippe Hurbain (*http://www.philohome.com/scan3dlaser/scan3dlaser.htm*) has contributed an extensive number of parts to the LDraw library, a collection of digitized LEGO elements. One difficulty he encountered was creating the design files for oddly shaped, nongeometric parts. His solution was to create a MINDSTORMS robot that measures the outlines of elements with a laser connected to a simple assembly that rotates the object to be scanned, along with a webcam that senses the reflected light. The resulting data is sent to a laptop because the NXT brick's memory can't store it all.

3it3ot: A Dancing Robot

Vassilis Chryssanthakopoulos of Athens, Greece—better known to LEGO fans as NeXTSTORM (*http://web.me.com/NeXTSTORM/NeXTSTORM/Welcome.html*)—created this compact robot from a combination of MINDSTORMS, Power Functions, and third-party elements including eight servos, a HiTechnic IRLink, a sound sensor, and an ultrasonic sensor. His robot, 3it3ot (pronounced "Bit Bot"), dances in a music video featuring sophisticated visual effects and original club music.

Vending Machine

Portuguese LEGO fan Ricardo Oliveira's MINDSTORMS vending machine (*http://www.brickshelf.com/cgi-bin/gallery.cgi?f=229618*) dispenses 13 different products including cans of soda, bags of chips, and candy. It accepts Euro coins as payment and makes change using two RCXs to control the machine's eight servos.

(1) **Steve Hassenplug's gigantic chess set plays automatically with 32 independently controlled robot chess pieces.** (2) **While a laptop does the heavy computing necessary to solve this book of sudoku puzzles, a MINDSTORMS assembly turns the pages.** (3 & 4) **Frank de Nijs's fully functional (if not very strong) safe packs 305 billion possible combinations.**

Monster Chess Set

Steve Hassenplug and his team built this huge chess set out of 100,000 LEGO elements (*http://www.teamhassenplug.org/monsterchess/*). Each piece features a color sensor, servos, and an NXT brick, and the set can automatically replay historical matches, play itself, or accommodate one- and two-player modes. A laptop running a chess program sends Bluetooth commands to the 32 NXT bricks that control the individual pieces.

Sudoku Solver

Dutch engineer Vital van Reeven's robot (*http://www.youtube.com/watch?v=ReRSCSrtr58*) holds a book of sudoku puzzles, scans the first page, and sends the image to a nearby computer that solves the puzzle. The solver then turns the page of the book to reveal the next puzzle.

Safe

Although surely there are many better ways to protect your valuables than Frank de Nijs's LEGO safe (*http://www.bouwvoorbeelden.nl/home_eng.htm*), his robot nevertheless represents a fantastic working model of a safe. It requires 5 two-digit codes to unlock, providing 305 billion possible codes. An accelerometer-triggered alarm sounds if the safe is moved, and a motorized door opens automatically.

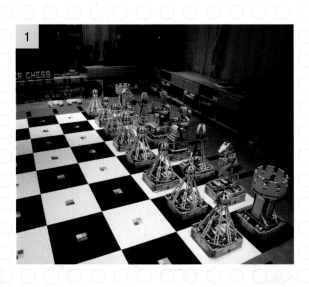

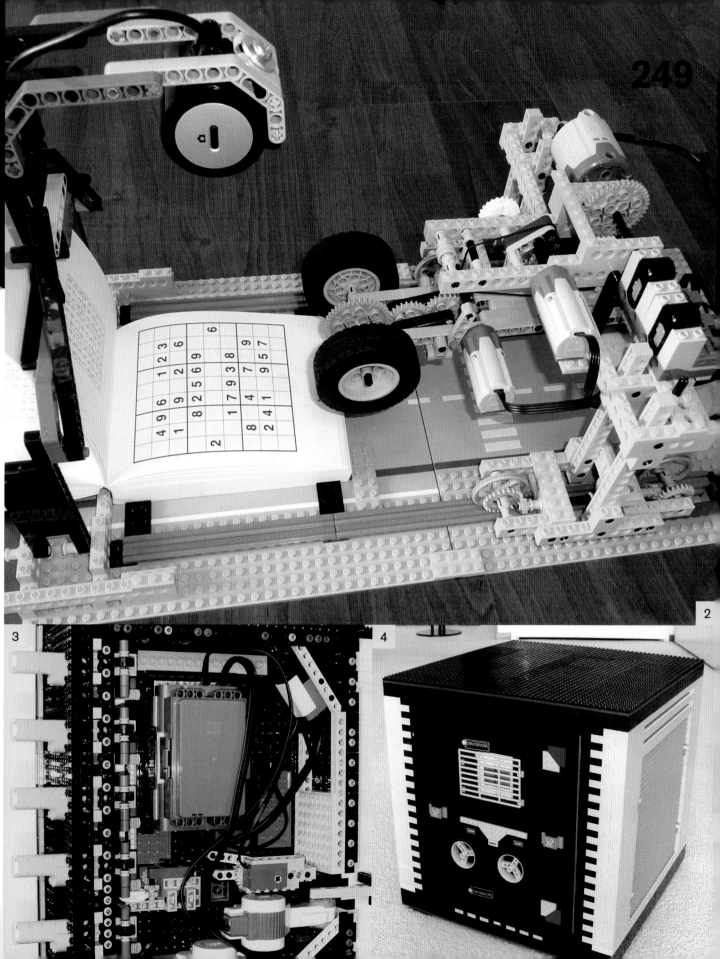

(1) **What better material to re-create a primitive computing engine than LEGO?** (2) **This RCX-driven Connect Four player wins 90 percent of its games.** (3) **BlueToothKiwi's SPIT robot floats in a swimming pool and sprays concentrations of insects with bug spray.** (4) **Will Gorman's LEGO printer will actually assemble a simple model from its magazine of bricks.**

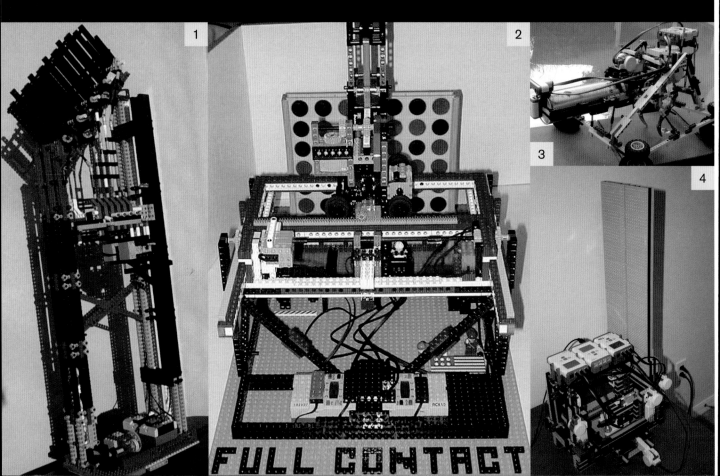

FULL CONTACT

Turing Machine

Like Charles Babbage's Difference Engine (described later in Chapter 12), the Turing machine (*http://tinyurl.com/turing1*), created by mathematician Alan Turing in the 1930s, works like a primitive computer and is even able to save its data onto a paper tape. Denis Cousineau, a professor of cognitive science at the University of Montreal, created a LEGO robot to simulate a Turing machine but used stacks of black-and-white LEGO elements instead of a tape. A light sensor can differentiate between the two colors and assign a numerical value to each stack.

Connect Four Playing Robot

Steve Hassenplug's robot, Full Contact, methodically scans a Connect Four game board, formulates a strategy, and makes a move (*http://www.teamhassenplug.org/robots/fullcontact/*). Full Contact, which wins more than 90 percent of its games, can play other robots or people.

Swimming Pool Insect Terminator (SPIT)

Three-man New Zealand LEGO collective BlueToothKiwi designed a robot to battle a problem that was giving them fits: chlorine-resistant insects that float on the surface of a swimming pool. Their solution? An autonomous floating robot equipped with a can of mild insect spray. SPIT uses TECHNIC wheels as floats, a light sensor to spot clusters of bugs, a servo to activate the spray, and a paddle wheel to submerge the bug carcasses so the pool filter will take care of them.

LEGO Model Maker

Will Gorman's LegoMakerBot is a robot that builds other LEGO models, pulling bricks from a gravity-fed magazine that holds 35 of each of 5 different types of LEGO elements. A computer program scans an MLCad file, determines a set of print instructions and then sends the instructions to the robot for printing. The LegoMakerBot's three NXT bricks and nine servos pull the correct brick from the magazine and tap it into place.

FIRST LEGO League

In 1998, the LEGO Group helped create FIRST LEGO League (FLL), a robotics competition that uses LEGO MINDSTORMS robots. An FLL team consists of children ages 9 to 14 who create a MINDSTORMS robot equipped with an NXT brick, servos, and sensors. They design their robot to solve certain challenges such as collecting an object or following a path. The robots must operate autonomously, and points are deducted if the team touches the robot during its run.

FLL is designed to be more than just a competition; it teaches the principles of teamwork, persistence, and good sportsmanship. Since its creation, the competition has grown to include nearly 140,000 students worldwide, with more than 13,000 teams from 50 countries competing. Dozens of teams may participate in any one event, with competitions culminating in the FLL World Festival in Atlanta, Georgia.

For the LEGO Group, the FLL events serve as great publicity for their projects and have arguably contributed to sales of MINDSTORMS sets as schools and other groups assemble FLL teams and participants are exposed to the product line. At the same time, its sponsorship of FLL has exposed thousands of children to technical concepts they may not otherwise have had a chance to explore. In other words, everyone wins!

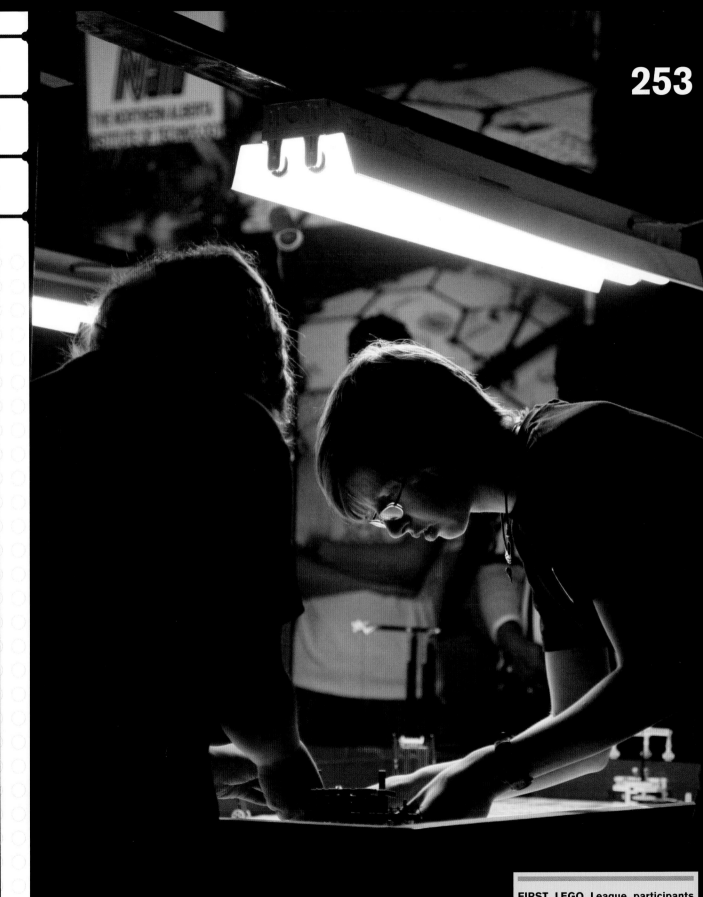

FIRST LEGO League participants fine-tune a robot with an intensity typical of these important events.

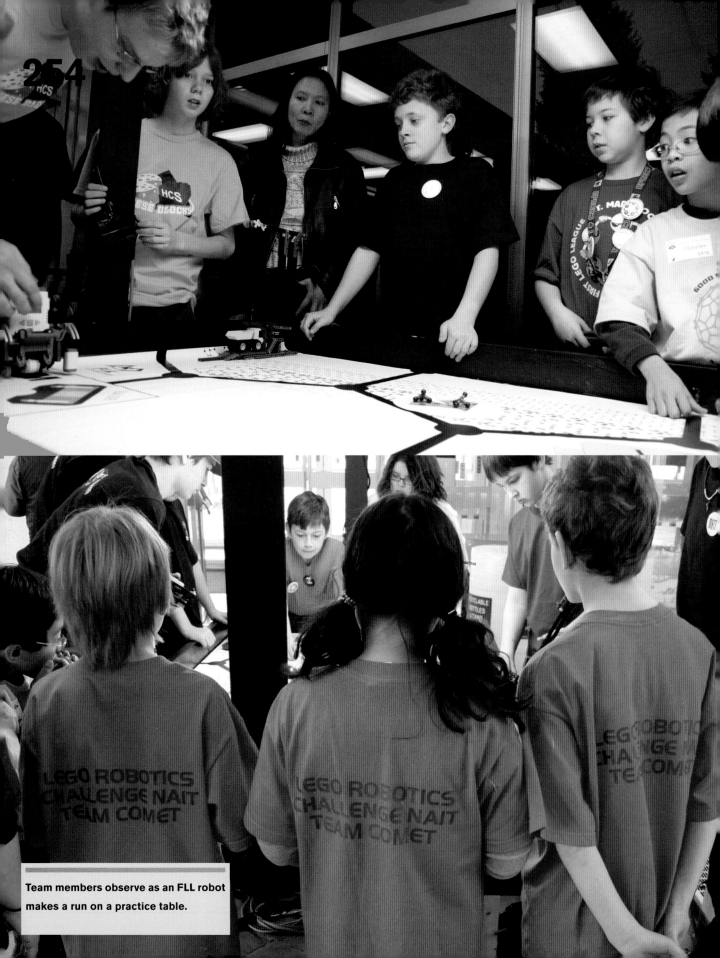

Team members observe as an FLL robot
makes a run on a practice table.

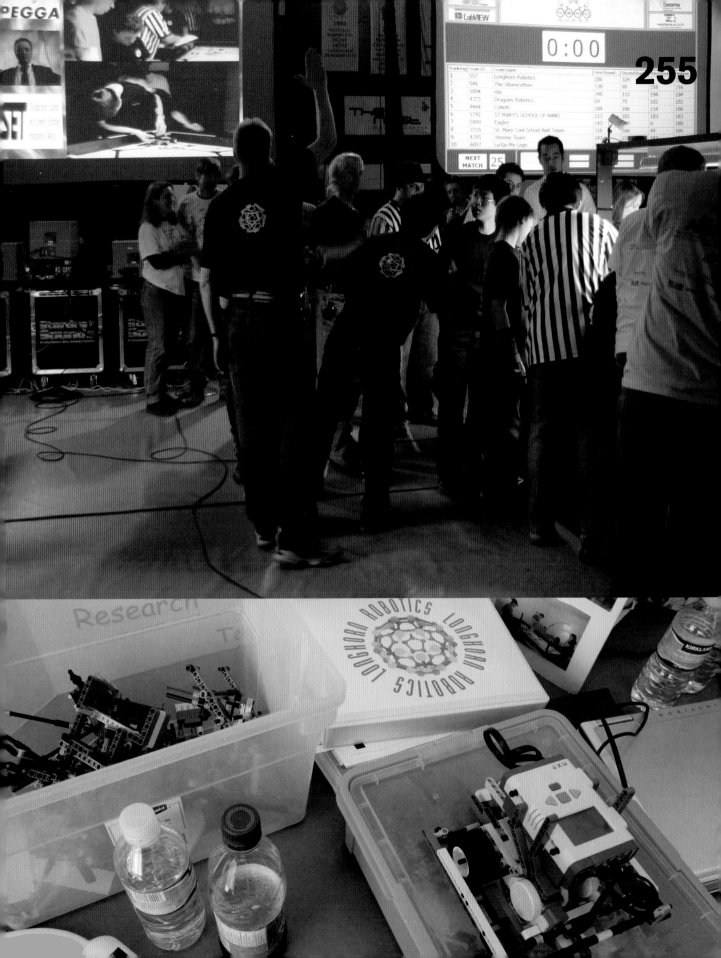

A Successful Sideline

LEGO robotics may have begun simply as a way for the LEGO Group to expand its core product line into new arenas, but with the success of MINDSTORMS it became something bigger. LEGO robotics has its own dedicated fans, blogs, books, and membership organizations. The status of MINDSTORMS as the best-selling LEGO product of all time has further cemented it as anything but an also-ran to the company's more traditional products. Despite the obvious differences, the projects shared in this chapter show that LEGO robotics has one important thing in common with System bricks—the possibilities are limited only by the skill and imagination of the builder.

Gatherings

From its genesis as a small gathering of fans, the LEGO convention has come a long way.

BRICKCON 08
LEGO EXHIBIT
OCT 4-5 11A-3P

HELLO

While the LEGO brick celebrated its 50th birthday in 2008, adult LEGO fan events have not been around nearly as long. The first gatherings took place in the mid-1990s, and they were small affairs more likely to be hosted in a house than in a public venue. However, in the years since, conventions have multiplied in quantity, quality, and popularity. Brickworld 2009 in Chicago featured a few hundred paid attendees and an appearance by LEGO Group owner Kjeld Kirk Kristiansen. Fans from almost every corner of the world come together at conventions, sharing ideas and showing off their latest creations.

Why did it take so long for adult LEGO fans to begin meeting? After all, the LEGO Group had been hosting its own events, such as the LEGO Truck Tours and Imagination Celebrations, with traveling exhibitions and displays by their Master Model Builders. But the LEGO Group–sponsored events were geared toward children, not adults. Adults wanted to have some fun, too.

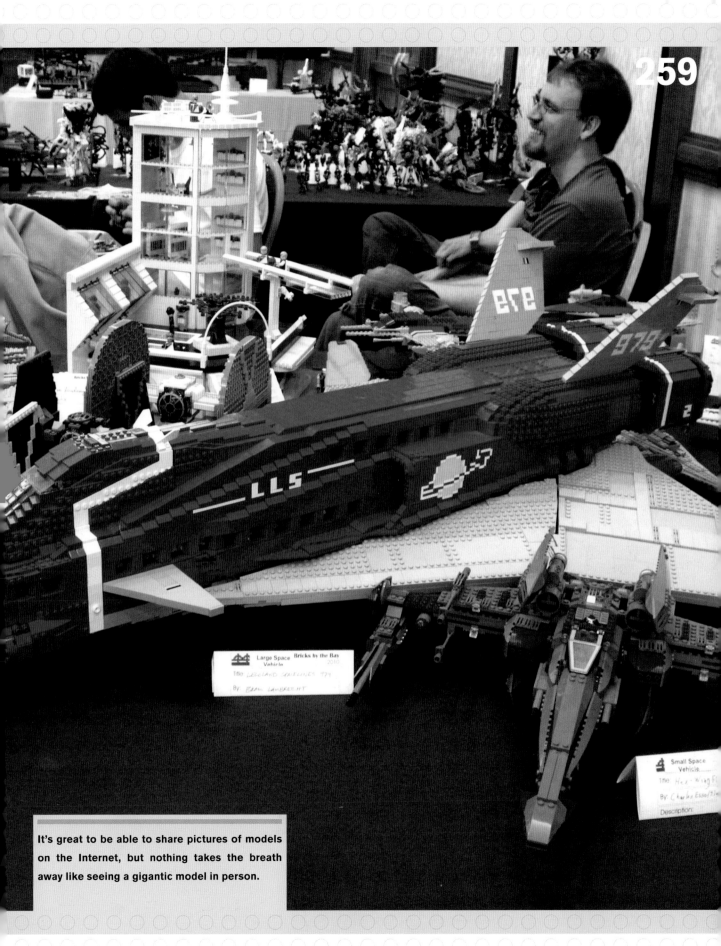

Large Space Bricks by the Bay
Vehicle 2010
Title LEGOLAND SATELLITES 979
By BRIAN LAMBRECHT

Small Space
Vehicle
Title Hex-Wing Fi
By Charles Essel??
Description

It's great to be able to share pictures of models on the Internet, but nothing takes the breath away like seeing a gigantic model in person.

The Online Beginnings

In 1994, an online newsgroup dedicated to the LEGO hobby was started on the then very new Internet. With the advent of LUGNET (LEGO Users Group Network), for the first time LEGO fans could connect and communicate with each other around the world.

The first recorded LEGO fan get-together in North America was in Chicago, Illinois, in August 1995. Dubbed LEGOFest Prime, this was initiated online by Colleen Kelly (her online persona: Minx Kelly Lego Goddess of Phobos) through the online rec.toys.lego group. Around 20 fans attended. Another convention, LEGO Fest, took place for the first time in 1996 at LEGOLAND Windsor in England. These were small gatherings, but from these meetings grander events grew.

LEGO Users Groups (LUGs)

Toward the end of the 1990s, LUGs—LEGO Users Groups—began to proliferate, flourishing throughout North America and Europe. LUGs are modeled after the user groups that sprang up around the personal computer revolution in the 1970s and 1980s, where aficionados of computer culture banded together in public libraries and college meeting rooms to share their experiments and experiences. LEGO Users Groups are, in essence, LEGO clubs; the users group model differentiates them from the child-oriented LEGO Club sponsored by the LEGO Group.

Most LUGs are organized geographically, like BayLUG (San Francisco Bay Area), WAMALUG (Washington, DC and metropolitan area), and NELUG (New England), just to name a few. They hold regular meetings in publicly accessible locations where members gather to trade elements, work on communal projects, and discuss building techniques. Some groups are organized around a particular theme or building interest, such as LUGNuts, which is focused on car models, and the International LEGO Train Club Organization (ILTCO), which exhibits a large LEGO trains display at the (US) National Train Show. LUGs often use the Internet to share their models and to recruit new members.

The LUGs' (typically) local focus makes it easy for fans to meet in person, but there is no substitute for the ultimate gathering: a national LEGO convention.

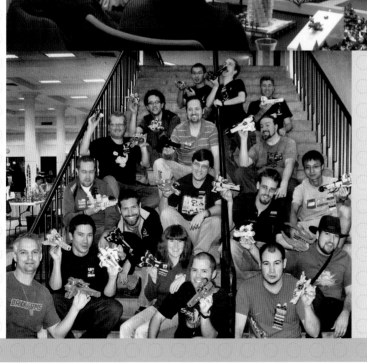

(TOP) **The founding members of Portland, Oregon's PortLUG fan group**

(MIDDLE) **Minneapolis and Saint Paul's TwinLUG meets**

(BOTTOM) **Not all LUGs are organized by geographic region. ChiefLUG consists of friends and fans of Ryan Wood (front center), who coordinated a** *Battlestar Galactica*–**themed display at BrickCon 2008.**

LEGO Conventions Come of Age

The early years of LEGO conventions saw small, scattered gatherings gradually lead to bigger, more ambitious events. In 1995, the small LEGOFest Prime was held in Chicago. In 1996, a LEGO Fest took place at LEGOLAND Windsor in the United Kingdom. In 1997, rtlToronto (a Canadian LEGO robotics club) began an annual LEGO robotics event using the MINDSTORMS RCX system.

The RCX was also the focus of the first MindFest, a conference, educational gathering, and robotics meet held in 1999 at the Massachusetts Institute of Technology in Cambridge, Massachusetts. One of the MindFest organizers, LUGNET cofounder Suzanne Rich, invited adult LEGO builders and NELUG members to visit and display their work. The result was a landmark event. More than 300 people attended, including teachers, kids, LEGO staff from both the United States and Europe, and other fans. MindFest set a new standard for LEGO fan events.

But nothing was quite like BrickFest. The brainchild of Christina Hitchcock, BrickFest first took place in 2000 in Arlington, Virginia, and it was the first convention dedicated to the LEGO fan. Seminars were set up with fan-centered subjects, and LEGO staff gave keynote speeches and took questions from the audience. Builders had space to display their models, and friends who knew each other through LUGNET had a chance to meet in person. For the newer fans, BrickFest was a grand introduction to the LEGO hobby by some of the best builders.

BrickFest became the main LEGO fan event on the East Coast. And thanks to the BrickFest organizers, 2002 saw the first BricksWest, held at LEGOLAND in Carlsbad, California. With assistance from BrickFest staff, BricksWest was both sponsored and endorsed by the LEGO Group. Presentations and previews of sets to come made the event a mecca for fans and allowed the LEGO Group to connect with and thank the fan community.

LEGO fan events suffered a setback when BricksWest 2003 closed. Financial obligations to the vendors and the event venue were not met, and the coordinator subsequently disappeared from the LEGO fan scene. As a result, BricksWest 2004 was never planned, and that year BrickFest was held both in Oregon (as BrickFestPDX)

Thousands of casual fans attend BrickCon 2009 to admire the beautiful models.

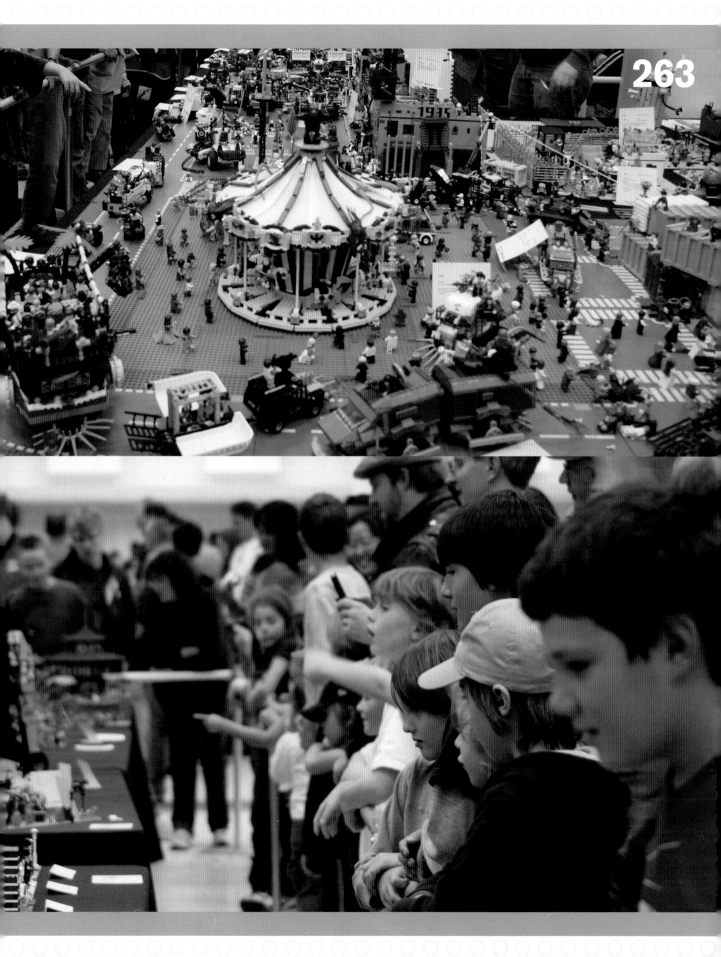

(LEFT) **Models at conventions run the gamut of themes and ideas; seen here is a space-themed "claw" game.**

(RIGHT) **Mark Sandlin's Voltron model wows experienced builders and casual builders alike.**

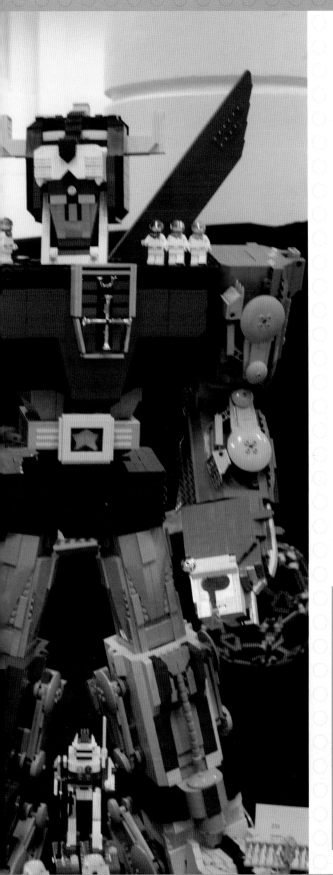

and in Virginia. (The West Coast is also served by BrickCon, which has been held annually in Seattle since 2002.)

LEGO conventions quickly sprouted around the world. In 2001, the first LEGOWORLD opened in Zwolle, Netherlands. This event differed from most because the LEGO Group was involved in organizing the event. New LEGO products were displayed, and LEGO staff mingled with attendees; LEGO set designers gave sneak previews of upcoming sets; and the LEGO Group called upon local clubs for staffing volunteers. In 2002, 1000steine-Land was first held in Berlin, Germany. This soon became the main German event for LEGO fans. Also in 2002, a casual annual gathering called LMO Japan began; here LEGO fans meet to eat and show off their military-themed models.

By the late 2000s, four US conventions (Brickworld, BrickFair, BrickCon, and BrickFest) were each drawing hundreds of participants and thousands of public visitors. 2010 saw Bricks by the Bay, the first LEGO fan event in California since BricksWest 2002. Worldwide, there are events in Germany, France, Denmark, the Netherlands, Portugal, Russia, Australia, and Italy, with clubs growing in Japan, Poland, Taiwan, and Hong Kong.

LEGO and Trademarks

Why did the early events use LEGO in their name, but more recent conventions use "Brick"? Like many companies, the LEGO Group is protective of its trademarks. When LEGO fan gatherings consisted of a few dozen builders, the company ignored the events and the implications of adults displaying their creations. As the adult LEGO fan movement and conventions have grown, the company has recognized the risk presented by the unlicensed use of their trademarks. The conventions' solution was to use the general term *brick*, which still carries a LEGO-specific connotation in fan circles.

Convention Activities

LEGO fan conventions are like many other types of fan conventions. There are discussions, talks, keynote speakers, and vendors. But unlike some fan conventions, there are no costumes and little if anything that is not related to the LEGO hobby. Vendors sell parts, sets, instructions, custom elements, and shirts, but everything has something to do with the brick.

In the United States, the typical convention is divided into a display area and a place to talk shop with other LEGO fans. Public display days bring revenue to the event and its vendors. The event's operating expenses are offset only by the registration fees and public ticket sales, so it's easy to see that the monetary risk is pretty high. Setting up a venue can potentially cost thousands of dollars, and registrations only recoup a small part of those expenses.

For attendees, conventions offer a chance to make new friends and catch up with old ones. Although most of the time LEGO building is a solitary endeavor, LEGO fans have a lot to talk about with each other, such as building techniques, projects, and all things LEGO.

(ABOVE) **Fans listen to a talk at Brickworld 2009.**

(OPPOSITE) **When not listening to talks about LEGO, convention-goers show off their models.**

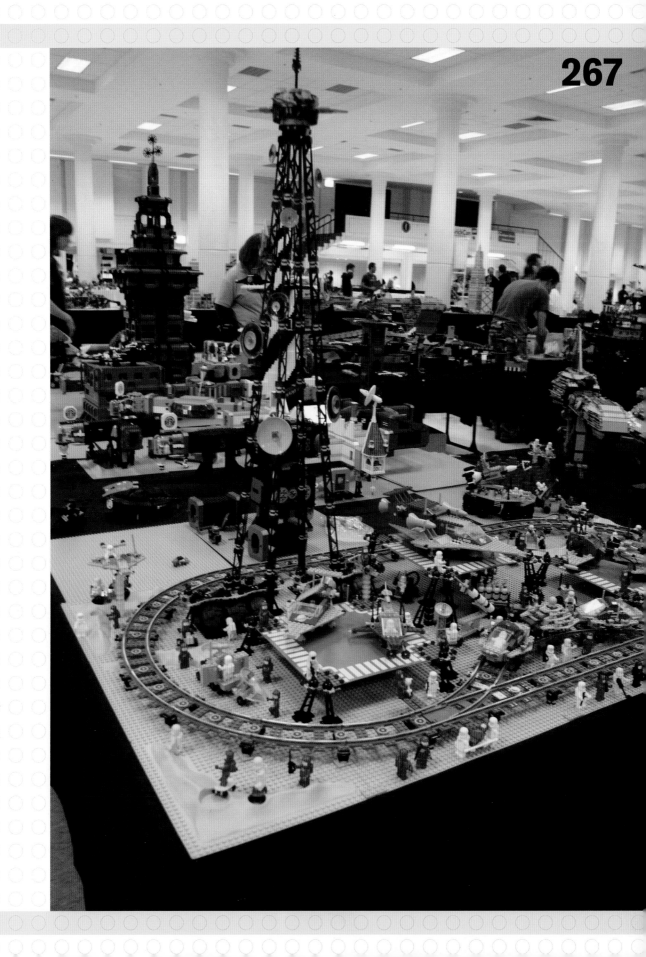

As LEGO conventions have grown in popularity, the LEGO Group has taken notice. It now uses the events to market and sell sets.

Theme roundtables are held at conventions, where interested fans discuss building ideas. Sometimes, community projects are initiated. For example, at BrickFest 2003, some Space builders developed a building standard for modular moonbases. This was an important development that allowed builders to create individual modules that could easily fit together. Castle builders and Town builders developed similar standards. (Train builders have had their own guidelines for tables, but for the most part, they follow Town standards or their own club standards.) The mechanically inclined TECHNIC builders developed standard start and end points for the Great Ball Contraption, which involves moving a LEGO soccer ball from point A to point B in a module, then on to the next module, and so on.

One of the most enjoyable parts of LEGO conventions is the chance for attendees to show off their models to adoring but more casual fans. Most events have public hours where anyone may visit for a small fee, admiring roped-off models and snapping pictures. Public hours are a great way to recruit new builders or simply to bask in admiration over a masterful build.

But for LEGO fans, the convention highlights are the keynotes and announcements from the LEGO Group, where LEGO representatives discuss upcoming sets and sometimes more. The LEGO Group now uses the events to unveil new sets and display upcoming sets not only to the attendees but also to the public. It's a winning proposition all around, as people get a peek at what's coming, and the company gets to do some casual market research on their sets.

Brick Cliques

Socializing begins the moment a fan sets foot in a convention. New fans quickly become friends with the more experienced attendees, and most fans connect with people who build the same themes. As a result, there is a friendly tension among the theme-oriented groups, most notably between the Train and Town builders and the Space builders. This tension sometimes manifests in a unique way … builders sometimes invade each other's layouts! The results are often hilarious, with space ships and invading robots destroying a Castle layout, for example. The Castle builders retaliate, attacking a Space layout with knights, horses, and … *sheep*? The attacks (and counterstrikes) take place over the course of a day, all in the name of fun.

When the convention closes for the night, though, the real socializing begins, often at a local bar. For many, conventions are the only time they get to meet with friends that they usually correspond with online.

European events are similar to American events but with a more relaxed atmosphere. Most meets have the casual feeling of a class or family reunion, where everyone knows everyone else. Events are also held in a diverse variety of venues, from community centers and churches to malls, and dinners are group affairs, where everyone converges on one restaurant to eat. By contrast, American AFOLs tend to go in their own groups to meet and eat.

All of these events are common in one regard, though: They allow LEGO fans to meet and learn from each other. With the international scope of the hobby, fans are now traveling overseas to attend events, where the obstacles of different cultures and languages are overcome by a universal love of LEGO building. Also, some European events are starting to follow a more American model. In 2010, AFOLcon, a new convention in Manchester, England, included dedicated AFOL-only days followed by public days. As the community evolves, it has begun to grow together.

Serious
LEGO

Nearly every kid loves playing with LEGO, but autistic children learn much more from the process than merely how to put two bricks together.

So far in the book you've seen all sorts of motivations for making LEGO models. One builder may see his LEGO model as fine art, on par with an oil painting or marble model. Others seek to replicate famous buildings or to build a huge model that breaks a world record. Many people simply consider LEGO a toy. Most of these urges are diversions for the builder.

Other builders, however, take LEGO more seriously. For them, LEGO is about assisting people, educating kids, prototyping new ideas, or simply helping their company sell more products. Far more than a toy, LEGO bricks have taken on a critical, life-impacting status: important LEGO. Serious LEGO.

Autism

Therapy

Most kids like playing with LEGO bricks, but for some children, that play takes on a greater importance: It helps them learn how to get along with other kids.

Autistic children suffer from a limited ability to interact with other children; it's a handicap that can't be overcome by forcing the child into social situations. Autistic kids must be coaxed into these critical interactions, lured into building the social skills most kids learn automatically. And what better way to challenge a kid's critical weakness than to involve them in an activity that appeals to their strongest suit?

"Let's face it, LEGOs are just plain cool," Troy DeShano, father of an autistic son, wrote in his blog at *http://www.strongodors.com/*. "In contrast to some other activities, it does not require a lot of persuasion from a parent for a child to want to play LEGOs."

An out-of-the-box LEGO model presents the child with an activity they already enjoy—playing with bricks—yet provides structure in the form of building instructions. Building LEGO models isn't mere play; the building process has its challenges and problems to be conquered. Finishing the model gives the child an all-important payoff. "With every piece in place,"

DeShano wrote, "the child can't help but learn the value of working off his strengths and pushing through the challenges faced along the way." In a world that seemingly frustrates and confounds the autistic kid, here is something he can do well and completely.

The surprising effectiveness of LEGO therapy has not gone unnoticed in more traditional settings. At the Center for Neurological and Neurodevelopmental Health (CNNH) in Voorhees, New Jersey, an organization devoted to helping patients conquer brain disorders, doctors and therapists have been offering LEGO therapy for autistic children for more than 15 years.

Unlike DeShano's experience, CNNH's LEGO therapy sessions involve groups of children. One of the most crippling aspects of autism is the difficulty the child experiences in interacting with his peers. Such everyday experiences as chatting and playing together leave autistic kids frustrated and withdrawn. LEGO therapy leads them to cooperate while doing something they find enjoyable.

"To prompt interaction among the children and help them come up with their own solutions, adult coaches divide up tasks so they have joint and interactive jobs to do," the CNNH website explained. Facilitators divide the teams into different roles. One child might focus on reading the instructions, another may organize the elements, while a third puts the bricks together. None can succeed without the others. When the kids get comfortable in their roles, instructors switch them up. Older, more technically savvy children eventually tackle stop-motion LEGO films (described in Chapter 7), taking turns as director, camera operator, and model wrangler. This allows kids to continue to work on their social skills while offering them greater challenges.

A rare subset of builders actually gets *paid* to put LEGO models together. Sean Kenney's LEGO DSi was commissioned as part of the portable game console's 2009 release.

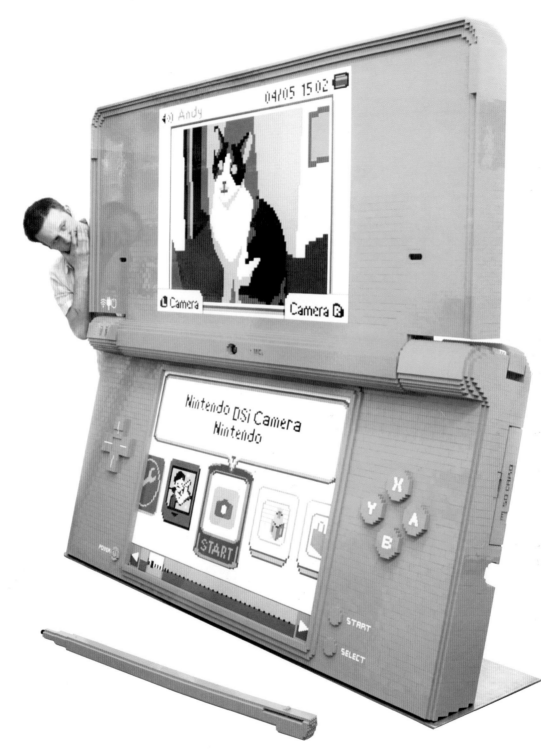

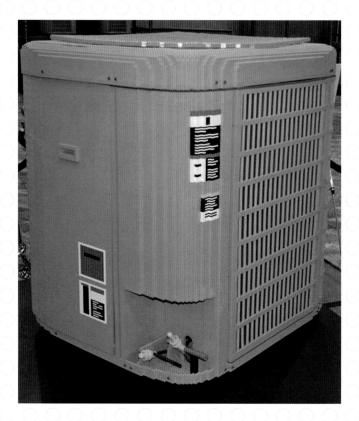

Nathan Sawaya's model of a Carrier air conditioner even worked—a fan inside the unit emitted a breeze from the vents.

Although perhaps not as important as helping a kid with autism, companies seeking to promote new products or events often turn to LEGO bricks. Unusual LEGO models become news and marketing people like their products to find their way into the news.

Sean Kenney, a LEGO Certified Professional mentioned in previous chapters, was commissioned to create a giant model of a Nintendo DSi for the device's launch. Built with 51,324 bricks over a welded-iron framework, the model was described by dozens of major gadget sites like Engadget and Gizmodo, while a time-lapse movie of the creation was featured on Boing Boing. The sculpture ultimately moved to the Nintendo World Store in Rockefeller Center in New York City.

In addition to attracting the attention of the media, giant LEGO models are a hit at conventions. Sometimes a builder will even construct the model at the sponsor's booth to give convention-goers an opportunity to observe the process in action. In the 2005 Seattle International Boat Show, the convention's organizers called pro builder Nathan Sawaya (profiled in Chapter 6) to commission a model for the show.

"When he mentioned that I needed to build it within the 10 days of the Seattle Boat Show, I said sure," Sawaya said in an interview. "When he said he wanted it to be a half scale of a 20-foot Chris-Craft speedster, I said sure. When he said that there would be free Twizzlers, well, I booked my ticket and started building." Sawaya built the speedboat at the show, working 18 hours a day for 9 straight days. He used hundreds of thousands of bricks, attracted thousands of gawkers, and created a huge splash for the show—and set the world's record for a LEGO boat model along the way.

Prototyping a Space Elevator

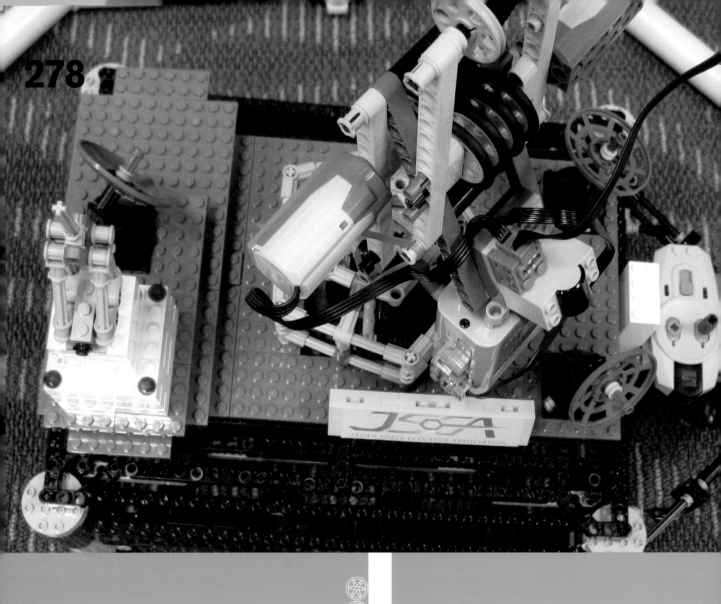

The members of the Japan Space Elevator Association (JSEA) created a buzz for their project by constructing a working model of a space elevator out of TECHNIC girders.

A space elevator is a theoretical method for achieving orbit by stretching a cable from a geosynchronous satellite down to the earth and sending an elevator car, called a *climber*, up the cable using electricity rather than rocket fuel. Although the technology sounds good on paper, government agencies have estimated a working space elevator is about a century off and haven't put much energy into research. Despite this official lack of interest — or perhaps because of it — groups of hobbyists have never given up on the technology and have formed organizations and held gatherings to share their findings.

One of those conventions was the 2008 Space Elevator Conference, sponsored by Microsoft and the Space Engineering & Science Institute. It was a small, sleepy gathering with about 60 to 70 participants, including JSEA's contingent, who brought with them the LEGO model.

"They built that particular model to cause a splash," Space Elevator Blog editor Ted Semon recalled in an interview. And it worked — the conference vaulted into the limelight when tech blog Gizmodo posted about JSEA's prototype, once again proving that even a relatively exciting area like space exploration can use the bump offered by a LEGO model.

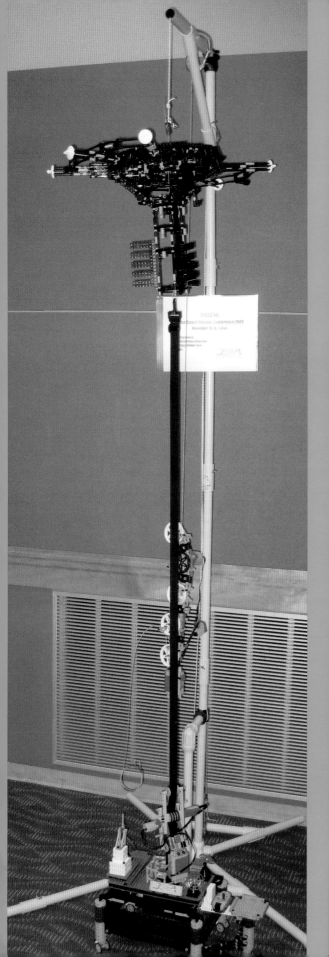
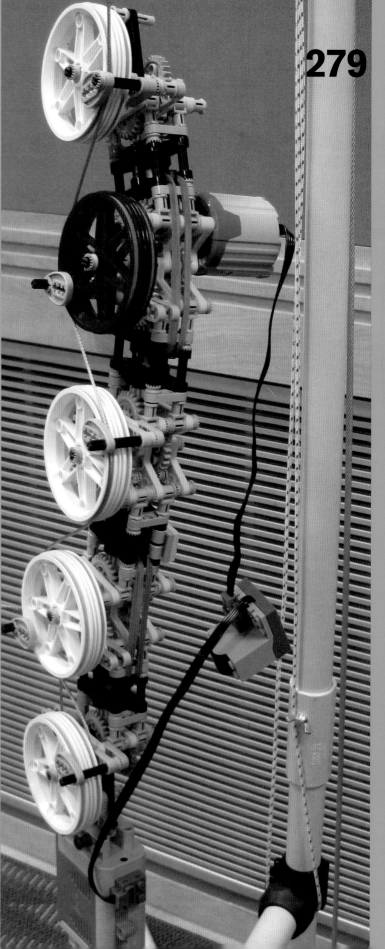

Launch day in the United States: LUXPAK and other experiments sail into the sky and are recovered as the balloon bursts.

High-Altitude LEGO

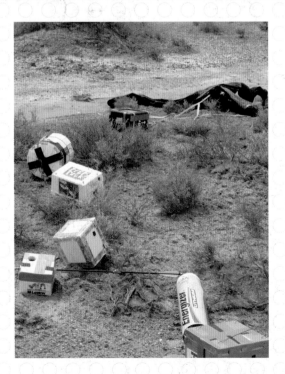

While some companies seek to make an impact using LEGO in their marketing efforts, sometimes it is the LEGO Group itself doing the promoting, using its deep pockets and keen marketing sense to promote its product line. In 2008, the LEGO Group, along with the Energizer Battery Company; National Instruments; the University of Nevada, Reno; and the Nevada Space Grant, sponsored a series of science experiments conducted on two weather balloons: the High Altitude LEGO Extravaganza (H.A.L.E.), found at *http://www .unr.edu/nevadasat/hale/*. The catch was that all of the experiments had to be based on the LEGO Group's MINDSTORMS robotics system (described in Chapter 10) because the LEGO Group wanted to publicize the product's 10th anniversary.

Schools around the world were invited to submit MINDSTORMS-powered meteorological experiments to be carried aloft by the balloons. Ultimately nine teams of schoolchildren from the United States, Taiwan, Luxembourg, Sweden, and Denmark sent payloads to an altitude of 99,500 feet, the balloons' maximum range.

The Luxembourg team, mentored by Claude Baumann and three other teachers, created project LUXPAK, which measured ozone concentration, air pressure, temperature, and reflected light using a variety of student-built electronics controlled by a MINDSTORMS RCX microcontroller. Although not able to attend the balloon release in person, the students packed the experiment in a box and shipped it to Nevada. Once activated, the project's telemetry could be tracked via Google Maps' APRS service, which takes weather and position data from amateur radio operators and displays them on a map.

Physics professor Brian Davis submitted two proposals. The first, named Gypsy, consisted of a digital camera mounted in a LEGO chassis with a MINDSTORMS servo pressing the power and shutter buttons and another assembly toggling between video and still modes. The other experiment, Lil' Joe, packed a HiTechnic accelerometer, a hiker's GPS beacon, and a parachute, and its job was to deploy high in the atmosphere and free fall until its parachute deployed; its trajectory could be tracked from the GPS's signal.

Other H.A.L.E. experiments included a Swedish robot called REEL-E that measured the change of g-forces as the sensor gained altitude; Brix-Catcher, a Taiwanese robot that collected atmospheric particles; and a project by a class of fourth graders that tested the effects of high altitudes on marshmallow Peeps candies. There was even a secret experiment conducted by the LEGO MINDSTORMS team that was lost during the mission.

Launch day. The balloons were released and shot aloft. At 82,000 feet Lil' Joe was deployed and began its free fall; meanwhile, the H.A.L.E. balloons continued to rise until they burst at nearly 100,000 feet. At that altitude, the sky was black and the curvature of the earth was obvious—for all practical purposes the H.A.L.E. experiments were in space. After falling for 60 seconds, Lil' Joe deployed its chute and landed safely despite that the parachute had only partially opened. The other experiments survived as well with only the mysterious MINDSTORMS project going unrecovered.

H.A.L.E. was certainly not the first time schoolchildren participated in a weather experiment, but the story ran on numerous gadget, technology, and toy websites.

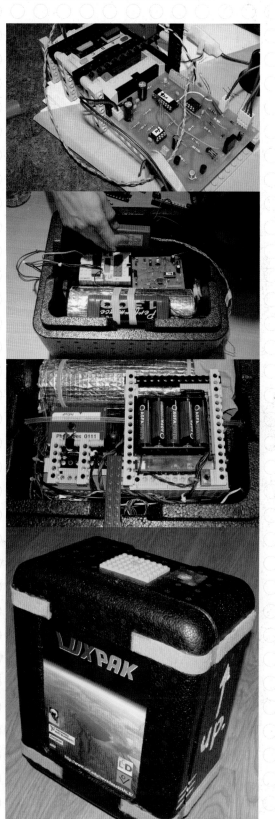

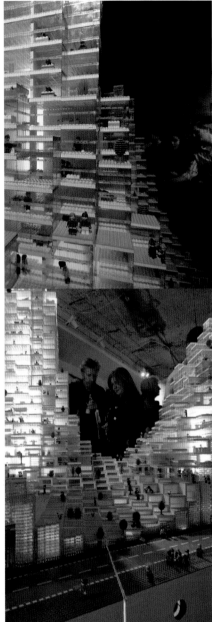

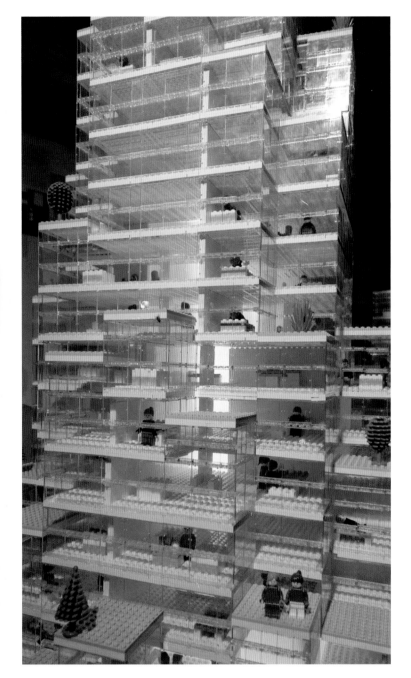

Visualizing

Would LUXPAK and the other H.A.L.E. projects have made the news if they hadn't used MINDSTORMS controllers as part of the experiments? Would the Nintendo DSi's release have gotten as much of a splash without a giant LEGO model of the product? It's hard to say. Those marketers capitalize on the fact that LEGO is such a household phenomenon that virtually any viewer will connect with the stories even if they aren't interested in science experiments or gadgets.

Sometimes, however, the use of LEGO draws from deeper roots than mere marketing opportunism. When Copenhagen architecture firm Bjarke Ingels Group (BIG) wanted to promote a skyscraper project, it constructed its architectural model out of LEGO rather than traditional media. It built the tower in minifig scale, resulting in a gigantic structure that filled an entire room, using a quarter million bricks and a thousand minifigs. The tower, along with four other BIG projects, was displayed in New York City's Storefront for Art and Architecture in the fall of 2007.

So, why did BIG use LEGO as a medium for an architectural model? As you saw in Chapter 1, Denmark is a nation inextricably linked with its most famous toy. "During the Marshall years when post-war Denmark was being rebuilt, the state chose to favour prefabricated concrete over all other forms of construction," the exhibition's flyer declared. "Contemporary Denmark has become a country entirely made from LEGO bricks."

With most of Denmark's construction projects utilizing prefabbed modules, it was a cinch to translate that to LEGO. It all began when BIG used the LEGO Group's Digital Designer service to convince a client hesitant to move forward with LEGO. "At the end of the presentation we gave the client his own LEGO project, preassembled. He passed it on to his son and gave us the commission to do it."

With the Scala Tower, BIG faced an additional challenge: Copenhagen's dislike of tall buildings, which dates back to the turn of the 20th century when fire departments' ladders extended only 70 feet. Numerous worthwhile projects had been canceled because of this quixotic tradition. In an effort to win over naysayers and mollify critics of high-rises, BIG designed the model with a wide base full of neighborhood amenities, rising up in a series of plateaus and balconies before narrowing to a full-fledged tower.

The use of LEGO added a playful aspect to the project and made it seem more human—minifigs could be seen throughout the model. The fact that the building material appealed to the Danes' love of LEGO didn't hurt either.

Skyscrapers

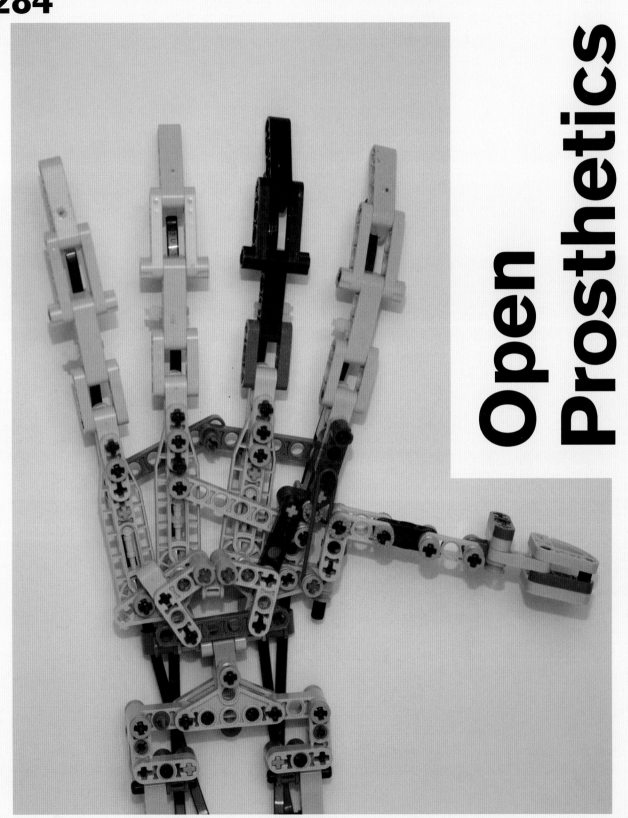

The Open Prosthetics Project (OPP) is a loosely knit association of amputees and their advocates who are attempting to bypass the expense and bureaucracy of traditional medical channels to design their own prostheses. As an open source project, the group shares its discoveries with anyone interested, potentially allowing the technology to help people around the world.

A casual glance at the OPP website shows a clear focus on transradial (lower arm) and transhumeral (upper arm) prostheses. According to the organization's wiki, of the estimated two million amputees living in the United States, only about 5 percent are missing a hand or arm. This disparity automatically causes for-profit prosthetics manufacturers to deemphasize upper-limb research and is part of the reason why the OPP was formed.

The OPP generated a nice amount of buzz with its first project, a reverse-engineered version of an obsolete prosthesis, the Trautman Hook. The project published CAD drawings online for anyone to download, catching the attention of *Scientific American*, which featured them in an article. However, the holy grail of upper-limb prostheses isn't some sort of hook but rather a hand-shaped device capable of full articulation. That's where LEGO comes in.

Stymied by the steep expense of creating professional prototypes, project volunteer John Bergmann had the idea to build the hand with LEGO. "I used the parts from a couple *Star Wars* droid kits, and it took a few weeks," he said in an interview.

The biggest challenge for Bergmann was developing the thumb so that it operated as a human's digit would. "That joint is very difficult to replicate," he said. "LEGO does not make a suitable ball joint with the strength needed in this application."

John Bergmann of the Open Prosthetics Project built this experimental robotic hand.

Bergmann, a sailor in the US Navy, hopes to ultimately provide motorized LEGO prostheses in kit form, with actuation triggered by myoelectric sensors. This technology senses the faint electrical signals generated by voluntary muscle contractions and activates a prosthesis based on that input. Of course, myoelectric technology is prohibitively expensive. But not to worry, the OPP is working on its own open source version.

Serious Play participants discuss their creations.

Serious
Play

Earlier in the chapter you learned how autistic kids build LEGO models in a group, taking on separate roles in order to build social skills. The LEGO Group's Serious Play division uses a different but related technique to help companies develop teamwork, solve communications problems, and foster innovative practices: It has them build a LEGO model and then talk about it.

Serious Play is a session-based method of team building. While the reasons behind sessions are many, such as communication, management training, or corporate initiatives, the goal is to have a group communicate and bond. It turns out that LEGO building provides the common language for people to relate on both personal and, through the session, group levels. These sessions have a facilitator and use Serious Play kits available from the LEGO Group.

"Everybody builds, and everybody tells their story, which is one of the key strengths of the method," Serious Play facilitator David Gauntlett said in an interview. "It gives everyone a voice, and everyone participates equally, regardless of their status in the organization and no matter whether they are usually quiet or noisy in meetings."

When the participants' models are complete, the facilitator steps in to query the builders about their creations, encouraging them to spin tales, identify problems, and create solutions. For instance, the facilitator might first have the group create a model of an animal. Once the group has finished discussing their creations, each builder gets two minutes to create a model that is a metaphor for how he or she feels on a Monday morning. From there, a discussion centers around each model, with its creator talking about what they built.

While Serious Play is an official LEGO Group initiative, it hardly fits its usual business model of selling LEGO sets. The individual kits sold to participants don't amount to much in the way of sales, so why do it?

"LEGO Serious Play developed out of a problem within the LEGO company itself," Gauntlett wrote in his book *Creative Explorations* (Routledge, 2007). "In 1996–97, the president of LEGO, Kjeld Kirk Kristiansen, was feeling disappointed that his staff meetings did not seem to be able to generate imaginative strategies for the future of the company. He knew that his employees were talented people and so felt that some kind of tool was needed to unlock their imagination and creativity."

Consultants brought in to help work out the company's corporate snafus pointed to the product itself as a uniquely appropriate tool for unleashing employees' imaginations and encouraging a playful and nonjudgmental environment for generating ideas.

"[J]ust as LEGO had been telling children to 'build their dreams' for decades," wrote Gauntlett, "so perhaps adults could be asked to *build* their visions for future strategy." The very name of the project espouses the notion that the act of playing can be used for serious ends. "[T]here is a growing body of literature, in both academic journals and popular paperbacks, which argues that behaving in 'play' mode offers creative possibilities, because it emphasises freedom and plays down responsibility, self-consciousness and shame."

Unsurprisingly, a Serious Play session mirrors the transformation of adult LEGO fans around the world as they resume this childhood interest. Perhaps the transformation wrought on Serious Play participants isn't as dramatic as LEGO fans breaking out of their Dark Age, but the promise of these sessions—to unleash the imagination and creativity of individuals—confirms what LEGO fans have said for years.

Andrew Carol's Mechanical Computers

Software engineer Andrew Carol discovered something pretty remarkable: It's possible to re-create primitive computers using LEGO TECHNIC gears.

"I decided to explore where computational mechanics and LEGO meet," Carol wrote on his website (*http://acarol.woz.org/*). "This is not LEGO as toy, art, or even the MINDSTORMS fusion of LEGO and digital electronics. This is almost where steampunk and LEGO meet." Carol wanted to build hand-cranked computing engines.

Carol's first project was a re-creation of English mathematician Charles Babbage's Difference Engine #1. The Difference Engine was one of the first computing machines, conceptualized in 1822 by Babbage as a way of calculating polynomial functions, a mathematical process that is fraught with error when performed without a mechanical aid.

Babbage's Difference Engine, which could calculate 7th-order polynomials to 31 digits of accuracy, wasn't built until 1991 because of engineering difficulties and political troubles. Nevertheless, the invention was seen by historians as a monumentally important step in the development of the modern computer. Carol's replica of the Engine, now in its third iteration, was created out of TECHNIC bricks and allows users to compute third-order polynomials to four digits of accuracy.

Andrew Carol re-created an old-fashioned computing machine with LEGO bricks.

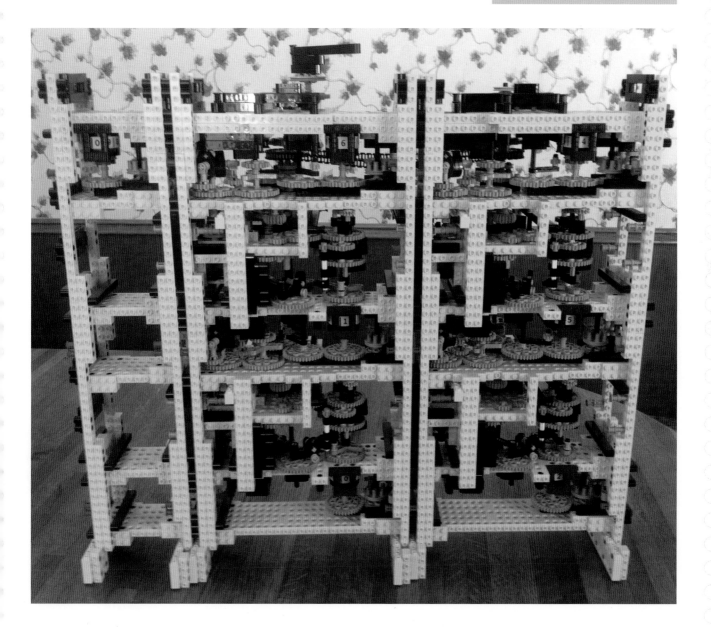

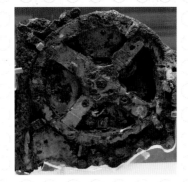

(LEFT) **The Antikythera mechanism remained a mystery until modern X-ray and CT scanners were able to penetrate the corrosion.** (RIGHT AND BELOW) **More than a century later, the Antikythera mechanism has been restored to what might well have been its original configuration—only formed out of LEGO.**

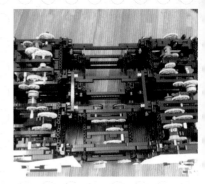

Carol also created a LEGO model of the Antikythera mechanism, an ancient mechanical computer lost in a shipwreck around 150 BC that was designed to calculate the position of the sun and moon and the dates of solar and lunar eclipses. The device was recovered in 1900 as a mysterious, corroded lump of gears. As technology enabled scientists to scan the mechanism, details began to emerge. The ratios of gear teeth matched ancient formulas used to predict eclipses, and lettering on the machine matched astrological terms used by the Greek city of Corinth. Carol's re-creation uses more than 100 TECHNIC gears and seven differential gearboxes. It is accurate to a day or two over its range.

Carol's models do an amazing job of re-creating these primitive computers, for all that they're made from toy parts—proving once again that LEGO can be used for serious, scientific pursuits.

It's true that LEGO's first and greatest purpose is as a toy for children. However, its ability to capture the imagination of countless adults, to help them expand the limits of their capabilities, and to release a playfulness seemingly missing from modern life makes it an important tool for adults. By helping inventors, therapists, architects, and scientists, LEGO takes on an importance unmatched by any other toy.

Epilogue

Serious LEGO.

The title of our final chapter in a way embodies the entire book. To a child, LEGO is fun but ultimately nothing more than a toy. Adult builders, on the other hand, devote valuable time and thousands of dollars to the hobby. They painstakingly build models and then share them online, basking in the praise of their peers or wincing when criticism is offered. They create inventions; they build robots; they devote half their houses to the hobby.

To the Cult, all LEGO is serious. They glare when you refer to the bricks as "LEGOs" (it's LEGO, never LEGOs). They snarl at knockoffs like MEGA Bloks and KRE-O. They argue over brick colors and concoct elaborate contests. Builders who include non-LEGO elements in their models or who alter or glue their bricks are lambasted by purists.

For the rest of us, it's hard not to be caught up in the whirlwind of creativity that is the adult LEGO scene. Flipping through the pages of *The Cult of LEGO*, one is faced with model after brilliant model. There are creations so epic in scale that most of us could never hope to build them simply because of the economics of buying so many bricks, and there are models containing a mere 20 elements that are designed so brilliantly they don't need scale to amaze.

It's tempting to attribute the adult LEGO fans' creativity and cleverness to the amazing toy they love: LEGO's adaptability, diversity of parts and colors, and quality of manufacturing are unmatched in the toy world. But it begs the question: How much of LEGO's success can be laid at the feet of these adult builders? Surely most children can't shell out $500 for super sets or care enough about their models to buy individual elements from the Pick A Brick store. These were created to cater to adult builders.

LEGO might have inspired the Cult, but the Cult also has helped shape LEGO into what it is today—and both are richer for it.

We hope that somewhere on some page of this book you too have been inspired to build your own remarkable creation and perhaps even to join the Cult. Welcome.

Index

FIG. 7.

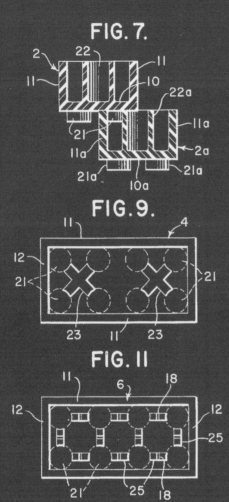

FIG. 8.

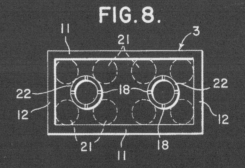

FIG. 9.

FIG. 10.

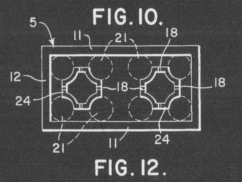

FIG. 11

FIG. 12.

INVENTOR

Godtfred Kirk Christiansen

BY
Stevens, Davis, Miller & Mosher
ATTORNEYS